Artist's
Photo Reference
FLOWERS

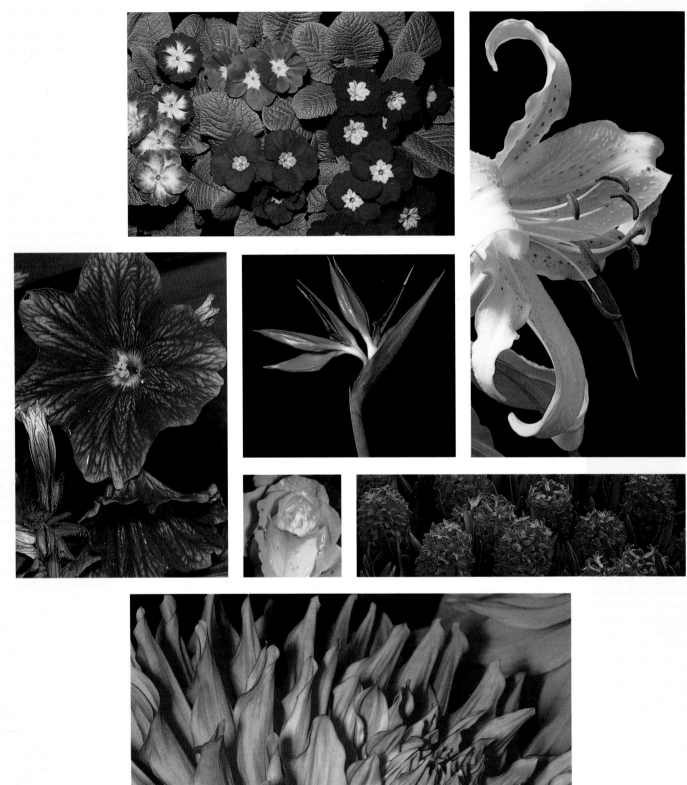

Artist's
Photo Reference
FLOWERS

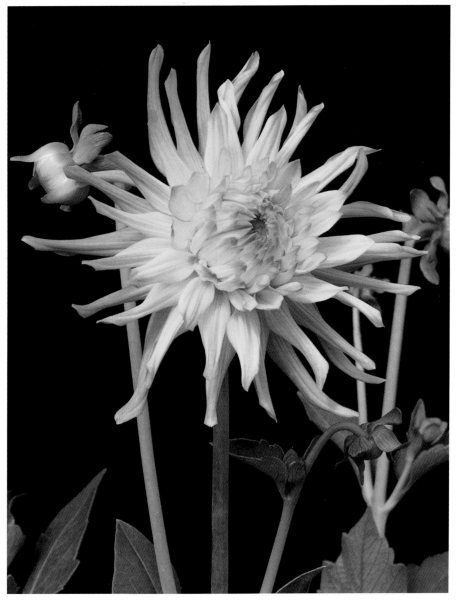

GARY GREENE

NORTH LIGHT BOOKS
Cincinnati, Ohio

Artist's Photo Reference: Flowers. Copyright © 1998 by North Light Books. Manufactured in Singapore. All rights reserved. No part of this book may be reproduced in any form or by any electronic or mechanical means including information storage and retrieval systems without permission in writing from the publisher, except by a reviewer, who may quote brief passages in a review. Published by North Light Books, an imprint of F&W Publications, Inc., 1507 Dana Avenue, Cincinnati, Ohio 45207. (800) 289-0963. First edition.

Other fine North Light Books are available from your local bookstore, art supply store or direct from the publisher.

02 01 00 99 5 4 3 2

Library of Congress Cataloging-in-Publication Data

Greene, Gary.
 Artist's photo reference: flowers / by Gary Greene.
 p. cm.
 Includes index.
 ISBN 0-89134-811-5 (pob : alk. paper)
 1. Photography of plants. 2. Flowers—Pictorial works. 3. Flowers in art.
 4. Painting—Technique. I. Title.
 TR724.G74 1998
 779'.34—dc21 98-11861
 CIP

Content edited by Pamela Seyring
Production edited by Bob Beckstead
Cover and interior designed by Angela Wilcox

About the Author

An accomplished professional photographer for more than twenty years, Gary Greene is also a talented fine artist, graphic designer, illustrator, author and instructor. His photos have been published by (among many others) the National Geographic Society, Hallmark, US WEST Direct, the Environmental Protection Agency, Hertz, the Automobile Association of America, *Petersen's Photographic Magazine*, *Popular Photography* and *Oregon Coast Magazine*. Gary has worked in a number of fine art mediums, including acrylic, airbrush, graphite, ink, and especially colored pencil.

Besides *Artist's Photo Reference: Flowers*, Gary is the author of *Creating Textures in Colored Pencil*, *Creating Radiant Flowers in Colored Pencil* and *Painting With Water-Soluble Colored Pencils* (1999), all published by North Light Books. Both his colored-pencil paintings and photographs have won numerous national and international awards. Gary has conducted workshops, demonstrations and lectures internationally since 1985.

Dedication

In loving memory of Gomer—to know him was to love him.

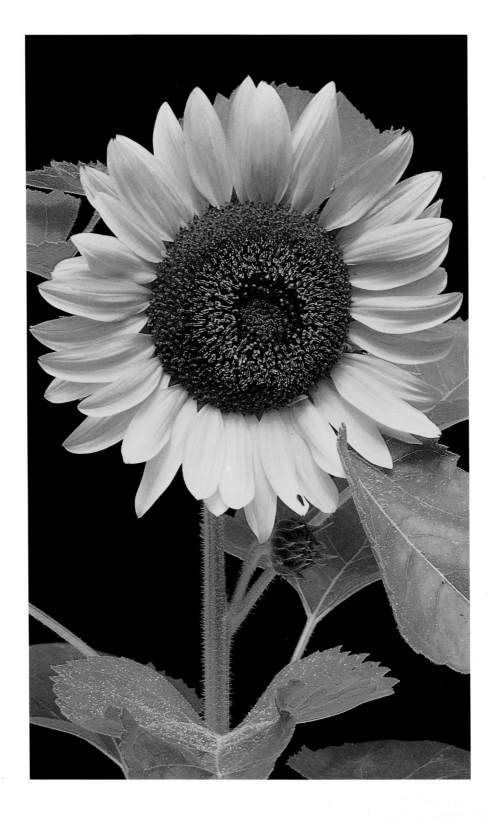

Acknowledgments

A special thanks to Molbak's Nursery, Woodinville, Washington, for allowing me access to their perfect plants for an entire year. Without their cooperation, the production of this book would have been extremely difficult. Thanks also to Fran Wester of Westerway Iris Garden and Holly O'Harra, for allowing me to tromp through their gardens.

Many thanks to contributing artists Norma Auer Adams, Sandra Jackoboice, Barbara Krans Jenkins and Shane, all of whose talent, creativity and professionalism I'm in awe of.

And to my wife, Patti, for her patience and encouragement.

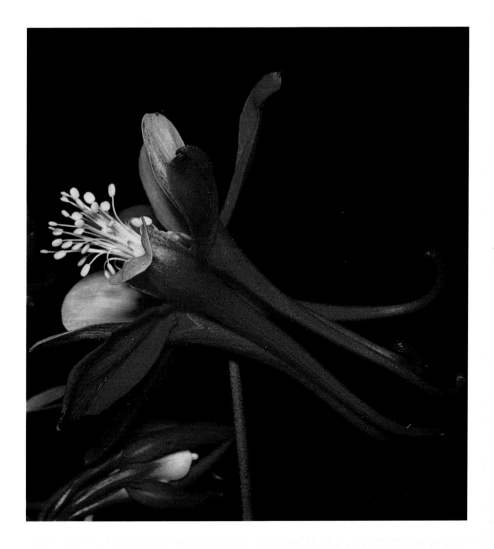

Table of Contents

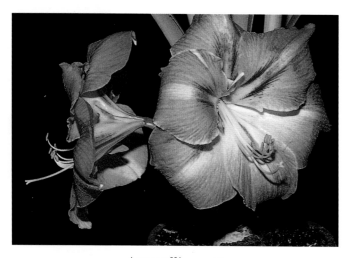

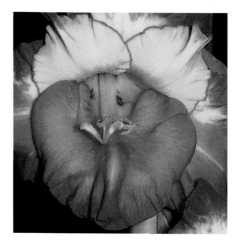

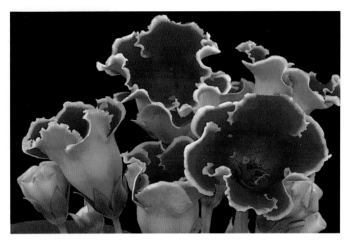

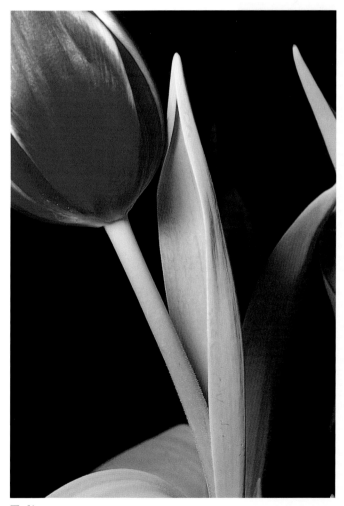

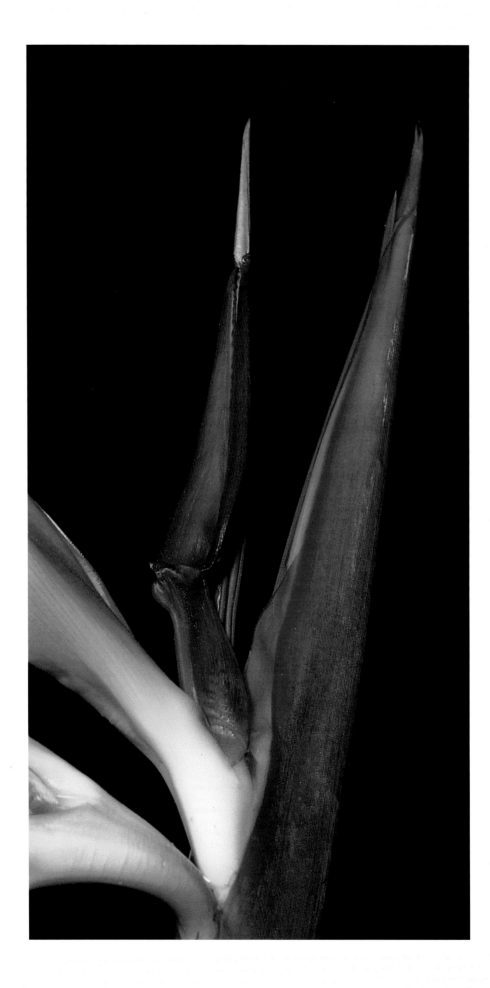

Introduction

Have you ever wanted to paint tulips in October, but couldn't travel to Australia? Did you ever get frustrated looking for good reference photos of a particular flower and, after searching through stacks of gardening magazines, get even more disappointed to find only photos that were either lacking important detail or didn't show what you wanted? Well, my fellow artist, this book is for you!

The idea of *Artist's Photo Reference: Flowers* occurred to me while writing my second North Light book, *Capturing Flowers in Colored Pencil*. Although I thought there were sufficient flower images in my photo library for reference, I discovered that I was missing several. I couldn't work from fresh flowers, even if I wanted to, because some were not in season or not indigenous to the region where I live. Besides, colored pencil paintings take much longer to complete than the lifetime of a bloom!

Undaunted, I began searching for reference photos. First I tried a "broad approach," using books such as *Simon and Schuster's Complete Guide to Plants and Flowers* and *The Color Dictionary of Flowers and Plants for Home and Garden*, published in collaboration with The Royal Horticultural Society. Both are excellent books for gardeners, but were woefully inadequate for artistic purposes. Many of the photos (especially the ones I needed) were taken at a distance, so important details were hidden. Others were taken in contrasty lighting, causing the details to be either blocked by shadow or washed out. Next, I tried looking for subjects in gardening magazines. Have you ever tried to find a particular flower in a gardening magazine? You practically have to look through hundreds, because the articles may not be simply called "rose" or "nasturtium." Finally, I resorted to using seed catalogs and seed packages as references.

Then I wondered, "What do other artists do?" and the idea for this book was born. It is intended for artists of all levels, from beginners who need good reference material to work from, to professionals who want to augment their reference material or have an unusual flower at their fingertips. There are five step-by-step demonstrations by accomplished artists in their chosen media, using flowers from the reference photos in the book and showing how reference photos can be used to create beautiful floral paintings. Finally, I briefly describe how to take your own reference photos using simple techniques.

This book was written by and for artists, not scientists, horticulturists, botanists or gardeners, so if you spot a technical error, please be forgiving.

Gary Greene
June, 1997

How to Use This Book

Though fresh flowers are good for accurate color rendition and detail, the advantages of using photographic references *far* outweigh using "live" models.

Photos free you from worrying about completing your artwork before your subject shrivels up and dies. In addition, flowers undergo rapid change from day to day, so a particular fold or angle may be completely different in a few days or less, depending on the flower. Imagine this: You've set up a floral still life, set the lighting just right, and your pet cat comes along and bumps into it! You were halfway finished with your painting—now what do you do?

The purpose of this book is to give artists quick reference for floral paintings. Each of the featured flowers shows various views of the bloom, close-ups of "points of interest," plus photos of leaves, buds and stems. Interesting color combinations and variations of the flower type are also often depicted.

When using the photographs, avoid copying. Create your own composition by studying various elements of the flower you want to paint, and then create an arrangement as either a main subject or as an element in a still life, landscape or whatever. Part of the creative process is solving problems. The photos will help find reference material, enabling you to concentrate on layout and technique.

A successful floral painting requires you to know the subject *intimately*, including every line, shape, detail and nuance. Notice I said *know* every detail, not *reproduce* every detail. Depending on medium and style, from abstraction and impressionism through realism, the amount of detail shown in your painting will vary.

Taking Your Own Reference Photos

Photography is an art form in itself. Instead of using paints, brushes and a canvas or paper surface, you use a camera, lenses and film. My interest in photography "blossomed" long after my love of art. Photography has done more to enhance my artistic creativity and skills than anything else I could have done. Conversely, my artistic bent helped to "develop" my photographic skills.

Following is a brief explanation of how the photographs for this book were made. Taking reference photos is not really that difficult. It merely requires a bit of practice to learn the process, just like any other artistic endeavor.

Equipment for Setup

35mm single lens reflex (SLR) camera with interchangeable lenses. Autofocus is *not* necessary (nor is it even desirable).

100mm macro lens that "sees" objects the same size as the human eye does. *Close-up filters* on a "normal" (approx. 50mm) lens or moderate telephoto (approx. 85mm to 100mm) lens can be used instead, although the photo will not be as sharp. These filters screw onto the end of the lens like any other filter and come in strengths of +1, +2 and +3.

Tripod with a ball head and quick release. The ball head allows you to swivel your camera into any position with ease, and the quick release consists of a plate mounted to the bottom of the camera that snaps into and out of the ball head without fumbling with screws, etc.

Electronic flash with light modifier. Choose a medium-powered unit (approx. 100 guide number) with a light modifier attachment that fits over the head to soften the light. A light modifier is a device that fits over the flash head to soften or modify the harsh output. It can be as simple as a handkerchief over the head, held on with rubber bands, to sophisticated professional attachments. The light can also be modified by attaching a white card to the flash unit in such a way as to make the light first bounce off the card, then to the subject. A few pieces of drafting film attached with rubber bands over the flash head will do the trick.

Battery pack. If you want to avoid waiting ten to sixty seconds between shots, as well as having to constantly replace small batteries, a battery pack is an important piece of equipment. It recycles immediately and allows you to shoot five to ten rolls of film without recharging.

Folding table approximately 4' (1.2m) square.

32" x 40" (81cm x 102cm) *foamcore board covered with black velveteen* for a black background.

32" x 40" (81cm x 102cm) *foamcore board* for a white background.

Two 32" x 20" (81cm x 51cm) *pieces of white "X board"* for reflectors. "X board" is two-ply white cardboard used to reflect light from the primary source back onto the shadow (or darker) side of the subject, lightening shadows and darker areas.

Points to Remember

The color is not exact. Color rendition in the photos is not precise, even though great care was taken in the choice of film, lighting and processing. The print processes involved in making this (or any) book further degrade color accuracy.

Lighting differs. Lighting for the reference photos was balanced for full daylight—you may want different lighting in your painting.

Watch the shadows. Light source(s) in your painting may be from a different angle(s) than depicted in the reference photos.

Photographs distort. Because a macro lens was used for all of the reference photos, photographic distortion is minimal, but keep in mind that the camera sees things differently than the human eye.

Photography Setup

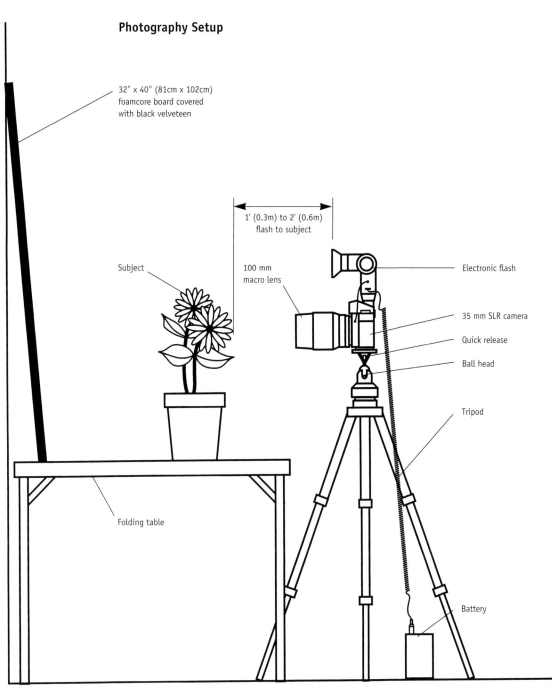

32" x 40" (81cm x 102cm) foamcore board covered with black velveteen

1' (0.3m) to 2' (0.6m) flash to subject

Subject

100 mm macro lens

Electronic flash

35 mm SLR camera

Quick release

Ball head

Tripod

Folding table

Battery

Film. Slide film is preferable to print film for many reasons. The color rendition is considerably more accurate, and image sharpness is greater. Top choices are Fujichrome Velvia 50 ASA, Provia 100 ASA and Kodak ES100SW. Kodachrome 25 and 64 ASA are also excellent, but may take up to two weeks to process; the others can be processed in two hours at a professional lab.

Procedure

1. Mount camera on tripod.
2. Place subject the desired distance from camera.
3. Set aperture at f22 or smallest opening.
4. Set shutter speed at 1/60th of a second or highest allowable flash synch speed.
5. If you're using an autofocus camera, set it to manual focus.
6. Place light modifier over flash.
7. Set flash unit to manual.
8. Focus on the part of the subject closest to the lens.
9. Point/angle flash at the subject.
10. Take three exposures with the flash at approximately 1' (0.3m), 1.5' (0.5m) and 2' (0.6m) from subject.

Some distance adjustments may have to be made depending on the strength of your flash unit, film speed and f-stop (some macro lenses stop down to f32).

Amaryllis

These large trumpet-shaped flowers are 4" (10.1cm) to 5" (13cm) across. They come in a variety of colors, including scarlet, pink, crimson, deep red and white. They are often striped, mottled or blended with other shades.

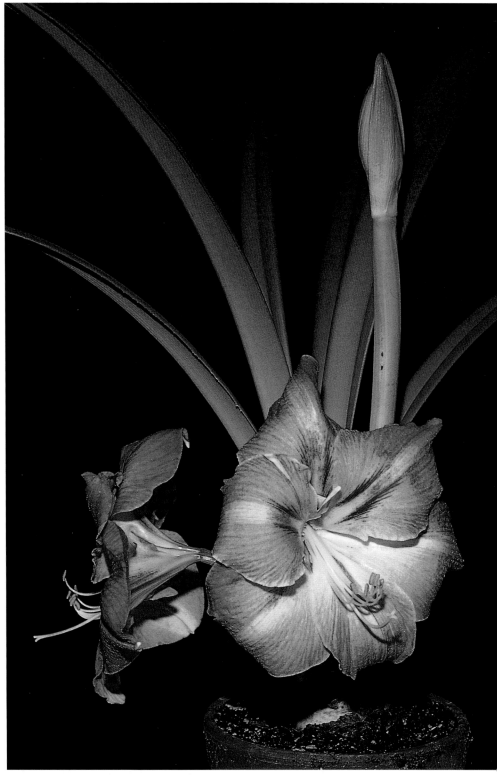

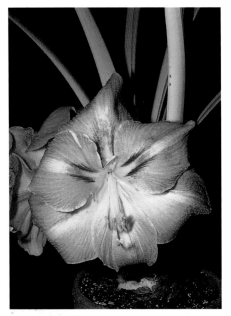

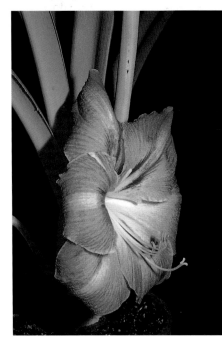

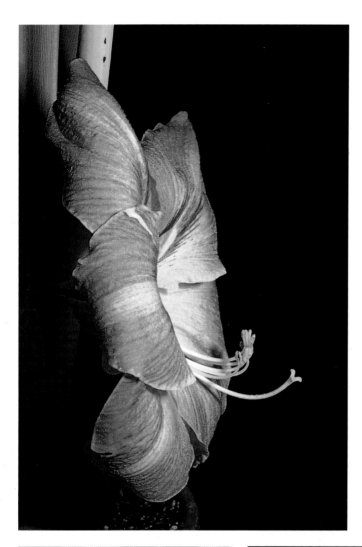
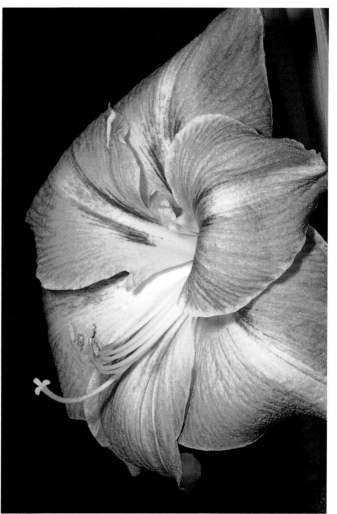
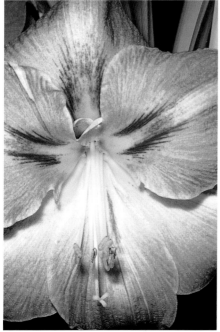
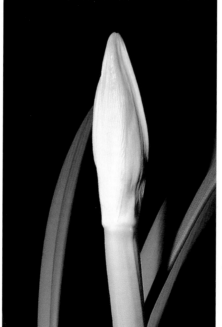
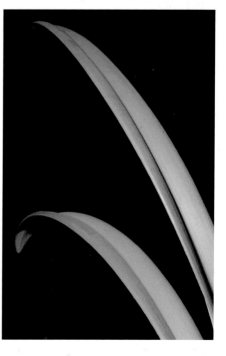

Anthurium

Anthurium is also known as "flamingo flower" or "painter's palette" because of its shape. These handsome tropical plants are approximately 6" (15cm) long and 3" (7.6cm) wide with a long, protruding appendage called a spadix. Colors range from bright red to maroon, pink and cream. They flower from spring to late summer.

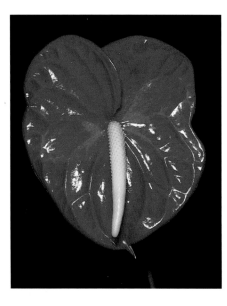

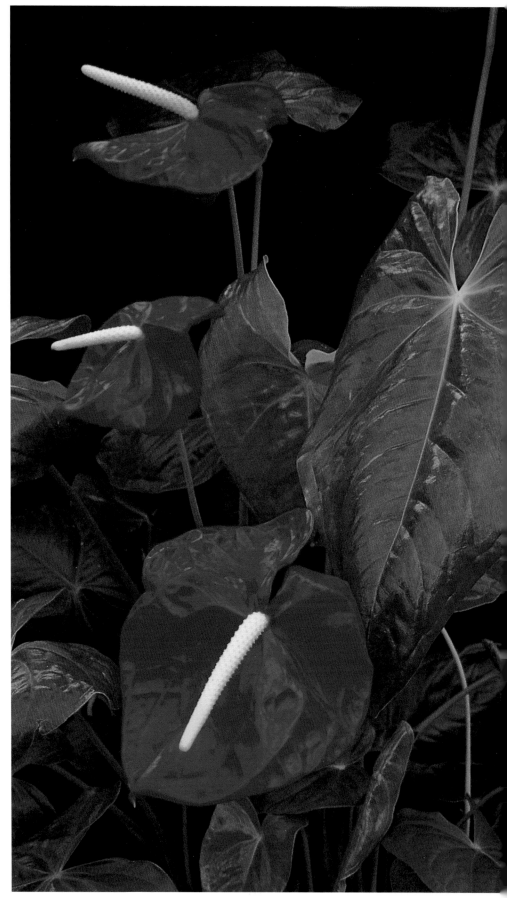

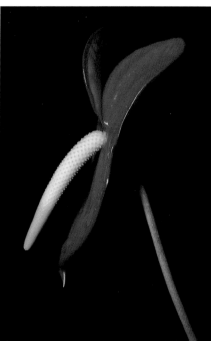

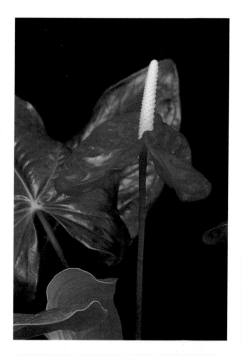

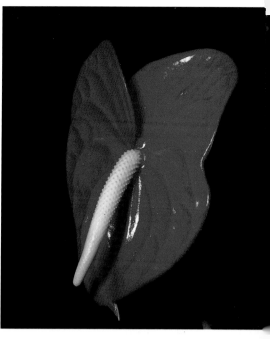

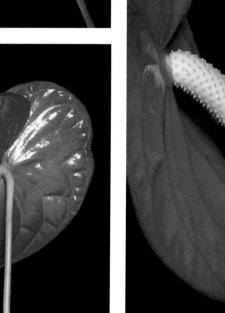

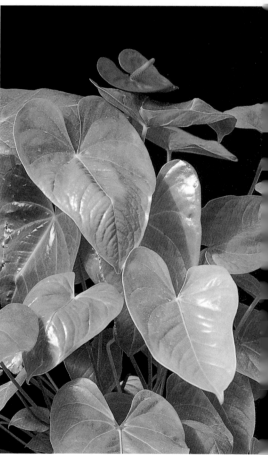

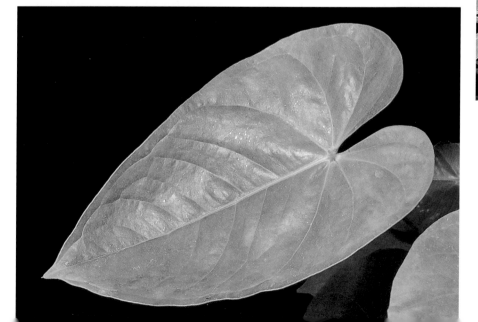

Aster

Resembling the chrysanthemum in many ways, the aster blooms in midsummer to early fall. The flowers, 1½" (3.8cm) to 2½" (6.3cm) in diameter, can grow 3' (0.9m) to 4' (1.2m) high and come in various colors, including mauve, light blue, lavender, magenta, pink, red, purple, yellow and white.

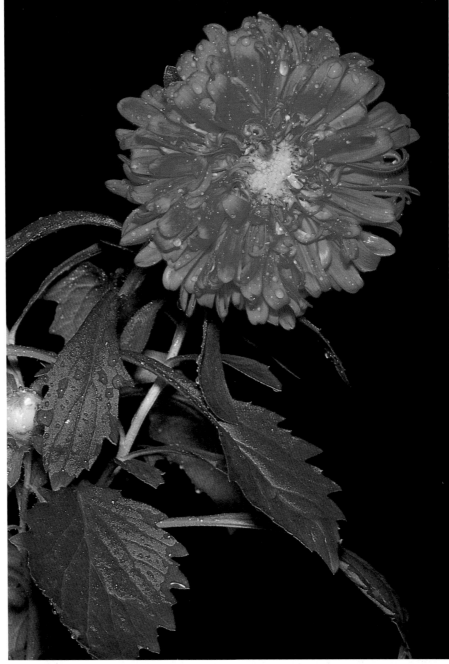

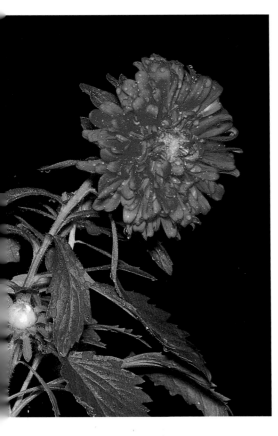

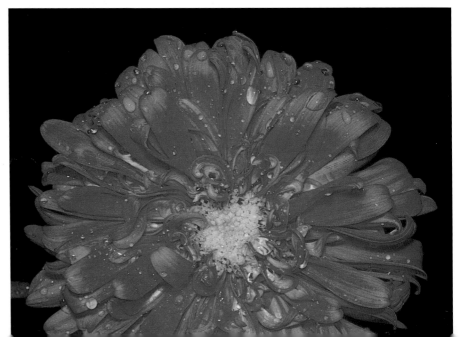

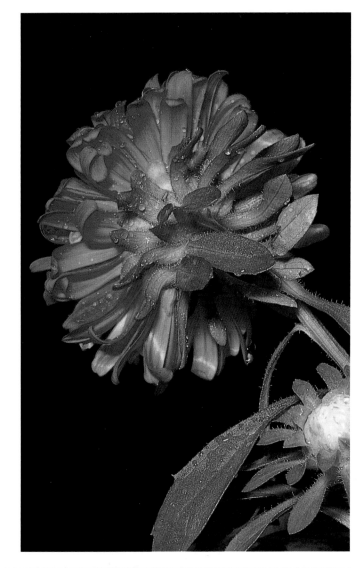

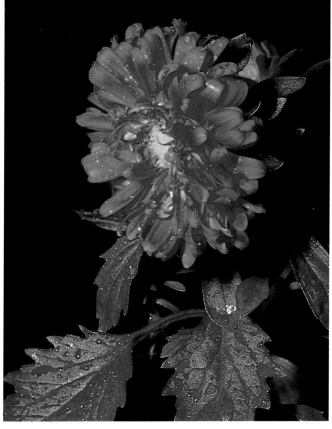

Aster

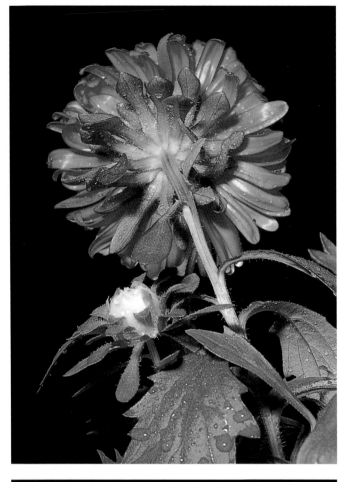

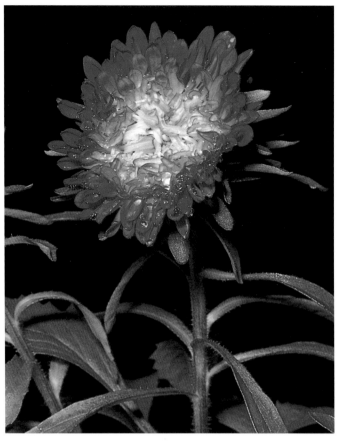

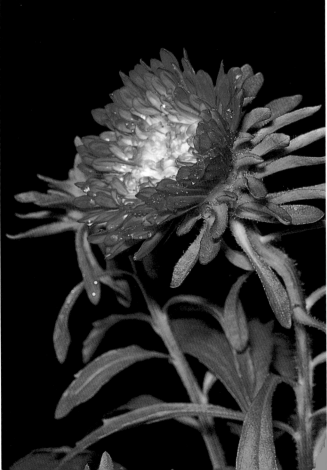

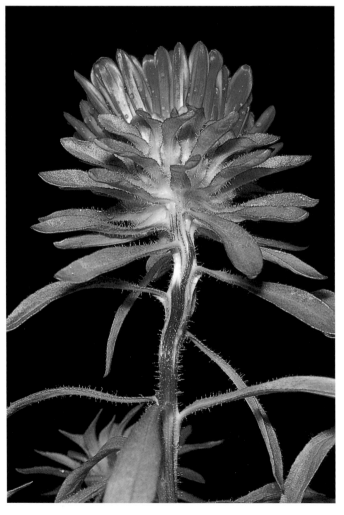

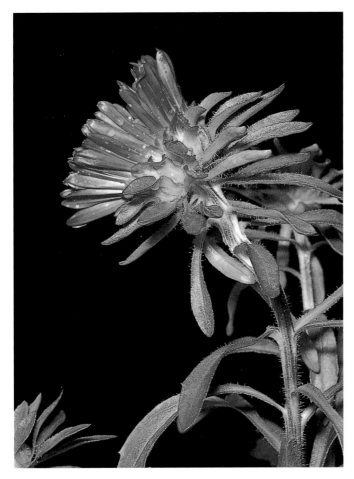
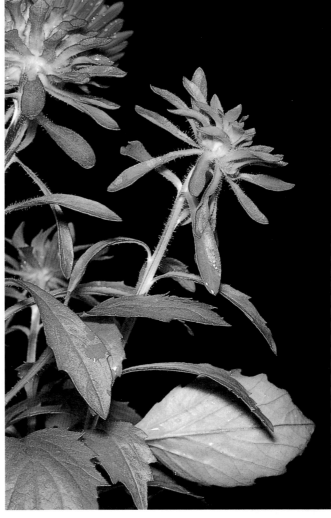
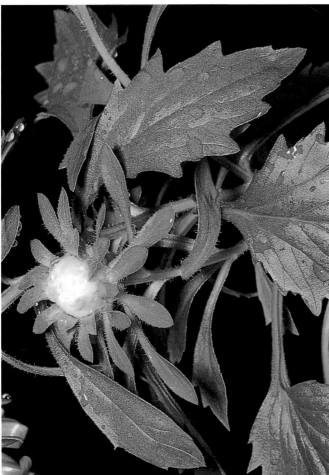
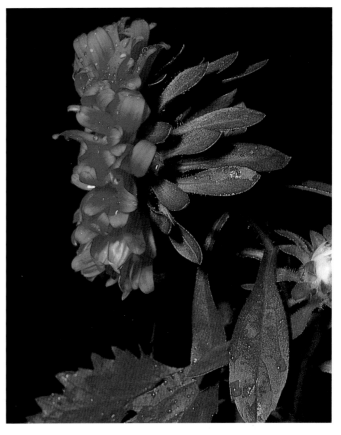

Azalea

The azalea, a spring to summer flower that grows in bunches, is actually part of the group of flowers called rhododendrons. The color range is extremely large, including white, pink, salmon, crimson, magenta, lavender, orange, yellow and variegated versions of white and crimson.

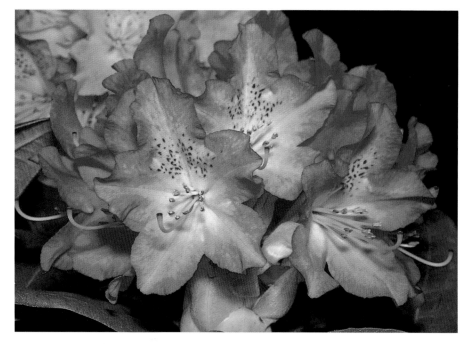

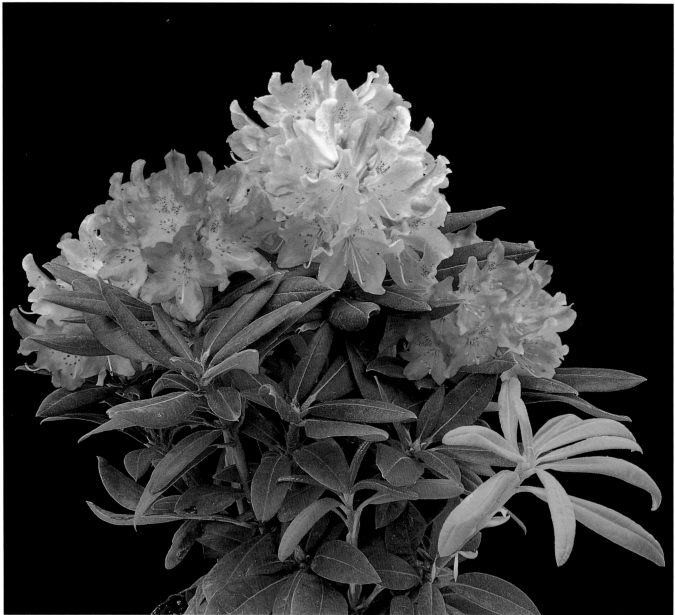

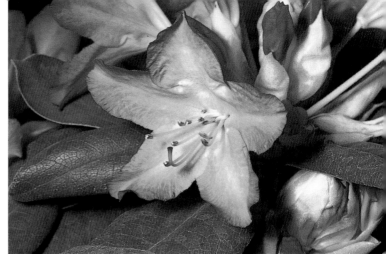

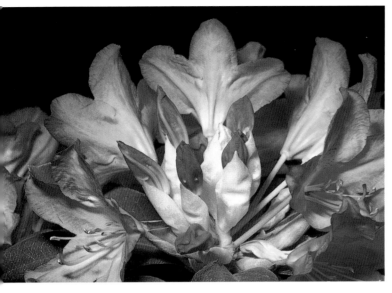

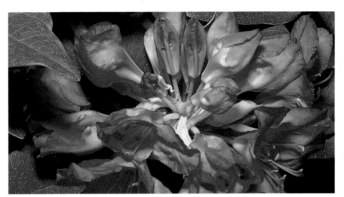

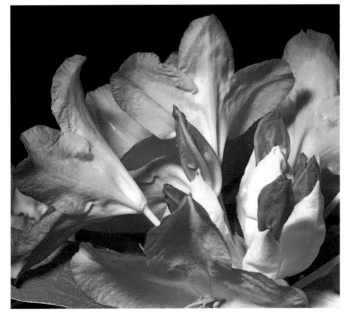

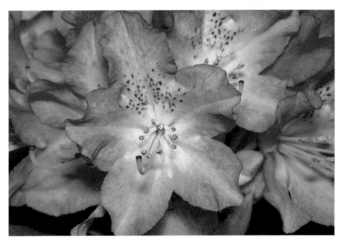

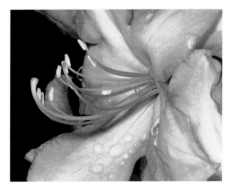

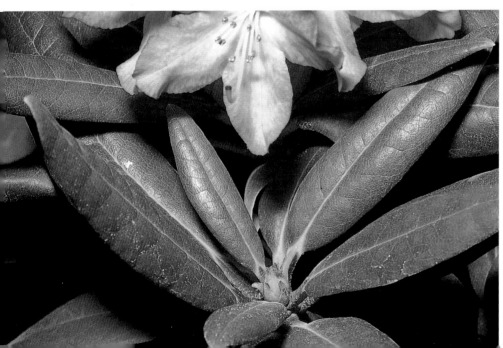

Begonia

The tuberous varieties shown here grow in clumps and are found in a wide range of colors, including orange, yellow, white, pink, red and crimson. The petals are frequently edged in other shades and are sometimes frilly or serrated.

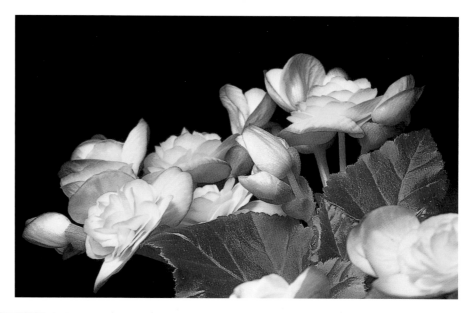

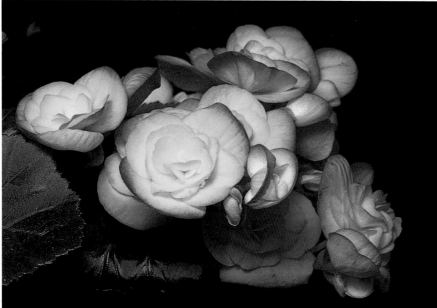

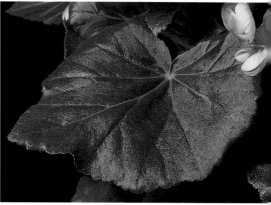

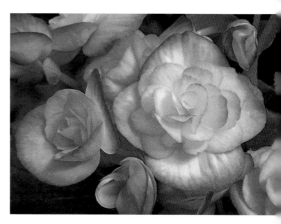

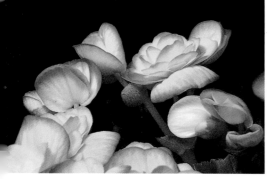

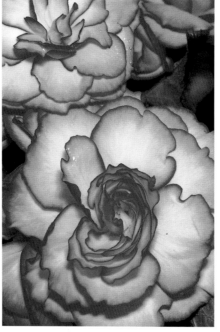

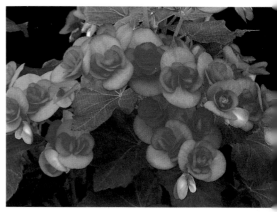

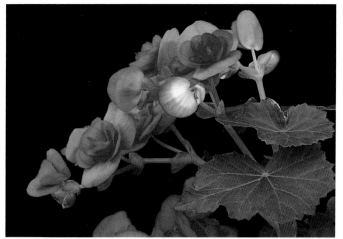

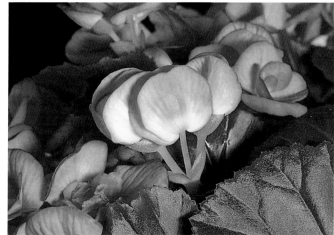

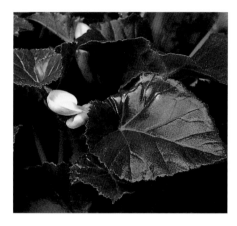

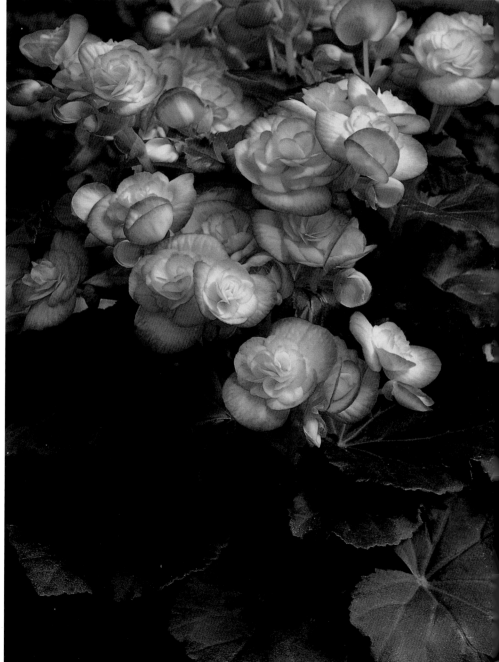

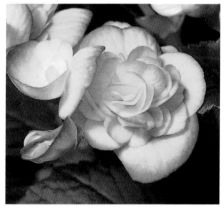

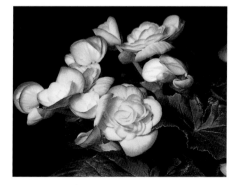

Bird of Paradise

This exotic flower resembles the plumed head of a tropical bird.

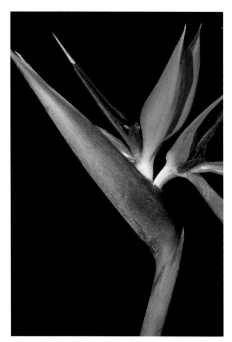

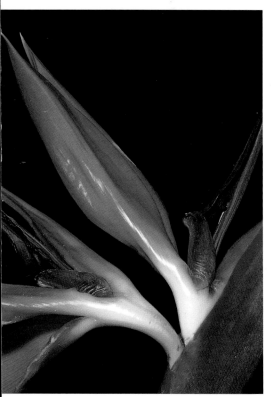

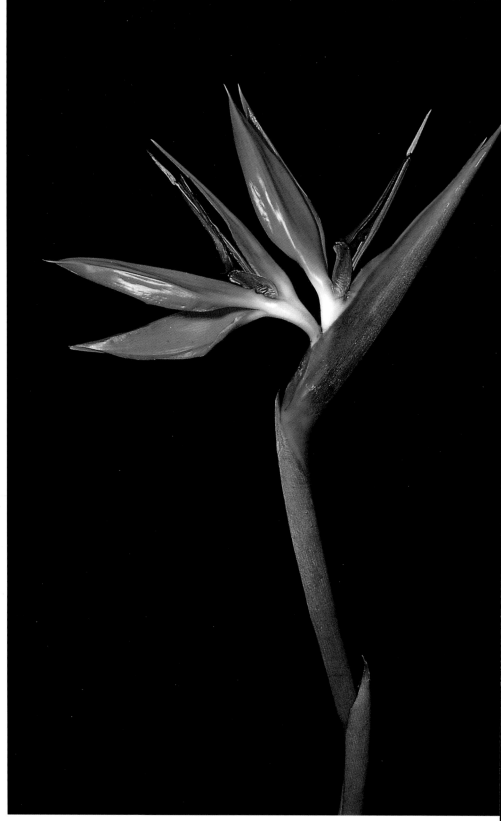

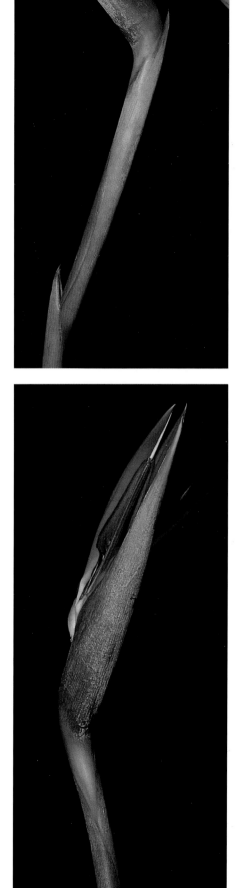

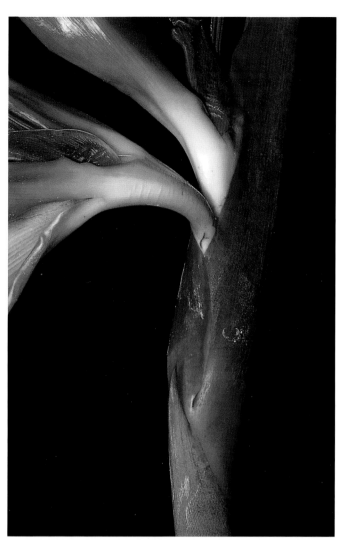

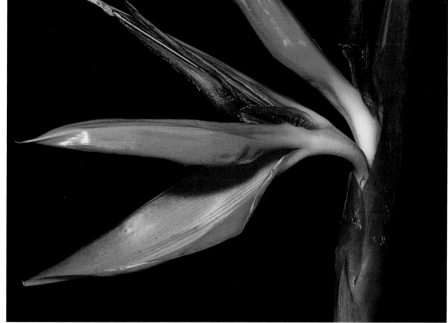

Calla Lily

This graceful summer flower is usually white with a yellow stigma and grows on stalks 2' (0.6m) to 2½' (0.8m) high.

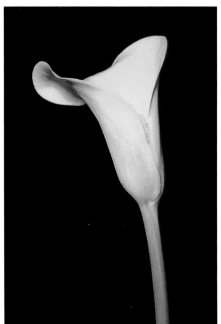

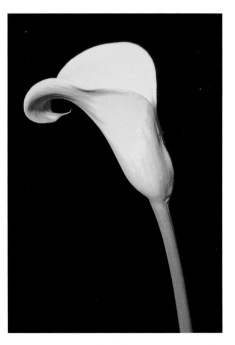

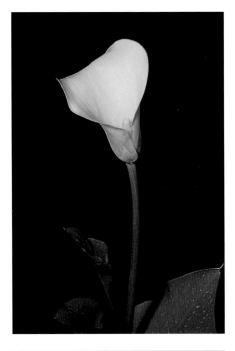

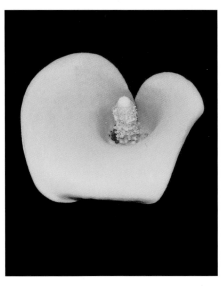

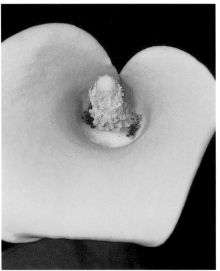

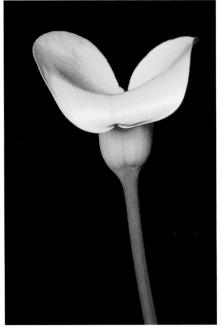

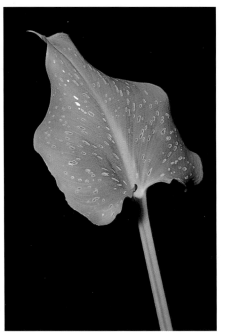

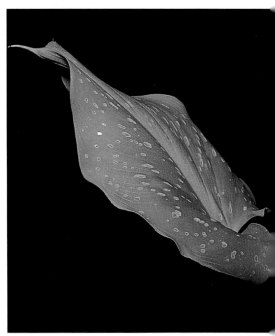

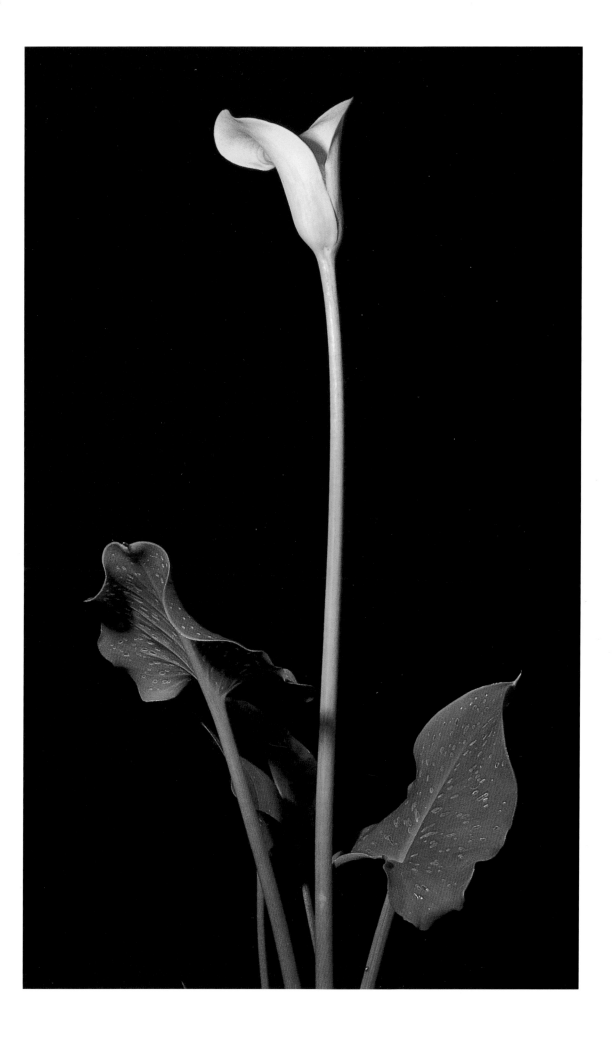

Camellia

These evergreen flowering trees yield blossoms in white, pink, red and hybrid combinations thereof in late winter and early spring.

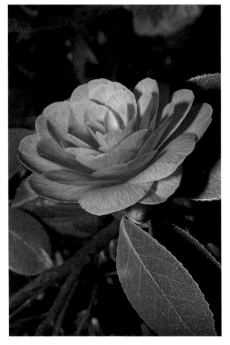

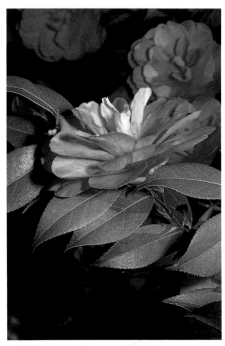

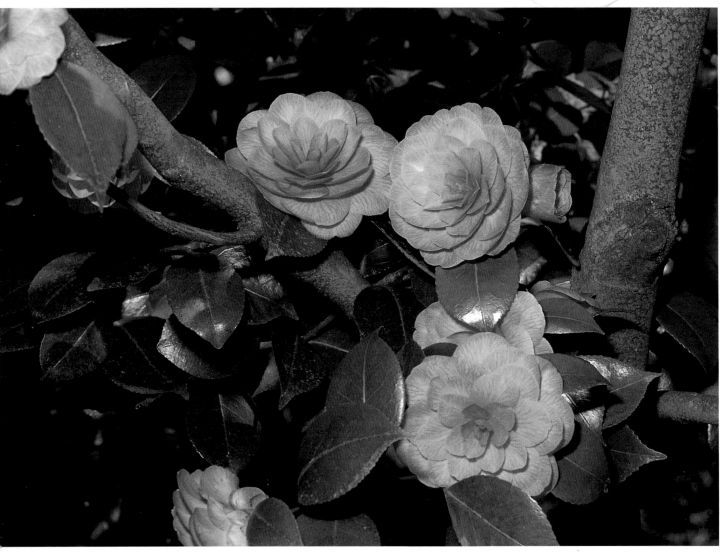

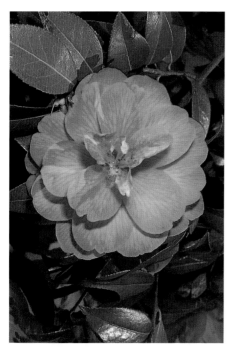

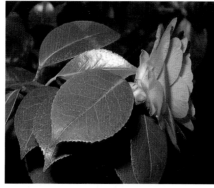

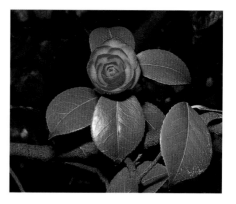

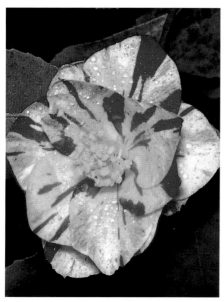

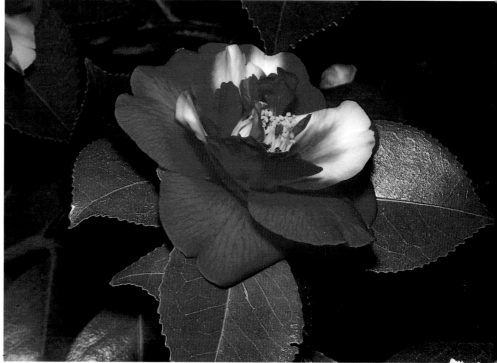

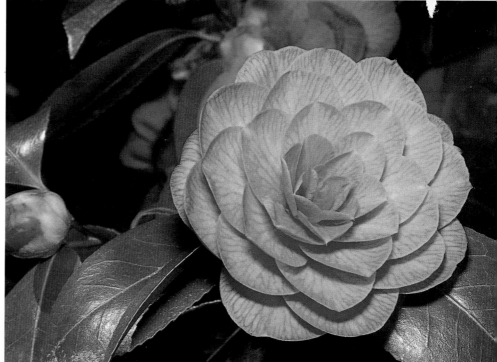

Carnation

A favorite with artists, carnations vary greatly in color: white, yellow, pink, red, orange and various species with striped or speckled variations. These summer-blooming flowers range from ½" (1.2cm) to 1½" (3.8cm) across.

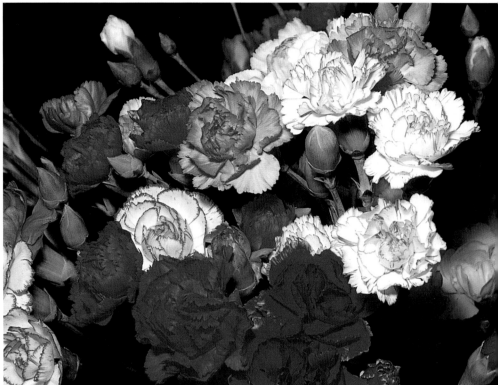

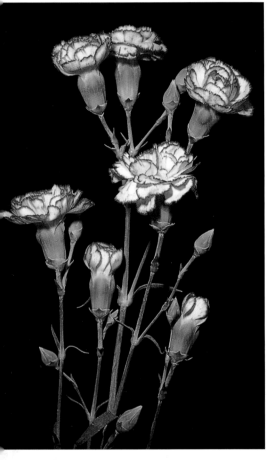

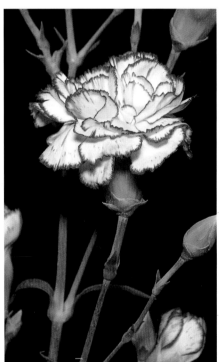

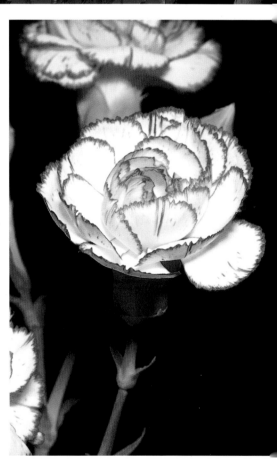

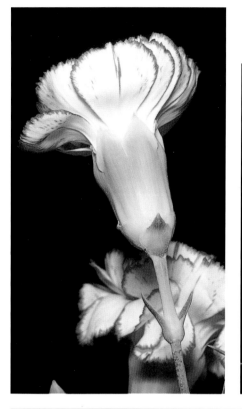

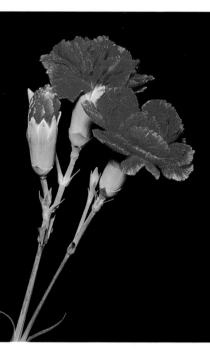

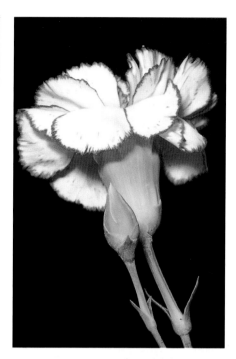

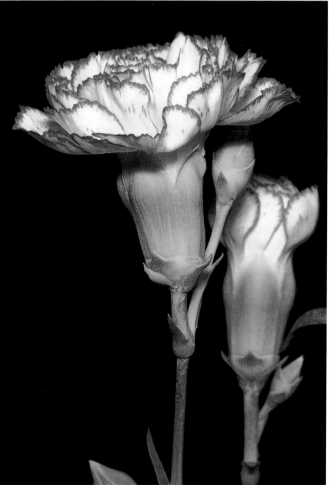

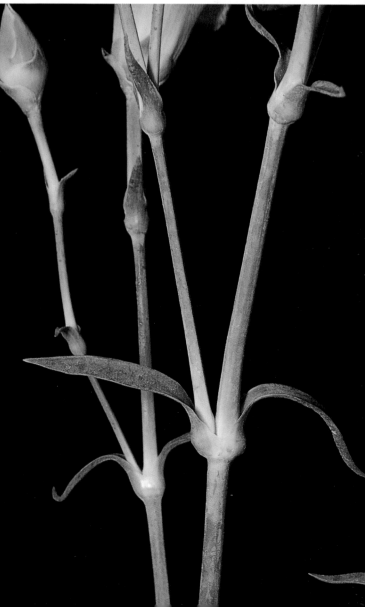

Chrysanthemum

Chrysanthemums come in a number of shapes: large pompons with petals that curve inward; small, globular pompons; radiant flowers with daisy-like petals; and flowers with spoon-shaped petals. Colors vary greatly, including yellow, white, pink, purple, red, crimson, lavender, bronze and combinations of these. Sizes range from 1" (2.5cm) to 4" (10.1cm) across.

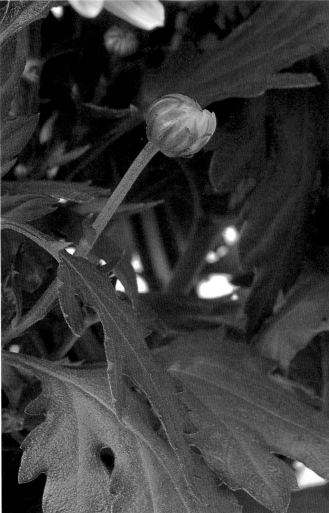

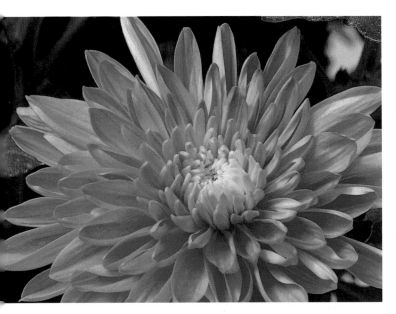

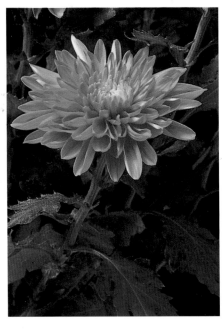

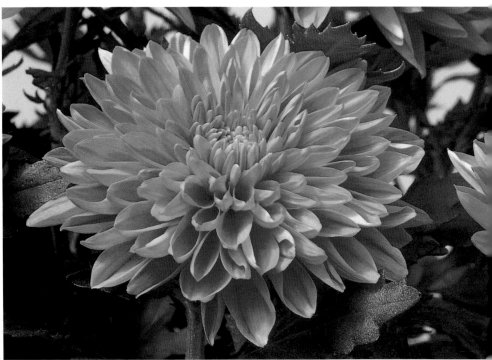

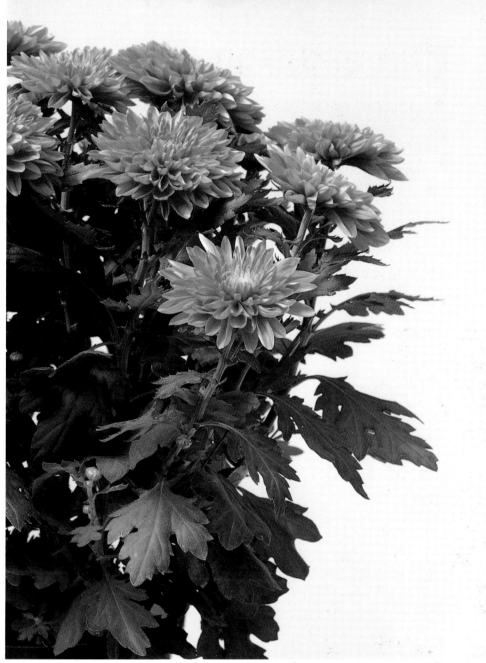

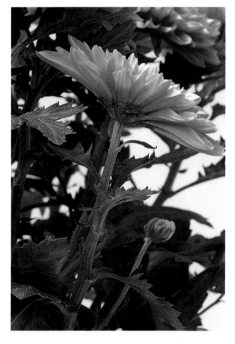

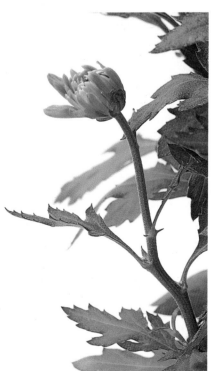

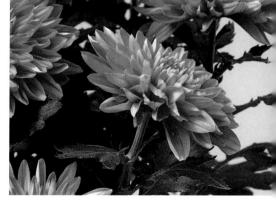

Chrysanthemum

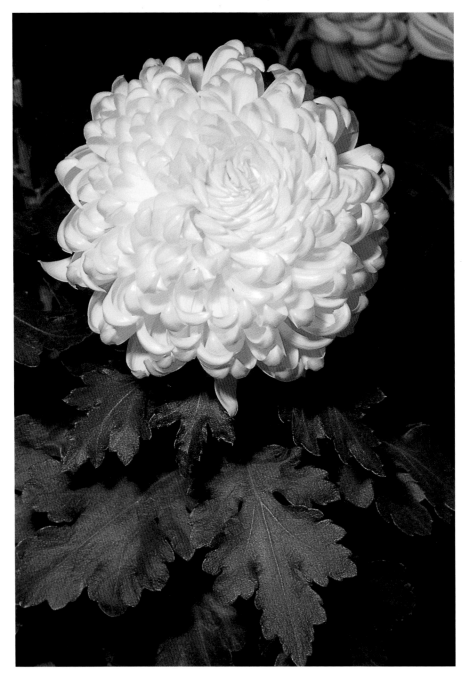

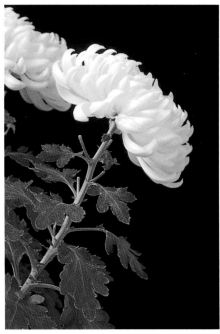

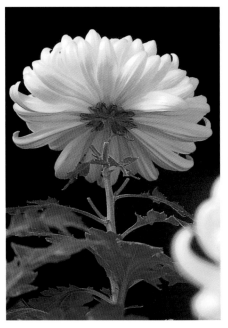

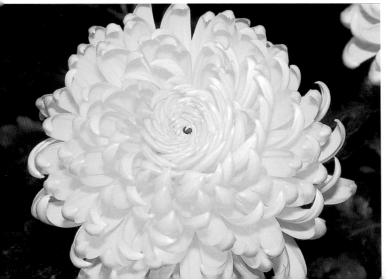

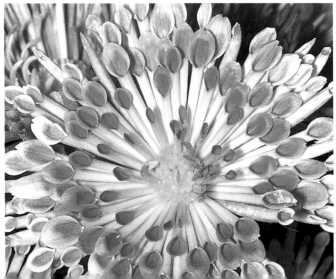

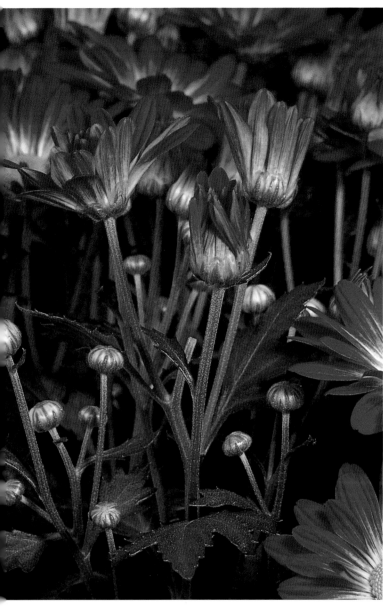

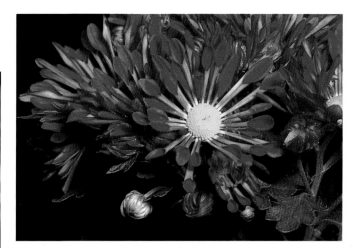

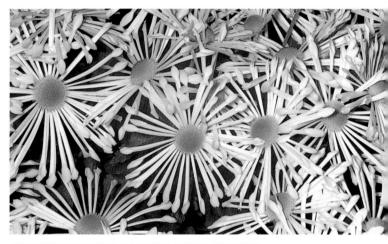

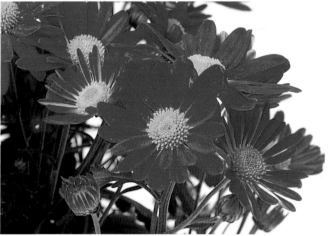

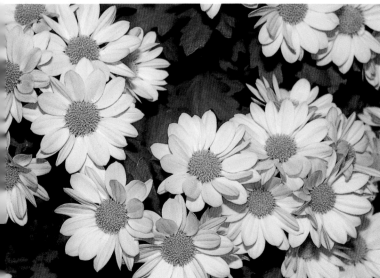

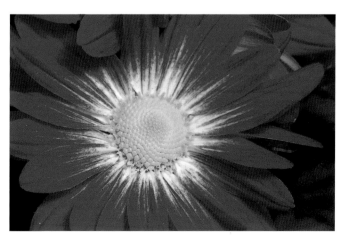

by Norma Auer Adams

Chrysanthemums in Acrylic

Supplies

- Acrylic gloss medium thinned with equal parts water
- Liquid acrylic paint in spectrum colors for mixing
- Iwata HP-C double-action airbrush(es)
- Airbrush solvent to clean airbrush(es)
- Arches 140 lb. cold-press watercolor paper stretched as for watercolor painting
- Black thread
- Compressor for airbrush(es)
- 2B drawing pencils
- Face mask to prevent spray inhalation
- Frisket film
- White acrylic gesso for priming watercolor paper
- Gesso brush for priming watercolor paper
- Pint-size glass jars with lids
- Masking tape
- #1 sable paintbrush
- #8 white nylon sable paintbrush
- Toothbrush
- Tracing paper
- X-Acto knife with #11 blades

Ever since she was young, Norma Auer Adams has been drawn to the land and nature with a deep passion. Her greatest satisfaction comes when she's surrounded by them. When Norma paints, she immerses herself in images from nature and tries to create works radiant with the peace, stillness and sense of awe she finds in the natural world. Originally an abstract artist, now a realist, Norma works with airbrush and acrylic paint on paper and canvas.

With airbrush painting, the softness of the sprayed application contrasts with the clear, crisp edges of the masking process. While neither of these qualities is unique to airbrush work, the ease with which airbrushing can accomplish them makes the airbrush a valuable tool.

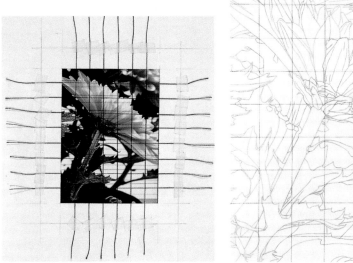

1. Lay Out the Composition

The reference photograph is cropped to create a strong, engaging design. Then the cropped photograph is divided into blocks in the same number and proportions as the gessoed painting surface will be. Grid lines are made of black thread, stretched and taped lengthwise and crosswise over both photo and painting surface (see above right and step 2 instructions). The lines can later be removed without leaving a mark.

2. Make the Drawing

A full-size piece of tracing paper is placed over the gesso-primed painting surface before grid lines are taped in place as shown above. The drawing is then made, using the photo as a guide, so corrections and changes can be completed on the tracing paper before the drawing is transferred. When the drawing on the tracing paper is complete, the grid lines are removed and the pencil lines are redrawn on the back of the tracing paper, and then transferred to the gessoed surface by rubbing.

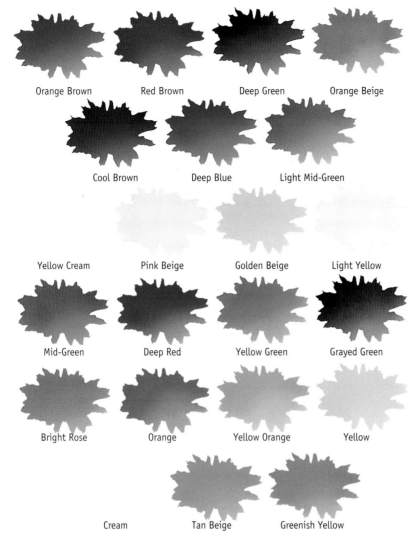

Orange Brown

Red Brown

Deep Green

Orange Beige

Cool Brown

Deep Blue

Light Mid-Green

Yellow Cream

Pink Beige

Golden Beige

Light Yellow

Mid-Green

Deep Red

Yellow Green

Grayed Green

Bright Rose

Orange

Yellow Orange

Yellow

Cream

Tan Beige

Greenish Yellow

3. Mix Colors

Colors are based on the photo as well as personal memories. A quantity of each color is pre-mixed, using jar acrylics. They're thinned to the consistency of slightly thick milk with acrylic gloss medium and equal parts water, strained and poured into pint-size glass jars, ready for use.

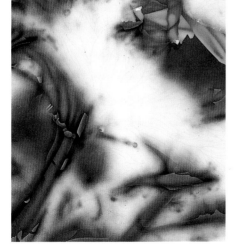

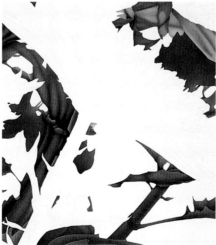

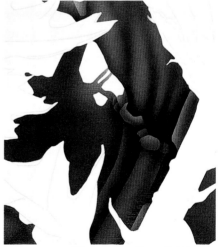

4. Mask With Frisket Film and Begin Painting

Frisket film is a low-tack adhesive-backed transparent plastic film designed for airbrush work. A frisket film mask is used to cover some areas before painting is begun. Cut the frisket film around the shapes to be painted with an X-Acto knife. Remove each section as the painting around it is complet-

ed, beginning with the background. Paint the darkest areas first, working from dark to light, establishing the relationship between values in each area. After the initial frisket film mask, alternate freehand airbrushing with film masking, increasing the amount of freehand work as the painting progresses.

Spray the darkest areas of the partial flower with Orange Brown, followed by a

lighter spray of Red Brown. Spray lightly with Deep Green in the shadowed area, and then lightly with Orange Beige over areas in sunlight.

For the background foliage, spray a medium-dense layer of Deep Green. Follow with a lighter layer of Cool Brown, and then a light layer of Deep Blue. Spray with Light Mid-Green to intensify and unify color.

Alternate Masking and Freehand
After the initial frisket film mask, alternate freehand airbrushing with film masking, increasing the amount of freehand work as the painting progresses.

6. Underpaint the Central Flower

Underpaint the central flower with Grayed Green, Bright Rose, Orange and Yellow Orange. Protect areas from overspray with frisket film and pieces of tracing paper.

5. Soften Edges

Soften edges to create a more realistic effect by re-spraying the painted areas. Lightly blend the partial flower with sprays of thinned white gesso, Yellow Cream and Pink Beige to unify. Repaint using the same color palette as in step 4 (Orange Brown, Red Brown and Orange Beige), spraying lightly. Spray mid-tones with Golden Beige. Spray lights and highlights with Yellow Cream, Pink Beige and Light Yellow.

Spray light areas of the background foliage with Yellow Cream and thinned white gesso to bring up highlights. Deepen and define dark areas with Mid-Green. Follow with lightly sprayed layers of Deep Red and Deep Blue. Spray Yellow Green over areas highlighted by Yellow Cream and thinned white gesso.

Mix Colors With Layers

Paint is thinly applied with each layer of spray, making it easy to mix colors on the painting surface itself. This layered paint application creates color that is luminous and vibrant.

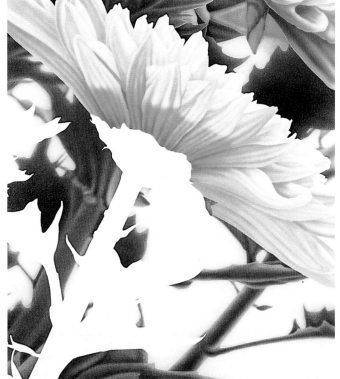

7. Unify Underpainting and Develop Highlights

Unify the underpainting by spraying with Light Yellow, Yellow Cream and thinned white gesso; details of the underpainting should be visible through this layer. Dust with a light spray of Yellow and Cream, especially at the tops of the petals. Develop highlights and color by spraying with Tan Beige, Light Yellow, Golden Beige and Light Rose. Compare step 6 with step 7. Step 7 shows the petals at the underpainting stage, covered with light-colored overspray and ready for repainting.

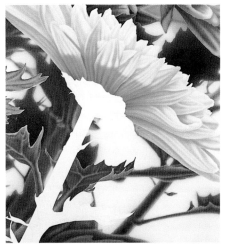

8. Paint Foreground Foliage, Stem and Partial Flower

Mask calyx and stem with frisket film, and then underpaint the leaves in. Underpaint the leaves at the left center edge of the painting and the two leaves attached to the stem by putting frisket film over the already-painted leaves and using the same colors as in step 4 background foliage: Deep Green, Cool Brown, Deep Blue and Light Mid-Green.

For the leaves at the left center edge of the painting, spray with Yellow Cream overall to blend and lift the value of leaves to a lighter tone. Spatter with Deep Green, Deep Blue, Orange Beige and Yellow Cream to create texture. Airbrush freehand with Mid-Green, Cool Brown and Deep Blue to put in veins, etc. Paint linear details and highlights with Yellow Cream and Light Yellow using a #1 paintbrush. Soften the edges of the lines with a slightly wet #8 paintbrush.

Complete the leaves attached to the stem by unifying their tone with an overall spray of Mid-Green. Airbrush light veins freehand with Light Yellow and Yellow Cream. Airbrush dark areas using Cool Brown, Red Brown and Mid-Green. Dust highlights and edges of leaves with Greenish Yellow. With #1 and #8 paintbrushes, paint light accents on tips of the leaves with Yellow Cream, Greenish Yellow and Orange Beige.

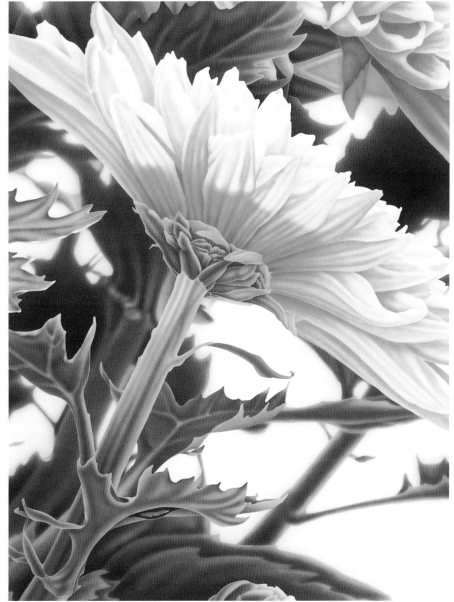

9. Paint Stem, Remaining Leaves and Finishing Touches

Remove the frisket film applied in step 8, and then airbrush the stem using the same colors for underpainting as in step 8, leaving the upper left part of the stem light in tone. Spray the stem lightly with Yellow Cream, and then spatter with Cool Brown, Grayed Green, Orange Beige and Yellow Cream. Airbrush darker lines freehand, then highlight the edges of the stem near the top with a #1 paintbrush. Hand paint light accents of Yellow Green and paint the remaining leaves.

Keep the sepals (nearest base of flower petals) light. Cover underpainting on calyx with a coat of Golden Beige and a dusting of Grayed Green. Repaint the dark areas of the calyx with the same colors used in underpainting. Sharpen details with a #1 brush using Golden Beige, Yellow Cream and Greenish Yellow, keeping the feeling of shade on the calyx.

To match the color intensity of the central flower, lightly spray the partial flower at upper right with Yellow Cream and Pink Beige. Spray dark areas with Bright Rose, Orange Beige and Red Brown again. Use Grayed Green on lowest leaves for shade.

Chrysanthemum Profile, © NORMA AUER ADAMS

Cineraria

This flower's textured leaves are almost as interesting as the flower itself. The flowers are ½" (1.2cm) to 1" (2.5cm) in diameter. They are solid pink, magenta and violet in color, or have white inner rings of varying depth.

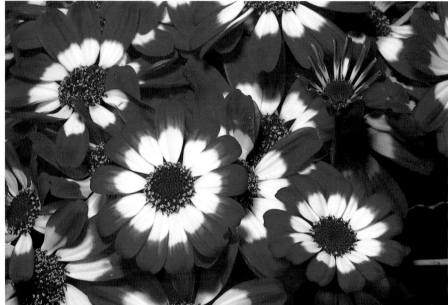

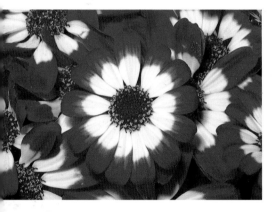

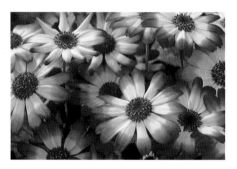

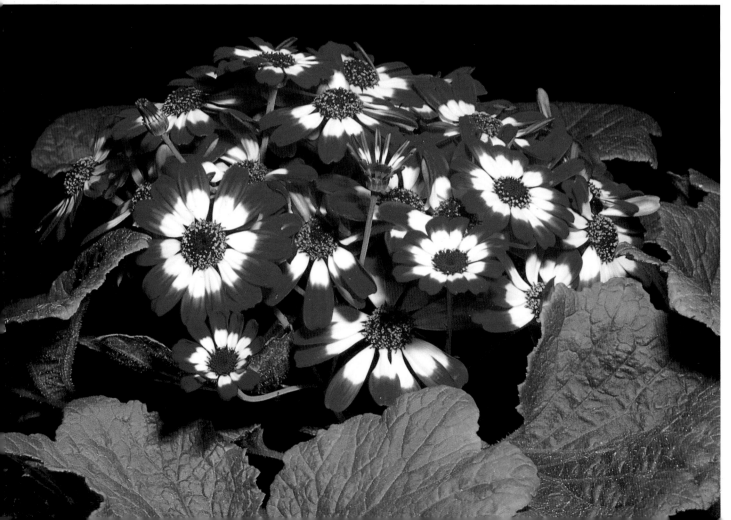

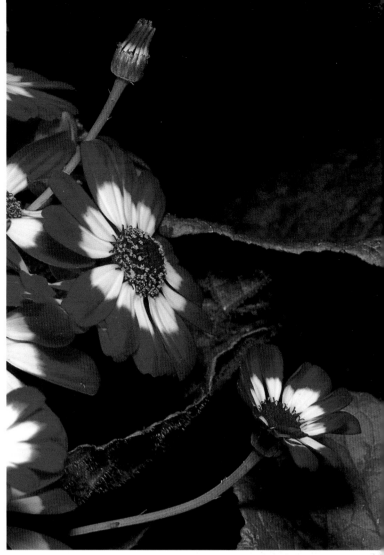

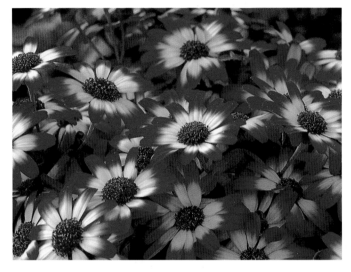

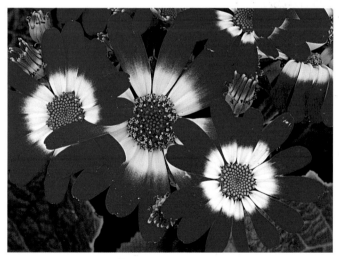

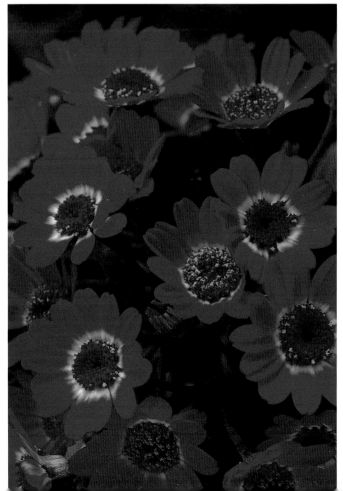

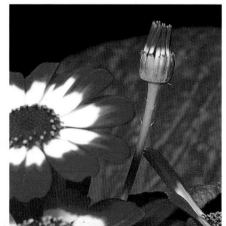

Columbine

Columbine is a small, delicate summer flower that grows on stalks 1½' (0.5m) to 2' (0.6m). Colors range from shades of crimson to pink, lavender, blue, yellow and white, and many are bicolored.

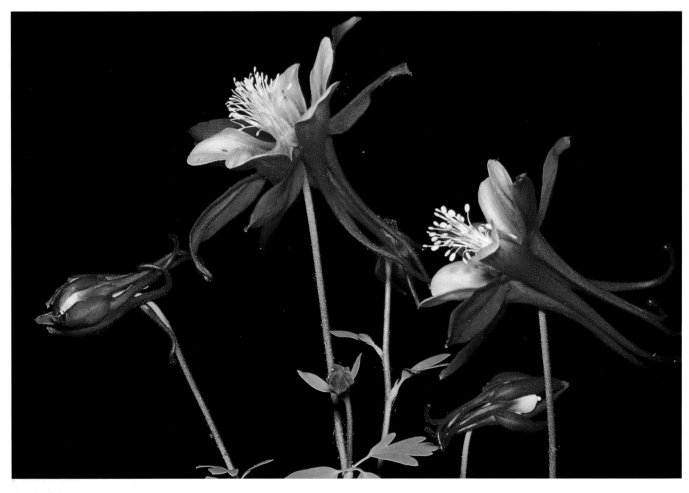

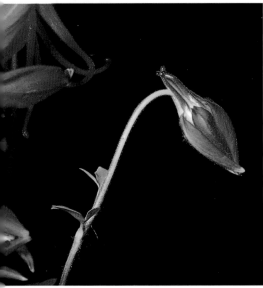

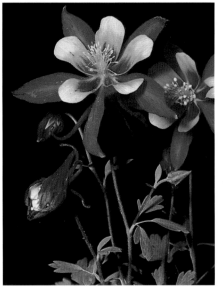

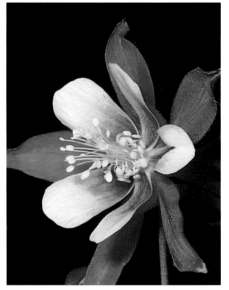

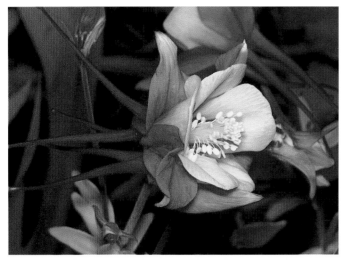

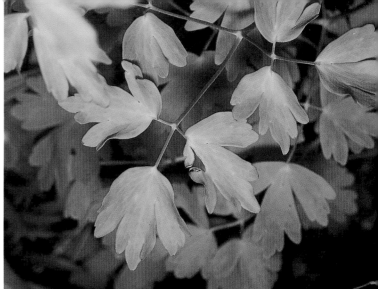

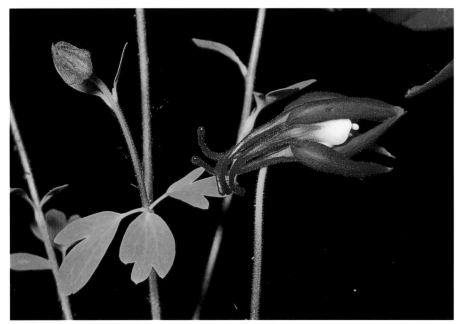

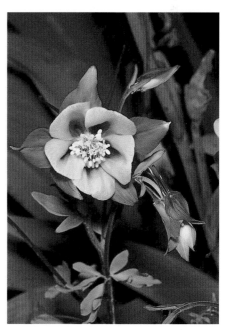

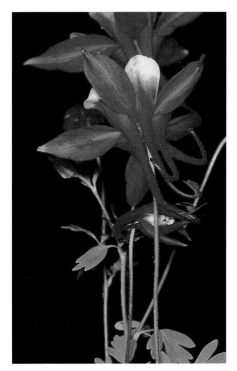

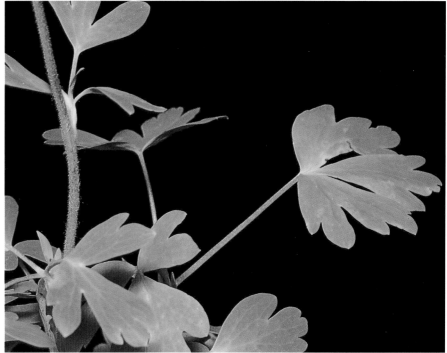

Daffodil

A sure sign of spring, daffodils come in various sizes and colors, including yellow, white, red and orange. Smaller versions are known as jonquils.

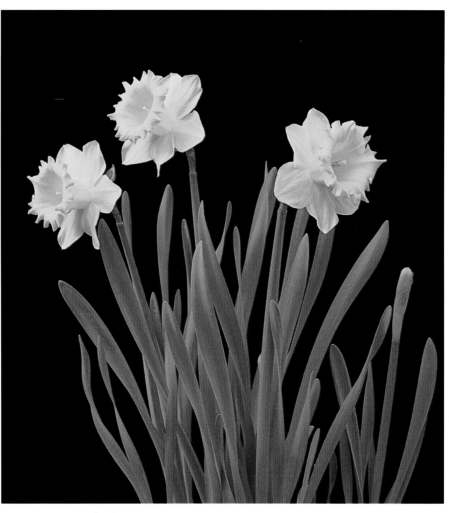

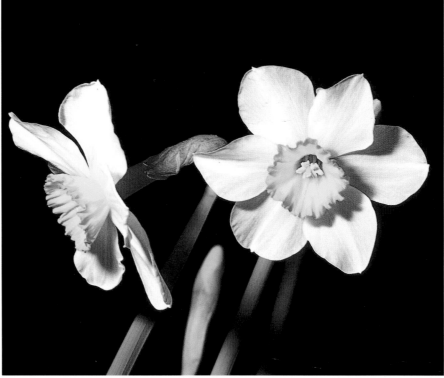

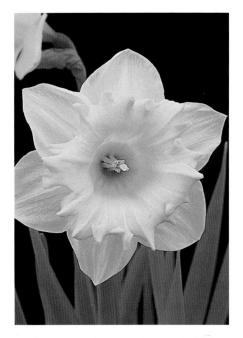

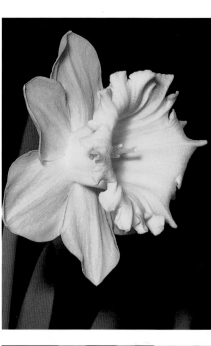

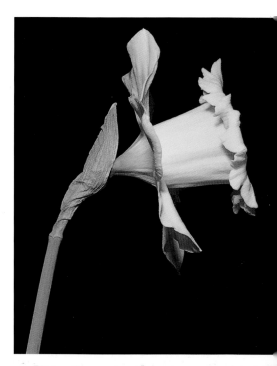

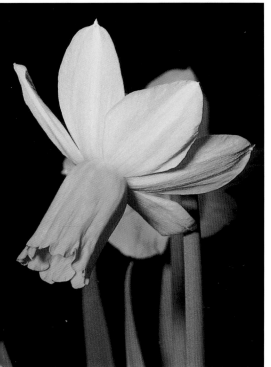

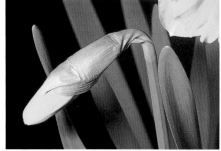

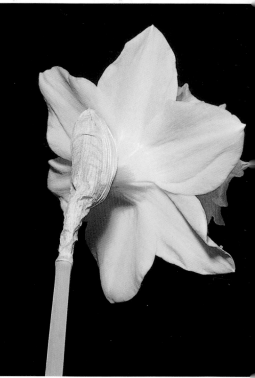

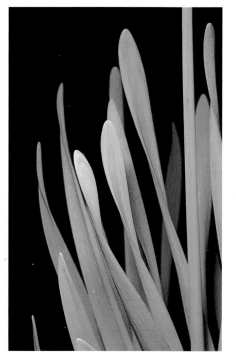

Dahlia

Appearing in late summer through early fall, dahlias have been hybridized into a vast variety of shapes, colors and sizes. They include flowers with broad, daisy-like petals; globular types with tube-shaped petals; and pompon-shaped flowers with tightly or loosely configured petals. Red, yellow, pink, orange and purple flowers in various bicolored combinations are basic to this fascinating bloom.

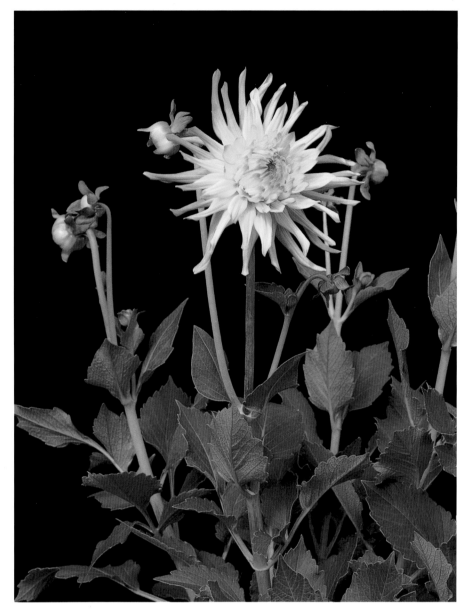

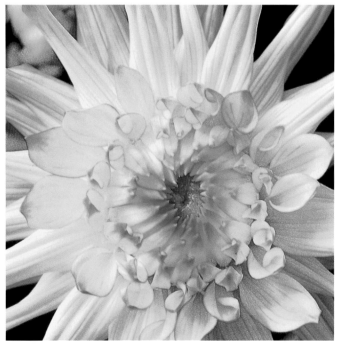

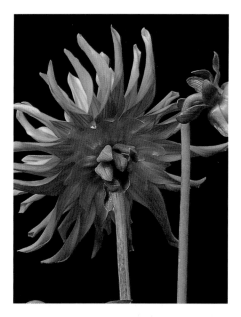
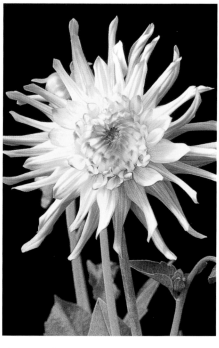
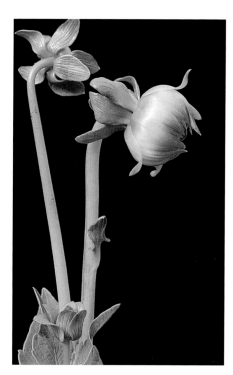
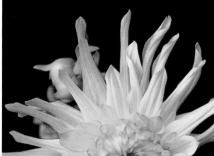
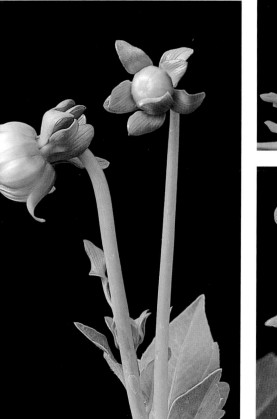
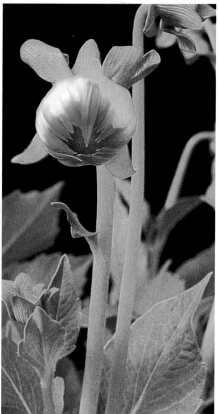

Dahlia

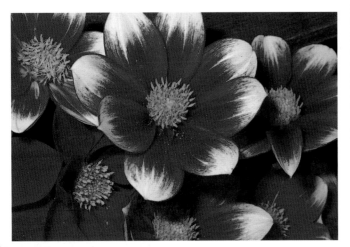

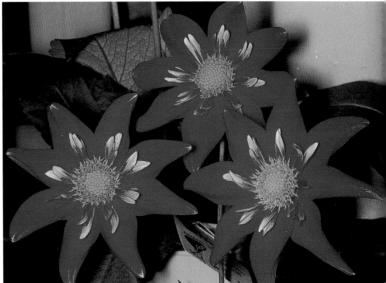

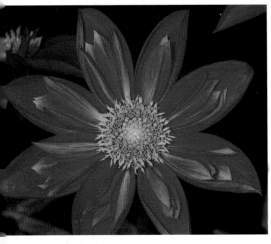

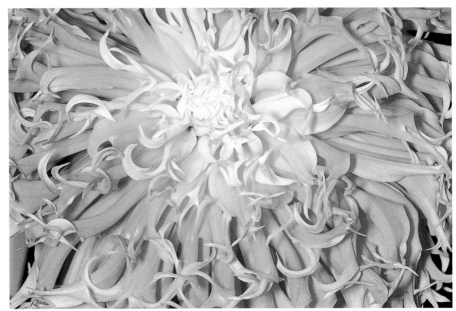

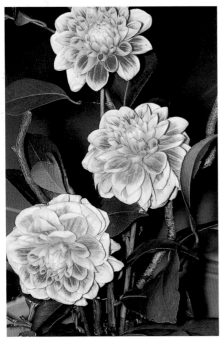

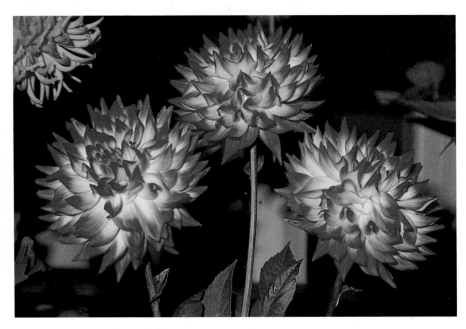

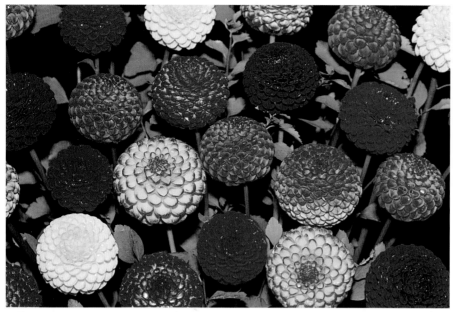

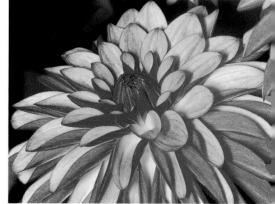

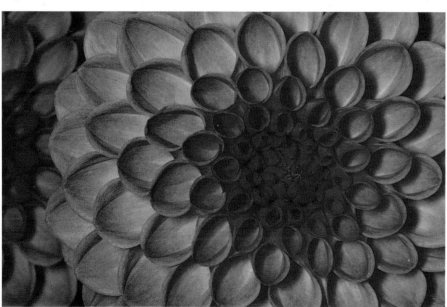

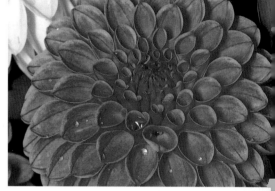

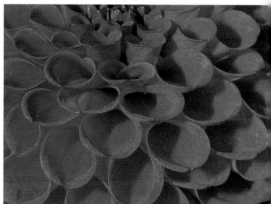

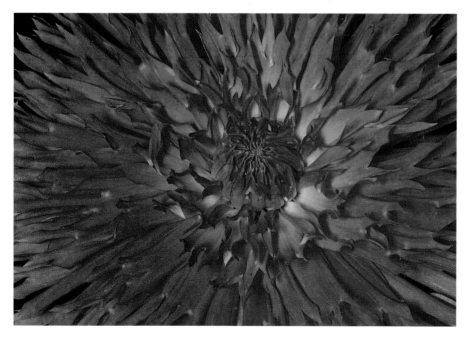

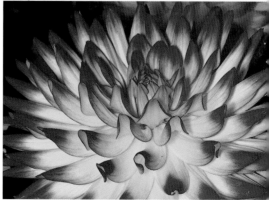

Dahlias in Pastel

Materials

- 8½" x 11" (22cm x 28cm) layout or sketch paper
- 2B drawing pencil
- Colored pencils
- 19" x 25" (48cm x 64cm) light blue Sennelier La Carte pastel card
- Piece of foamboard larger than 19" x 25" (48cm x 64cm) to clip pastel paper to
- Vine charcoal
- Krylon workable fixative
- Krylon Crystal Clear spray protective coating
- Cloths and paper tissues for blending

Color Palette

Because most pastels are identified by numbers instead of color names, hues are accompanied by numbers except where the manufacturer has no hue name.

Nupastel hard pastels

227P Corn Yellow
228P Hooker's Green
244P Blue Violet
254P Hyacinth Violet
266P Pale Vermilion
277P Ivory
298P Bottle Green
304P Orchid
365P Ceylon Blue
376P Peach

Rembrandt medium soft pastel

331 Madder Lake Deep
640 Bluish Green

Unison soft pastels

Greens: 1, 4, 5, 9, 13, 14
Red: 18
Light Neutrals: 25, 29
Dark Neutrals: 37, 39
Blue Green: 6
Gold: 13

Sennelier soft pastels

Yellows: 66, 346, 602
Pinks: 273, 278, 384, 407, 440, 485
Violets: 281, 310
White: 525

God creates the flower; the photographer produces beautiful images with the camera; and the artist creates a painterly work which evokes a personal style and feelings about the subject. Creating a floral work in pastel offers a sensual quality of soft petals and leaves. Working directly with pigment from hand to paper allows the feeling or essence of the flower to come through. Although the resource material is photographic, the flower seems to come alive.

Sandy's work is accomplished at an easel, mostly while standing. This allows for movement back and forth to see the whole image and how it is developing. Work should be straight, not slanted on the easel so that pastel particles can fall on the easel support or onto the floor (protected by papers or cloth).

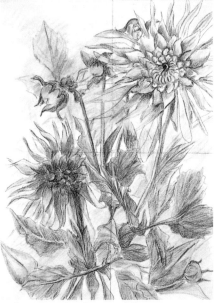

1. Lay Out the Composition

Sandy finds a pleasing composition by first laying out a preliminary sketch. Using reference photographs, sketch leaves, buds and flowers on 8½" x 11" (22cm x 28cm) layout paper with a 2B drawing pencil, followed by colored pencils to block in hints of desired color. Divide page into quarters.

Safety Notes

- Using fingers to blend pastels can be toxic, so be sure to wash your hands frequently.
- Do not have food or beverages in your work area.
- Use sprays in a well-ventilated area.

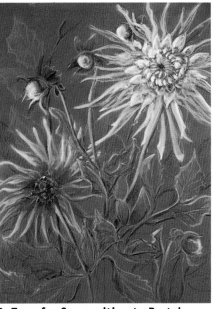

2. Transfer Composition to Pastel Paper

Lightly mark pastel paper in four parts, as in step 1. Sketch the composition, increasing its size corresponding to the four areas in step 1. Block in middle values for buds, leaves and flowers with Nupastel 376P Peach, 304P Orchid, 254P Hyacinth Violet, 228P Hooker's Green, 298P Bottle Green, 365P Ceylon Blue, 227P Corn Yellow, 244P Blue Violet, 277P Ivory and 266P Pale Vermilion. Spray with Krylon workable fixative.

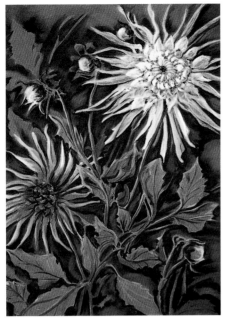

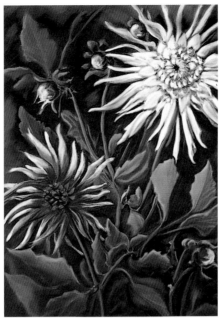

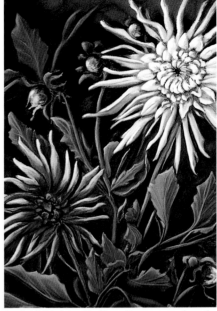

3. Add Darker Values

With softer pastels add darker background values to emphasize middle values in step 2. Use hints of dark, cool shades in the background with Unison pastels: Greens 9, 14, 1 and 13; Dark Neutrals 37 and 39; and Blue Green 6. Make small additions or composition changes as necessary by defining negative space with warmer Sennelier Violet 281 in the foreground.

4. Strengthen Middle Values

Enhance middle values and colors by using and blending varied shades of pastels for petals, buds and leaves: Rembrandt pastels 640 Bluish Green and 331 Madder Lake Deep; Sennelier Pink pastels 384, 407 and 440; Unison pastels Green 4, Red 18, Gold 13, Green 5, Light Neutral 25 and Light Neutral 29. Spray with Krylon workable fixative.

5. Add Lights, Define Foreground and Blend Background

Add light values to emphasize highlights with Sennelier soft pastels Yellow 66, Pink 485, Pink 278, Pink 273, Yellow 602, Violet 310, White 525 and Yellow 346. Using vine charcoal, define foreground shapes by sharpening darker areas around petals and leaves, and cleaning up smeared edges. Lightly fade background petals and leaves by blending edges into background colors. Spray with Krylon workable fixative.

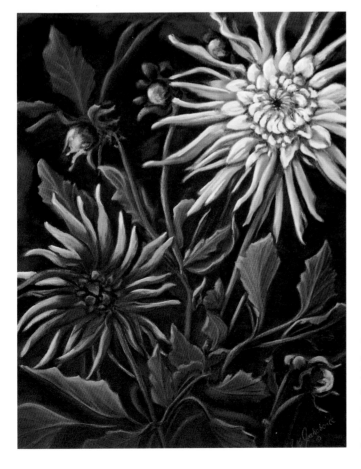

Tip

Loosen excess pastel dust, which can clog the tooth (texture) of the paper, by hitting the back of the paper a few times while tilting it slightly forward.

6. Make Final Adjustments

Make last-minute changes, if necessary, and then spray with Krylon Crystal Clear.

Dahlia © SANDRA K. JACKOBOICE

Daisy

A favorite subject with artists, this summer-blooming flower ranges from 1½' (0.5m) to 3' (0.9m) high. Flowers are 2½" (6.3cm) to 3¼" (8.2cm) across.

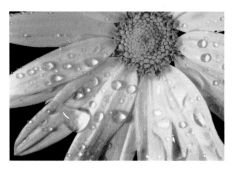

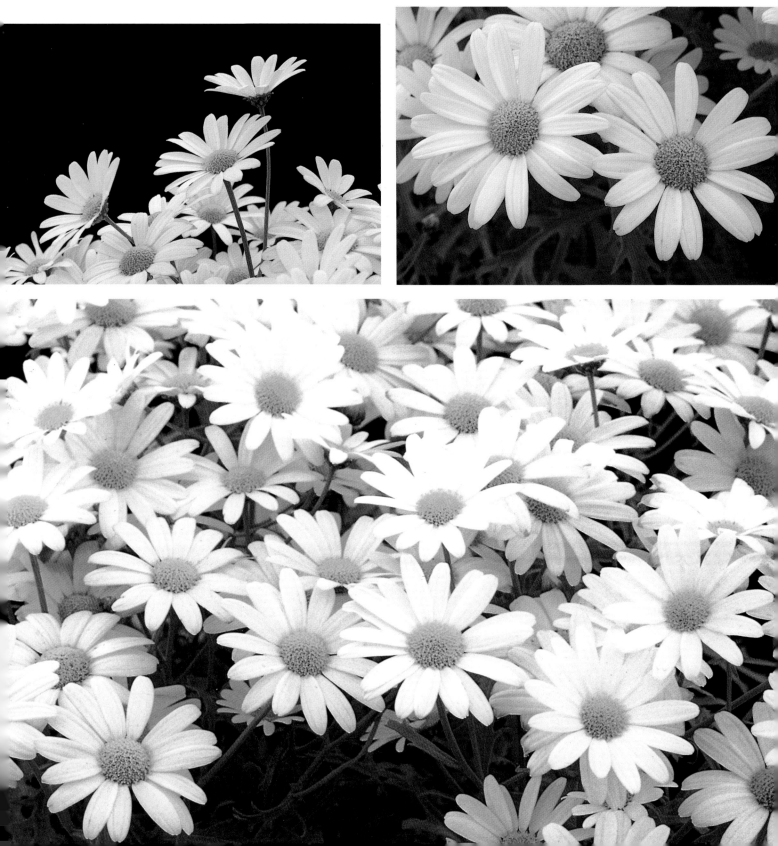

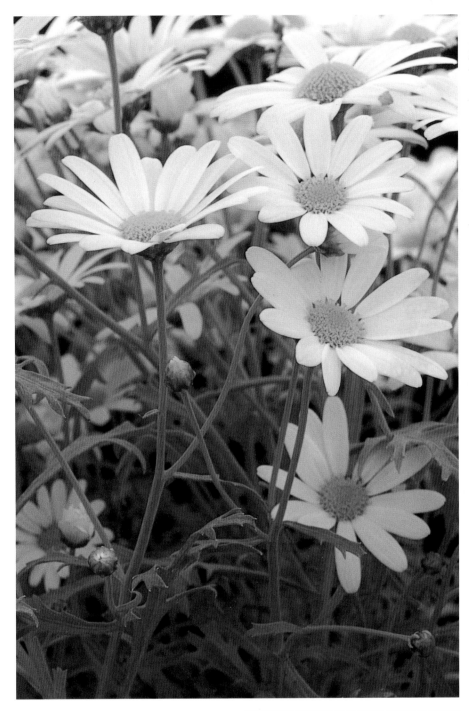

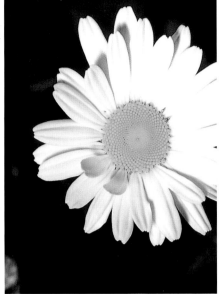

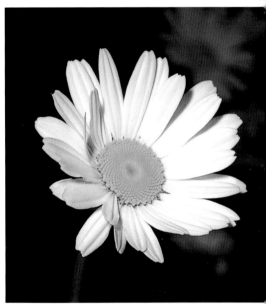

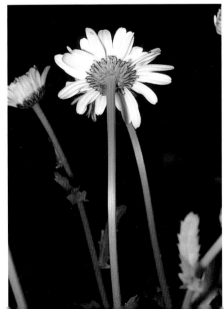

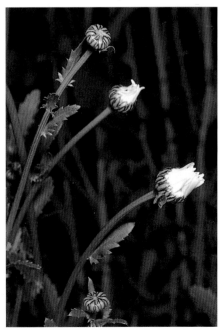

Foxglove

These 1" (2.5cm) tubular blooms grow on 2' (0.6m) to 6' (1.8m) stalks in late spring through midsummer. The flowers vary in color, including pink, primrose, carmine, cream and white, all with maroon spots.

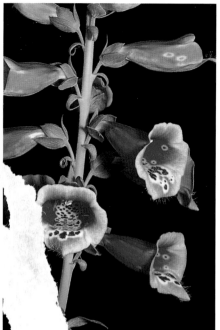

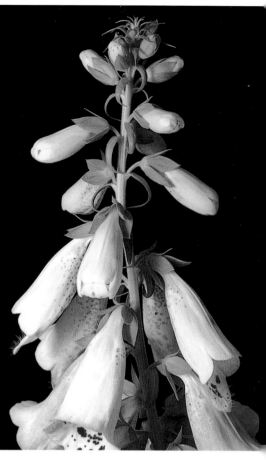

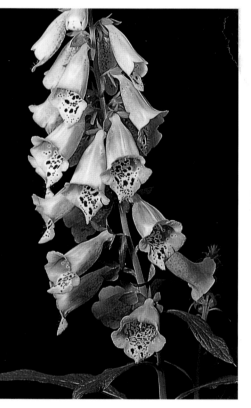

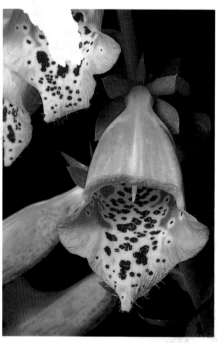

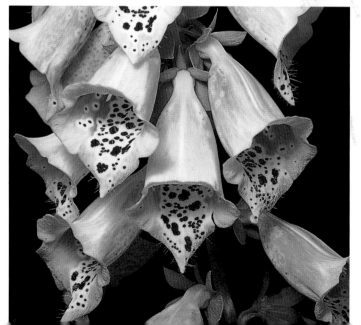

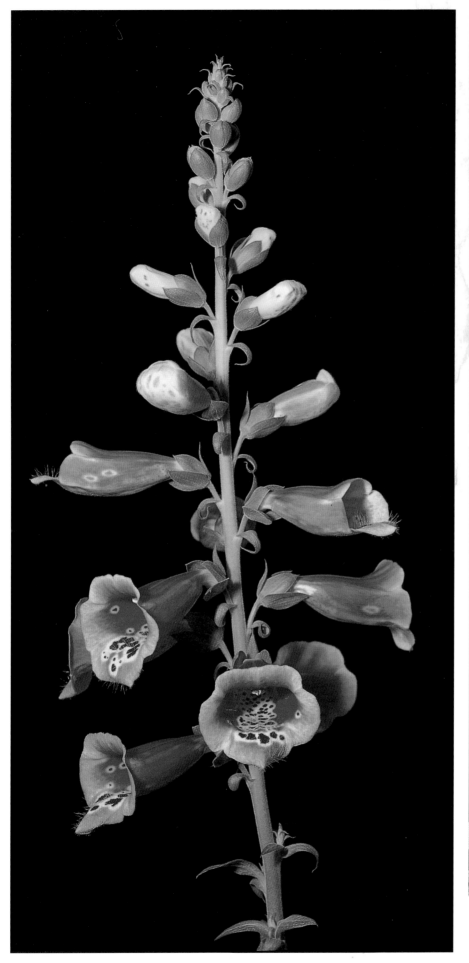

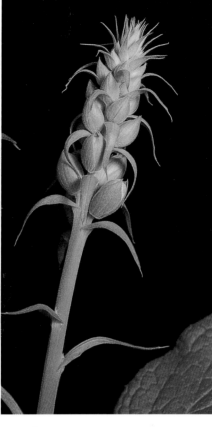

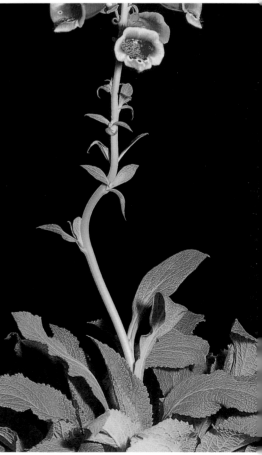

Fuchsia

The colors of the much-hybridized fuchsia vary widely. They include white, scarlet, magenta, pink, purple, violet and bicolored combinations. Fuchsias bloom in the spring and summer.

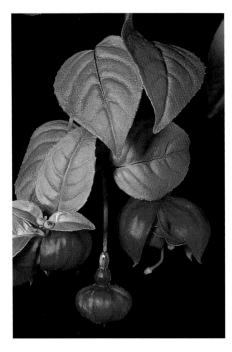

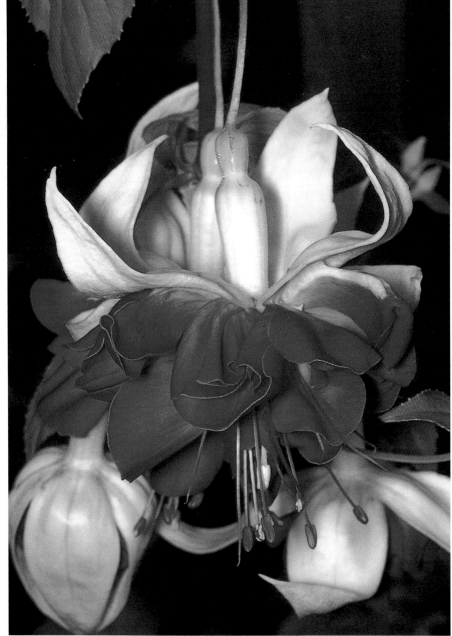

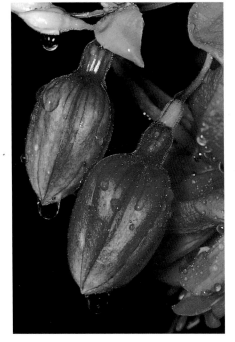

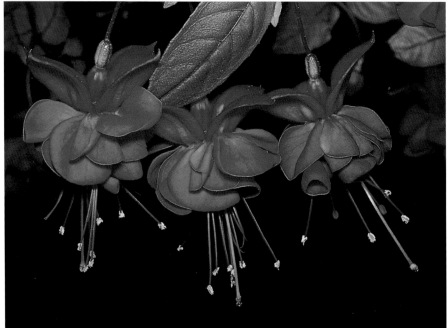

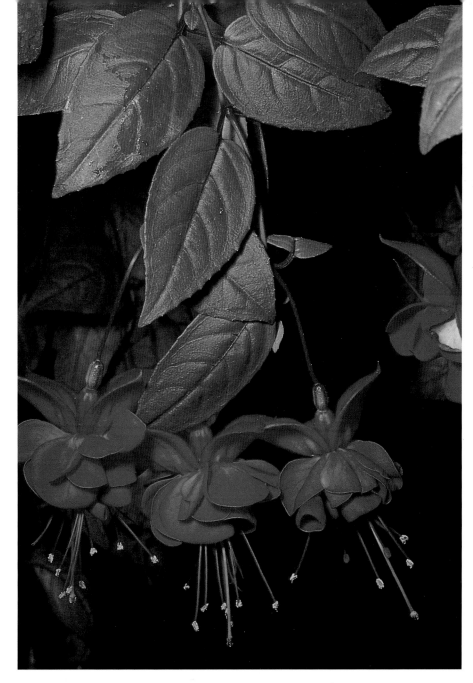

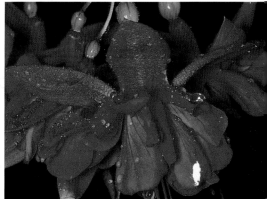

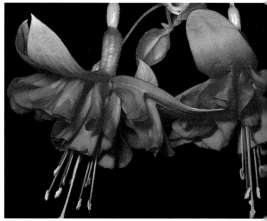

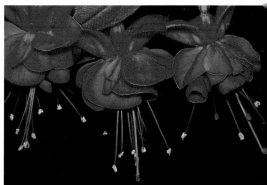

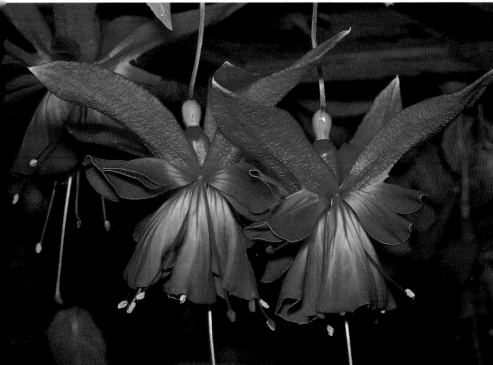

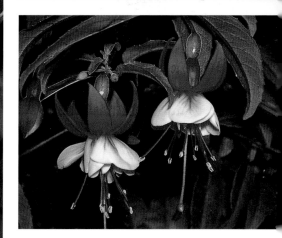

Gaillardia

Also known as blanketflower, gaillardia bloom in the summer and fall. They grow on 1' (0.3m) to 2' (0.6m) stems with 3" (7.6cm) to 4" (10.1cm) diameter flowers that can be found in deep red, crimson, cream, orange and other shades.

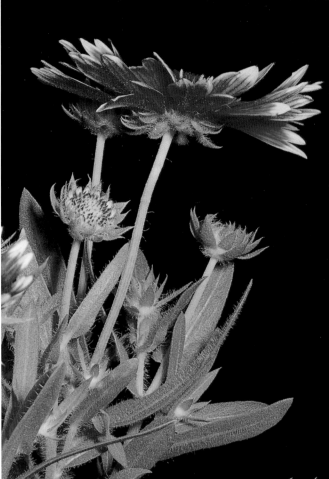

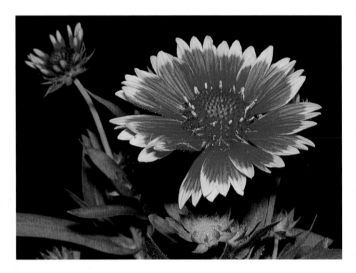

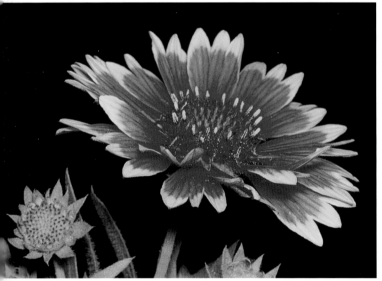

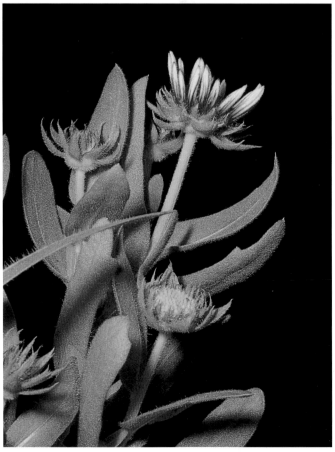

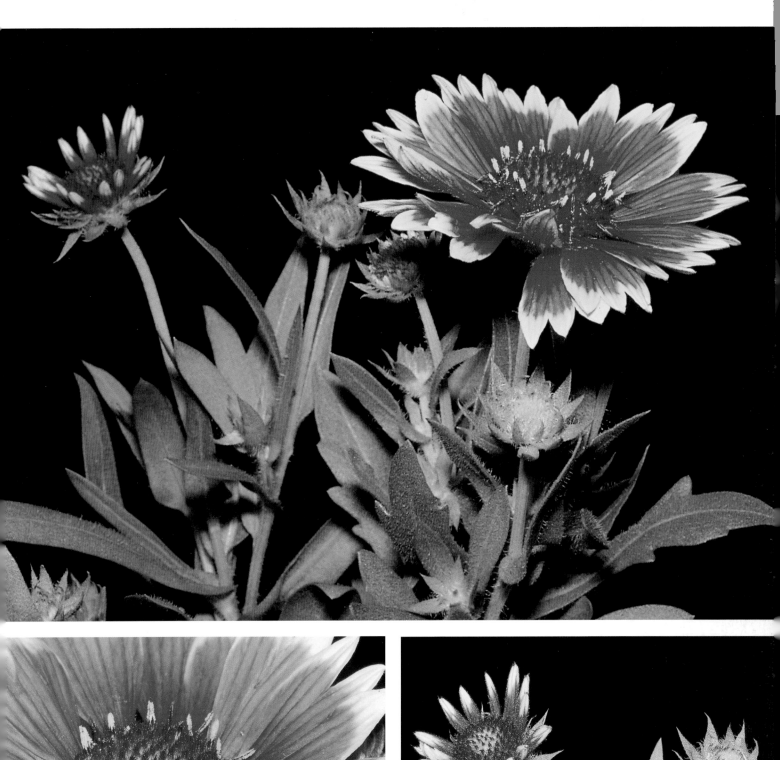

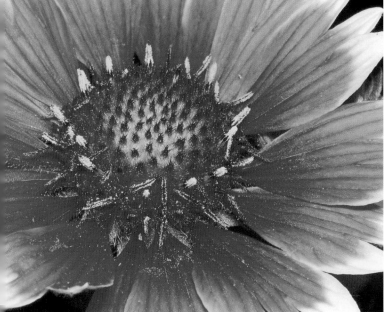

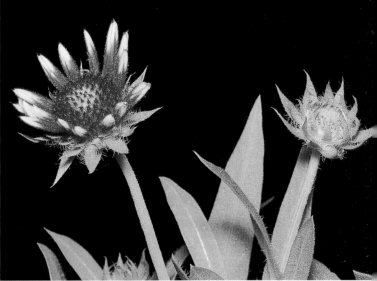

Geranium

Geraniums grow in bunches and range in color from white to various shades of pink, red, orange, magenta and lavender, including two- and three-color variegated types. The fan-shaped leaves often have deep red or white variegations.

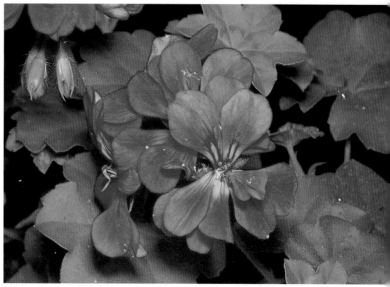

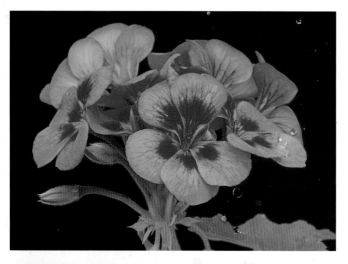

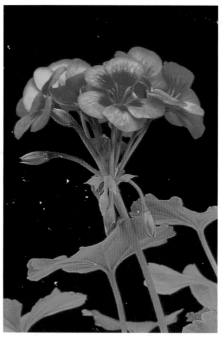

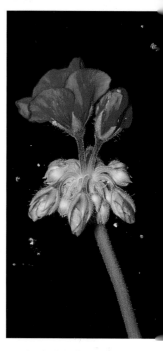

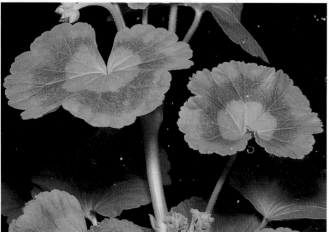

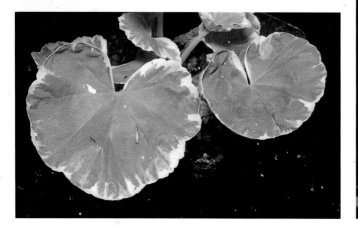

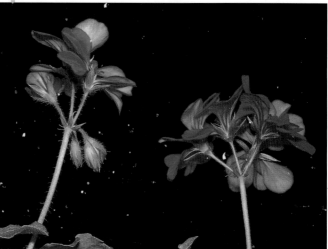

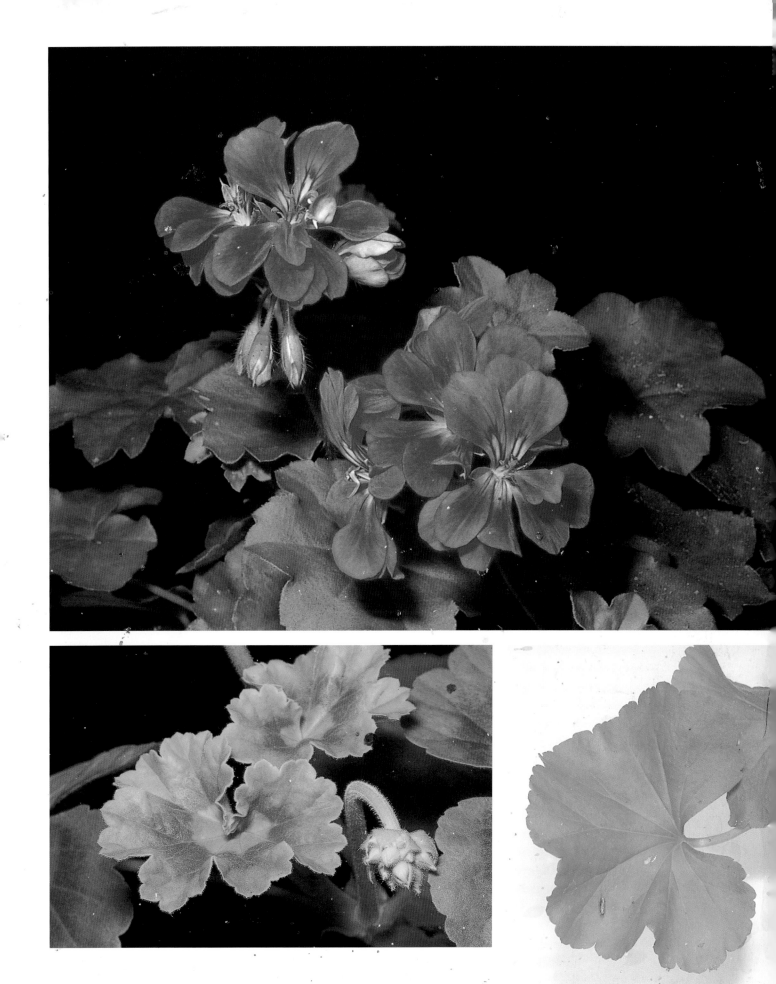

Gerbera Daisy

*A hybrid of the African daisy, this summer flower is 3"
(7.6cm) to 4" (10.1cm) across and comes in shades of red,
pink, bronze, yellow, orange, white and zones of contrasting
colors.*

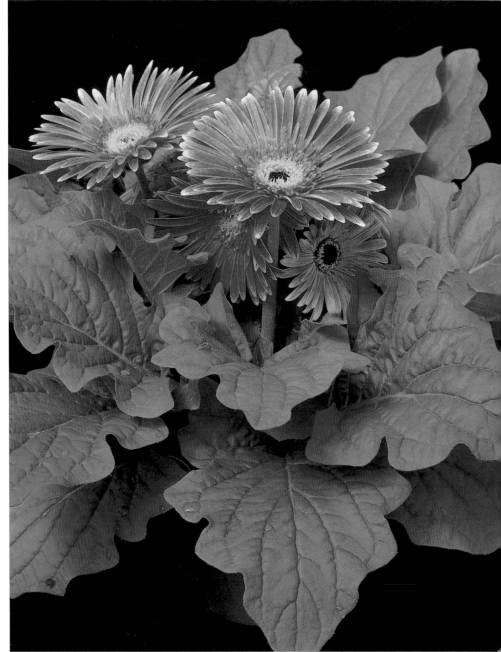

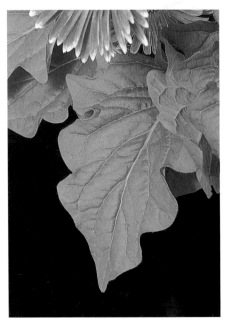

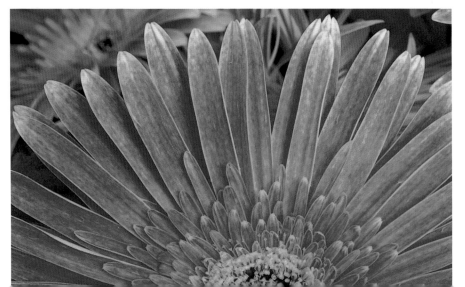

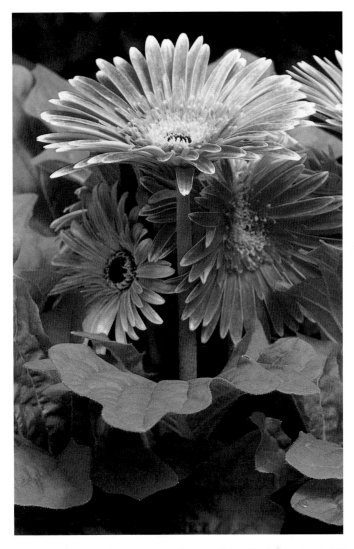

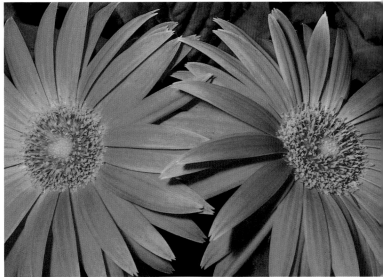

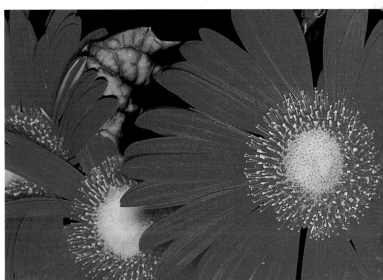

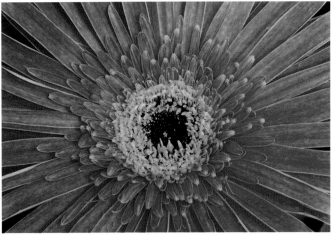

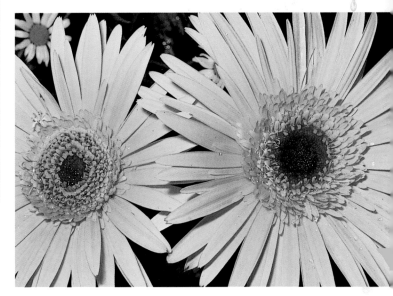

Gladiolus

Gladiolus grow on stalks in the summer and early fall. Colors include white, yellow, pink, orange, red, crimson, mauve and purple. They are often bicolored.

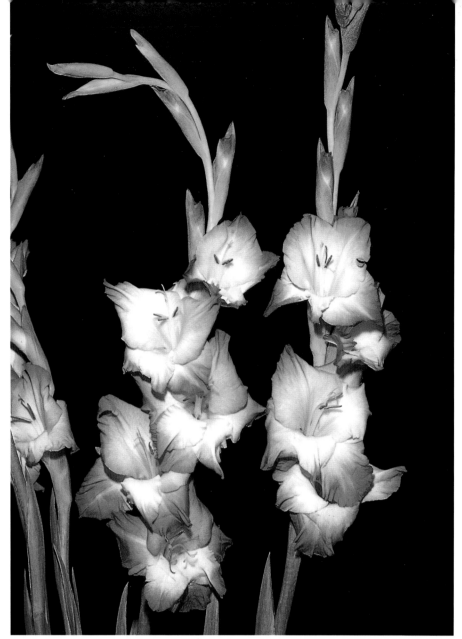

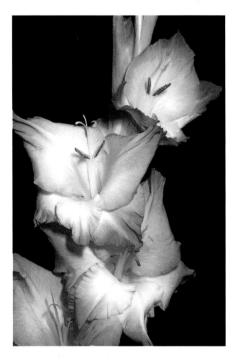

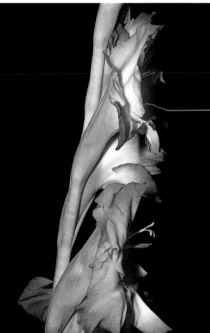

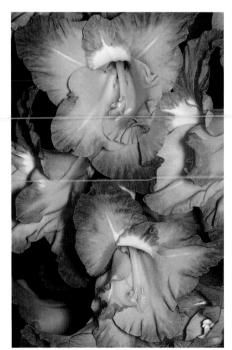

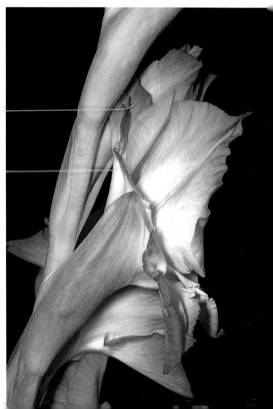

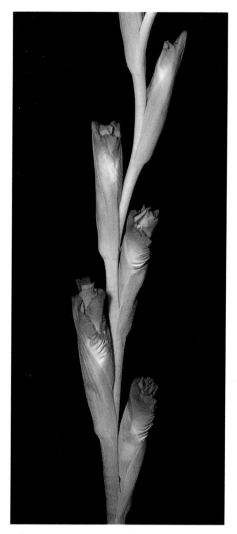
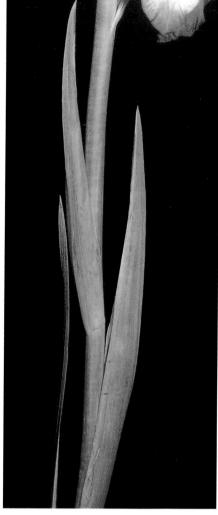
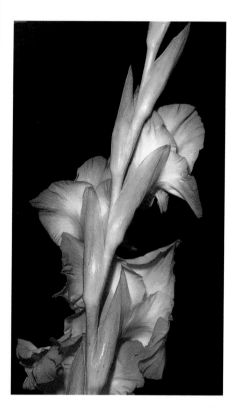
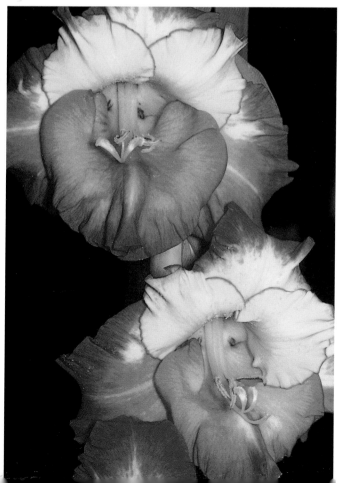
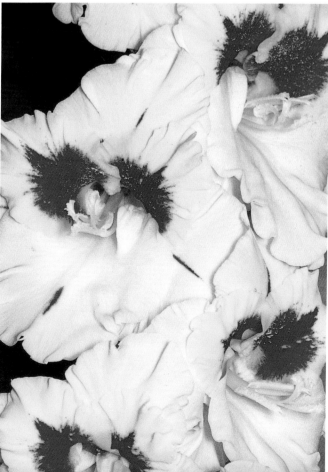

Gloxinia

These tubular-shaped flowers have petals that flare outward with frills at the edges. Colors include red, pink, white and purple, both plain and bicolored. Gloxinia are found in summer gardens.

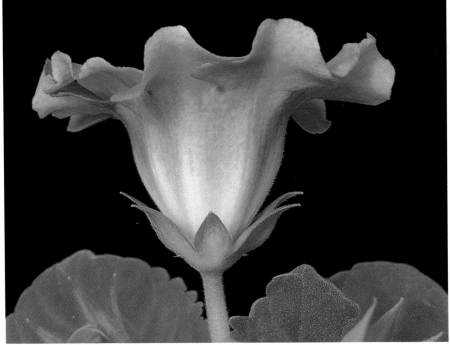

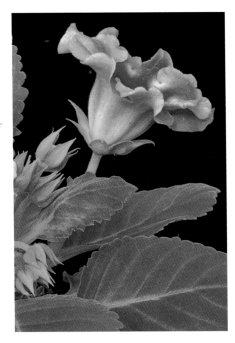

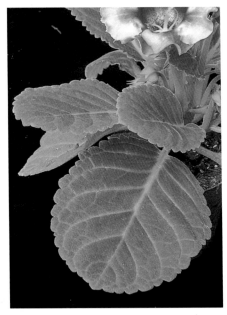

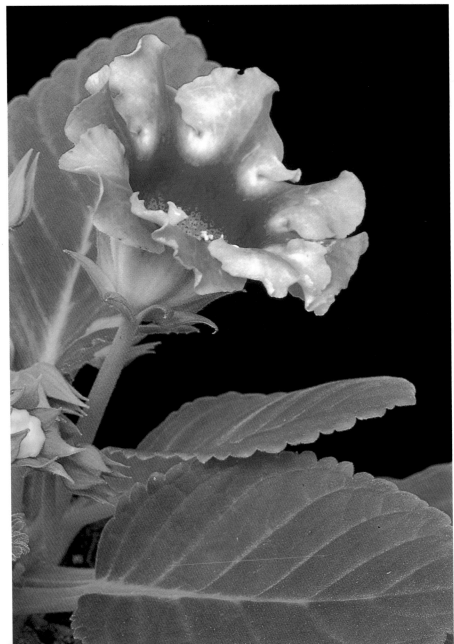

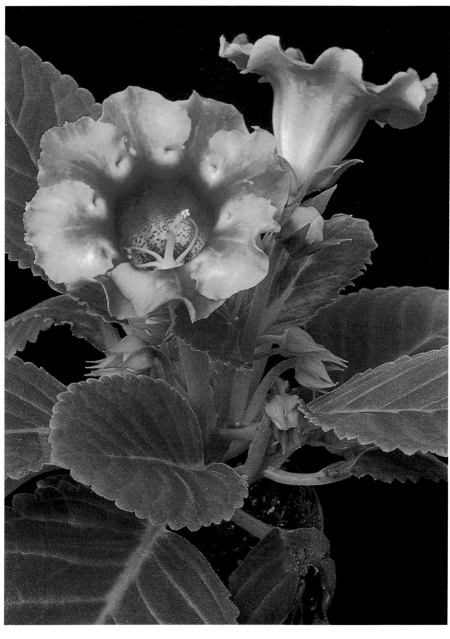

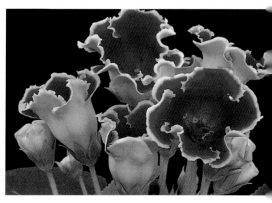

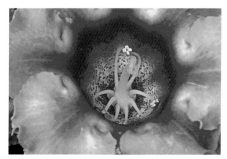

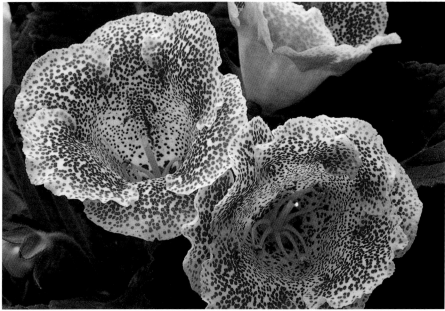

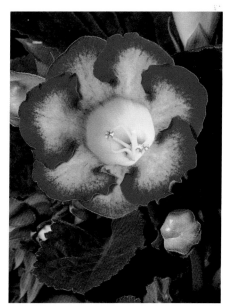

Hibiscus

Hibiscus bloom in midsummer and are usually bright red, but can be pink or salmon with a red center.

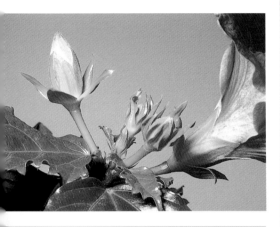

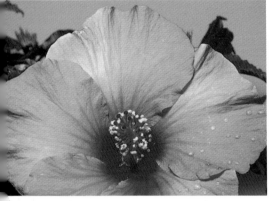

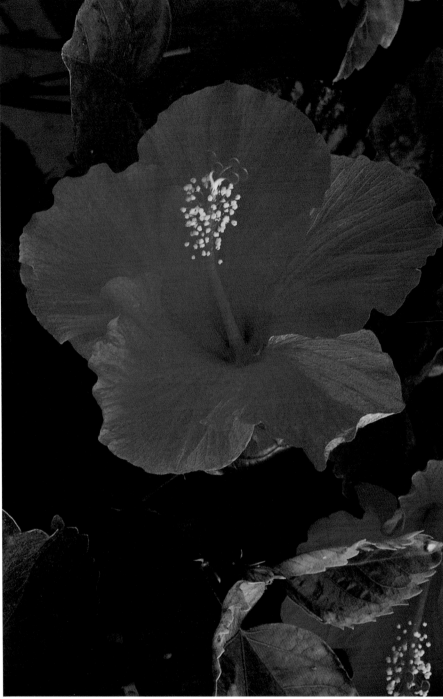

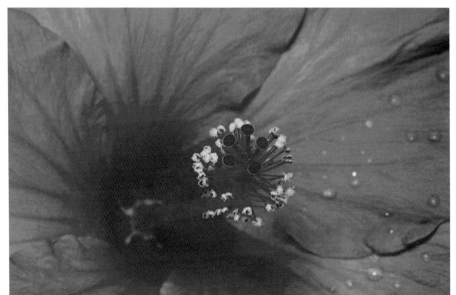

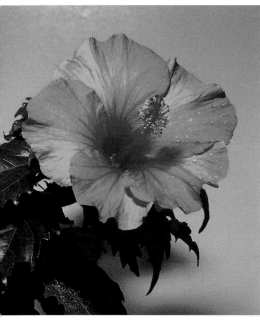

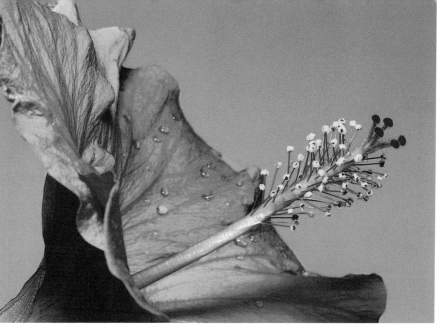

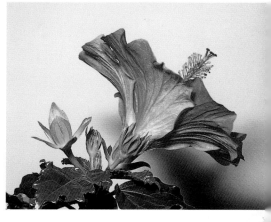

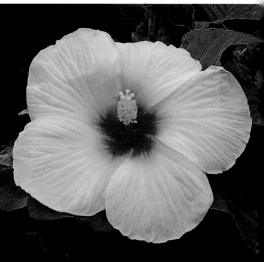

Hyacinth

The grape hyacinth depicted here grows in pompon-shaped groupings of five-petaled flowers. Pink, light blue violet, white and magenta versions occur in the spring.

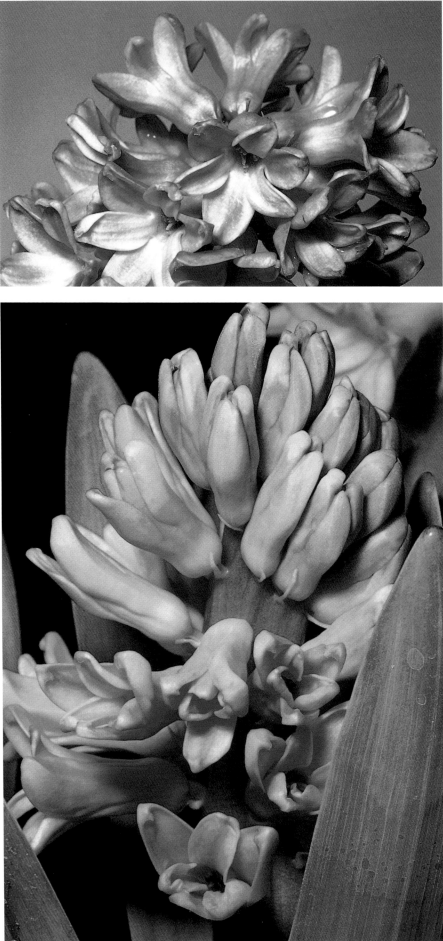

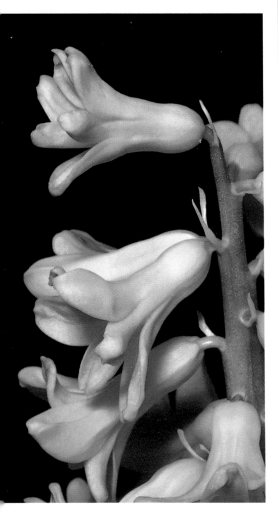

Hyacinth

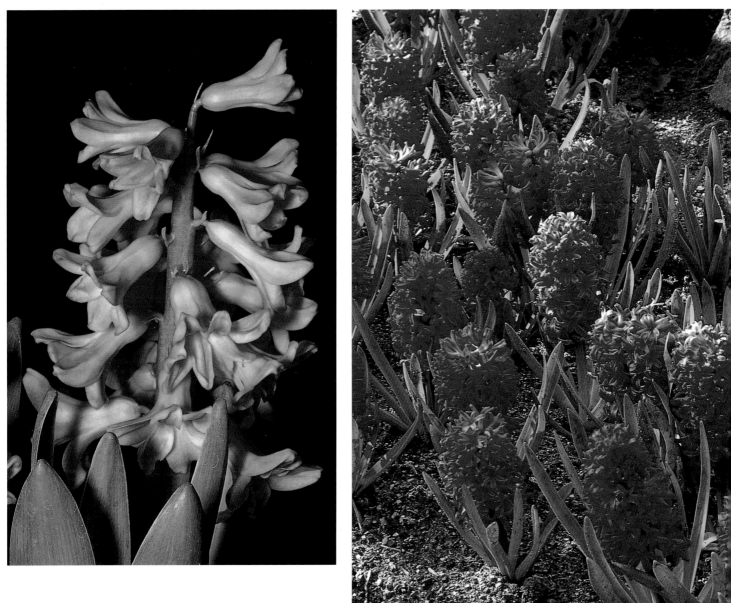

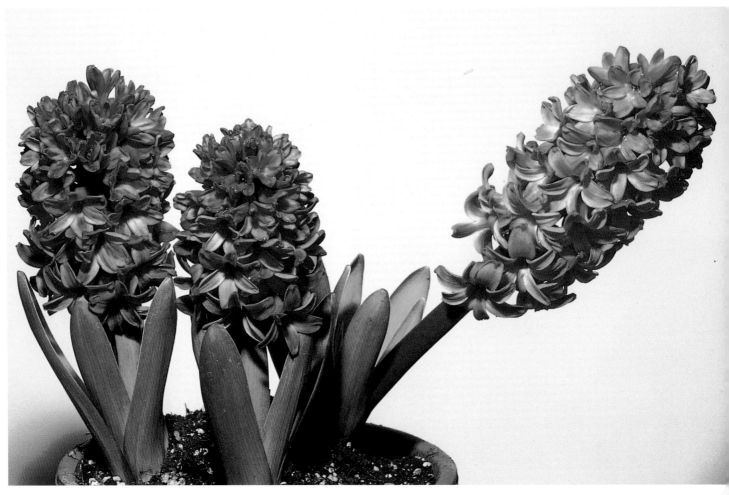

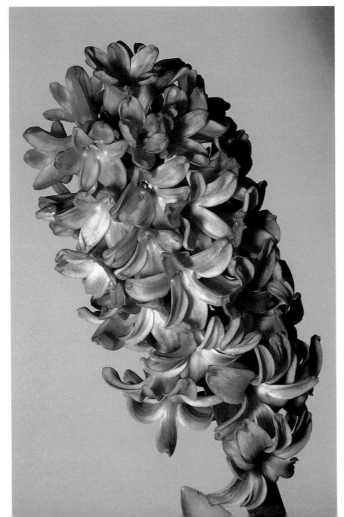

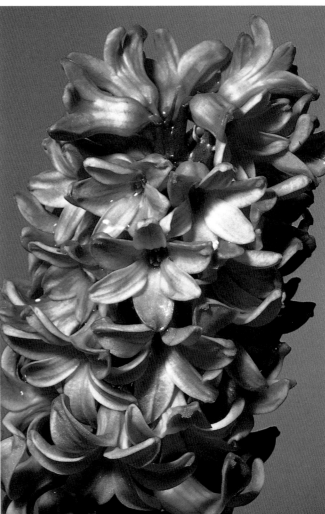

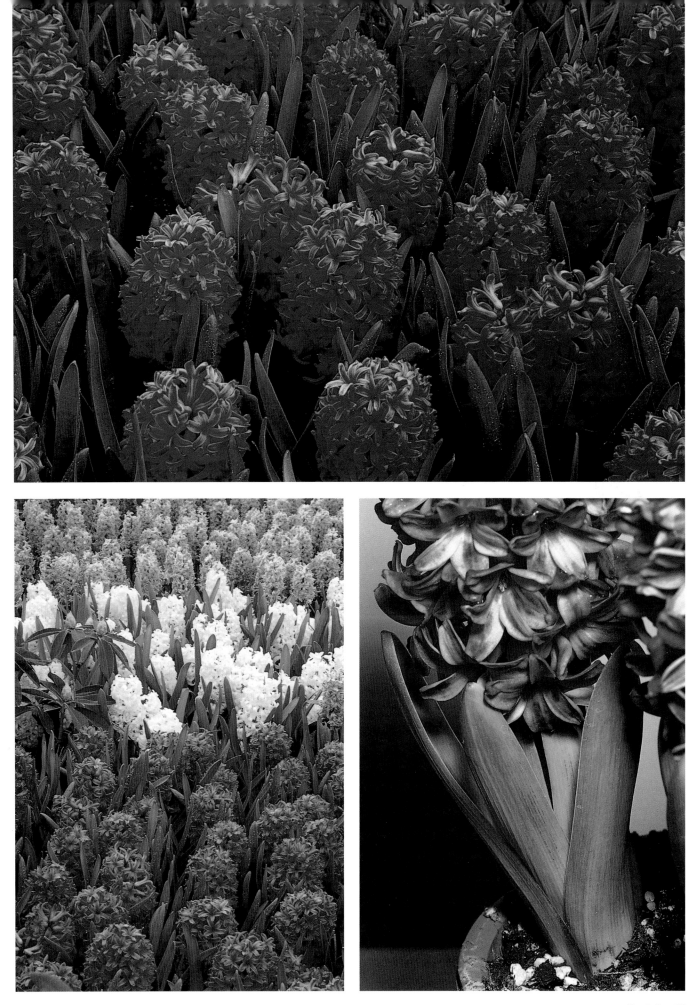

Hydrangea

These pompon-shaped clusters of small (¼"
[0.06cm] to ½" [1.2cm]) four-petaled flowers
grow in the summer and fall. Colors include
pink, magenta, white, cream, blue and mauve.

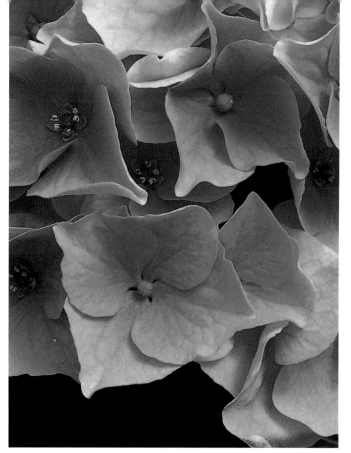

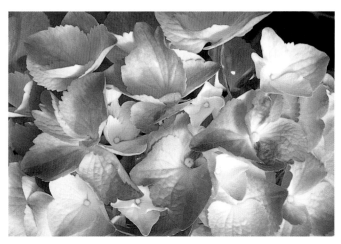

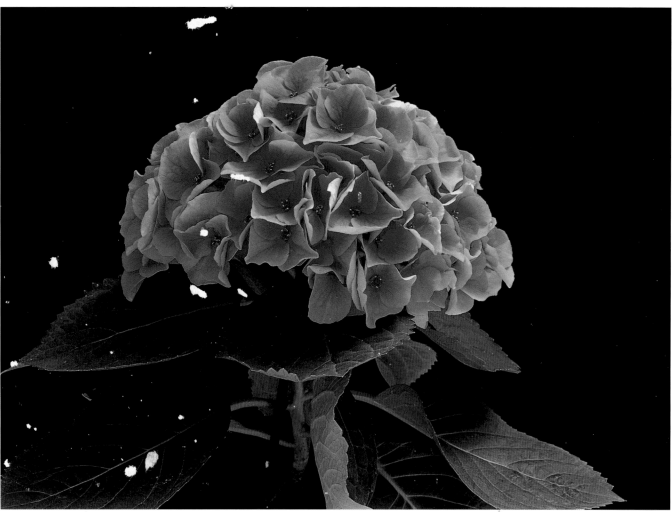

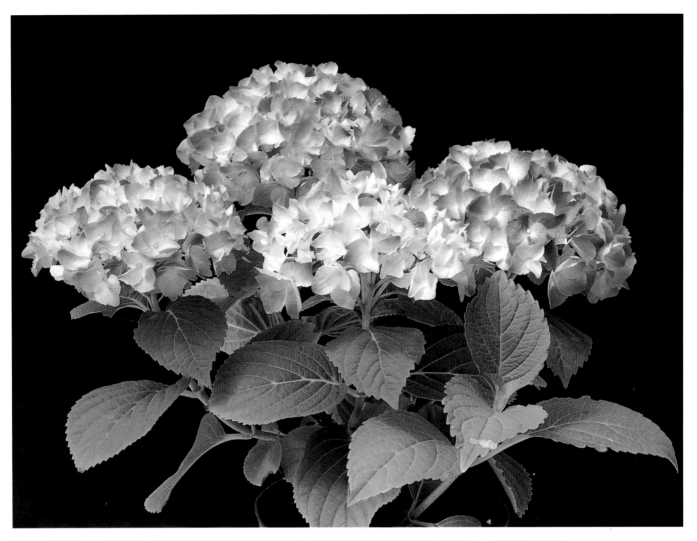

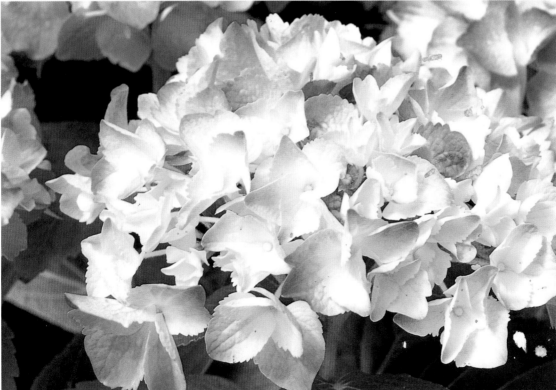

Hydrangea

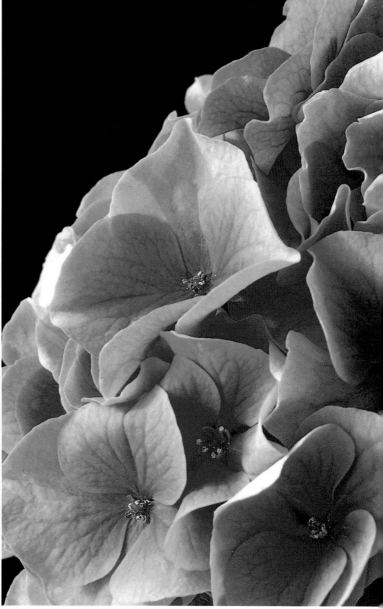

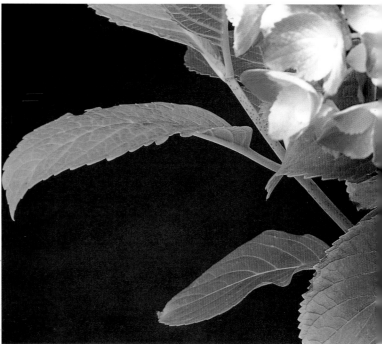

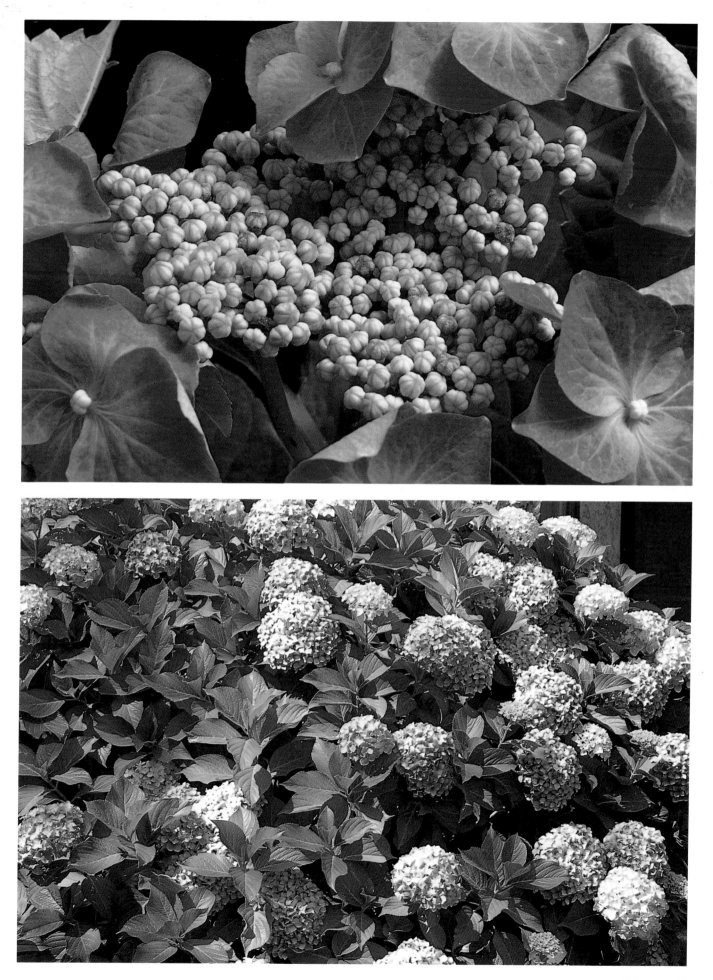

Iris

Iris are prevalent in the late spring and early summer. Their colors vary from white to yellow, sky blue, purple and violet with yellow or orange.

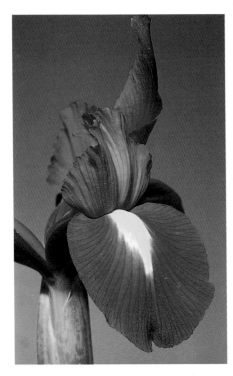

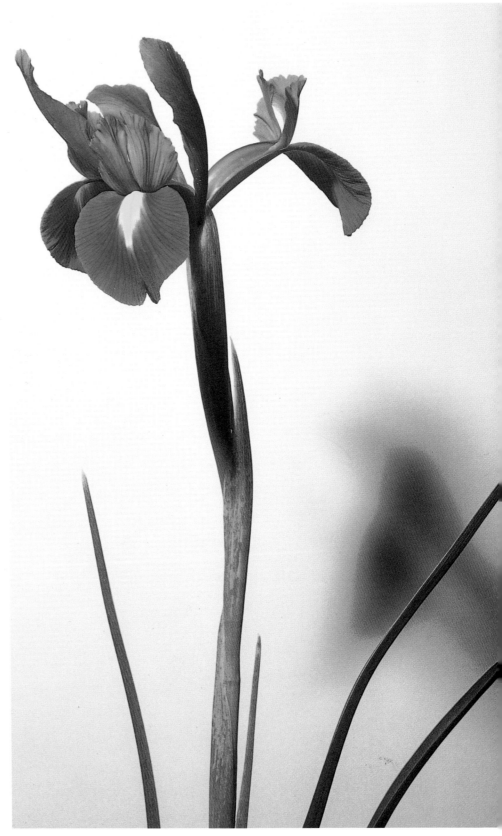

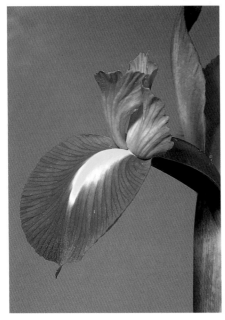

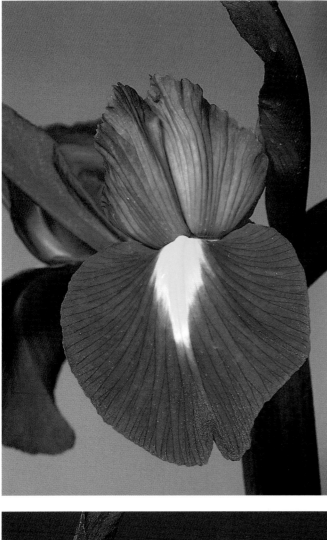

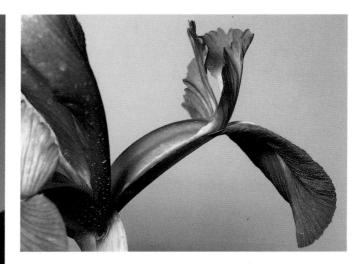

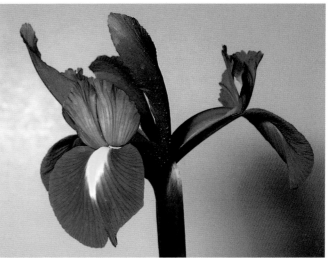

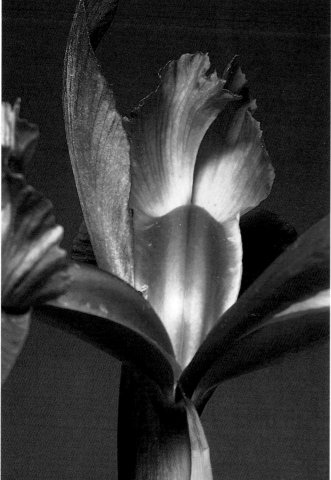

Iris, Bearded

Tall bearded iris appear in the early summer, growing on stalks up to 3' (0.9m) high. The flowers are up to 6" (15cm) across. They come in a wide range of color combinations and variations, including white, pink, red, yellow, mauve, purple, sienna, violet and pale blue.

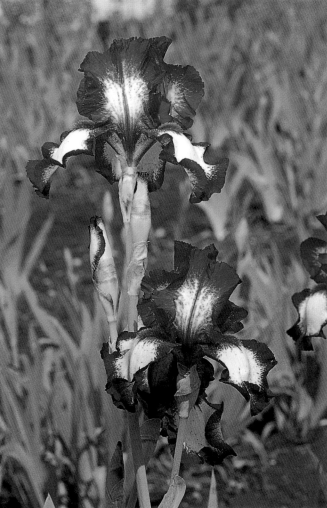

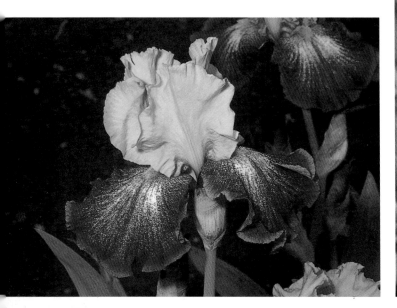

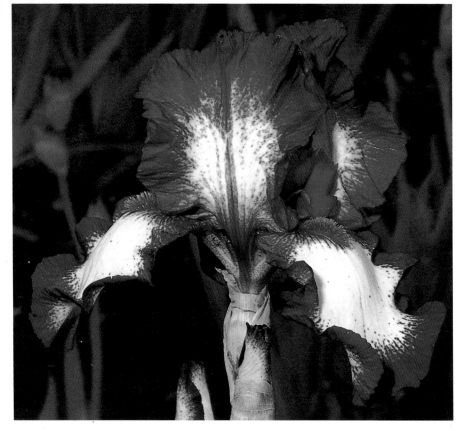

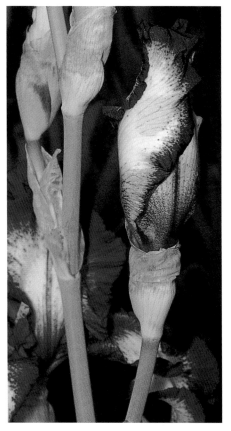

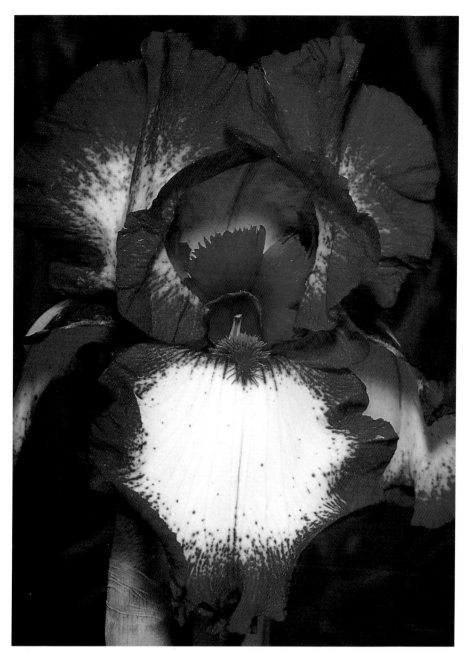

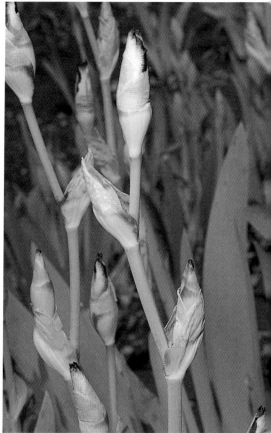

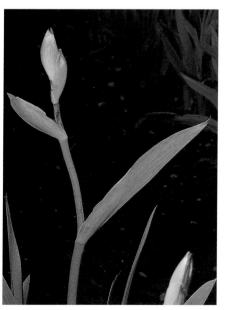

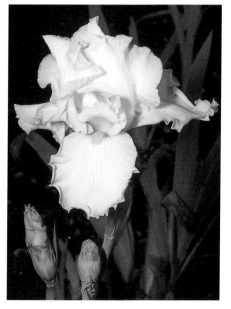

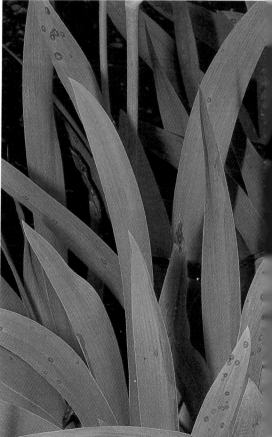

Kale

The ornamental kale shown here is obviously not depicted for its flower, but its fascinating structure is a favorite subject with artists.

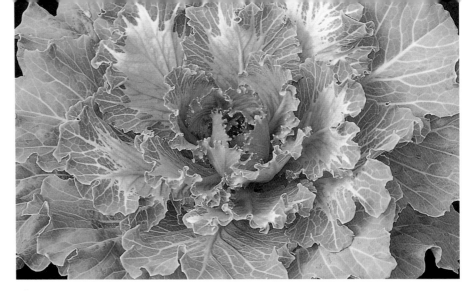

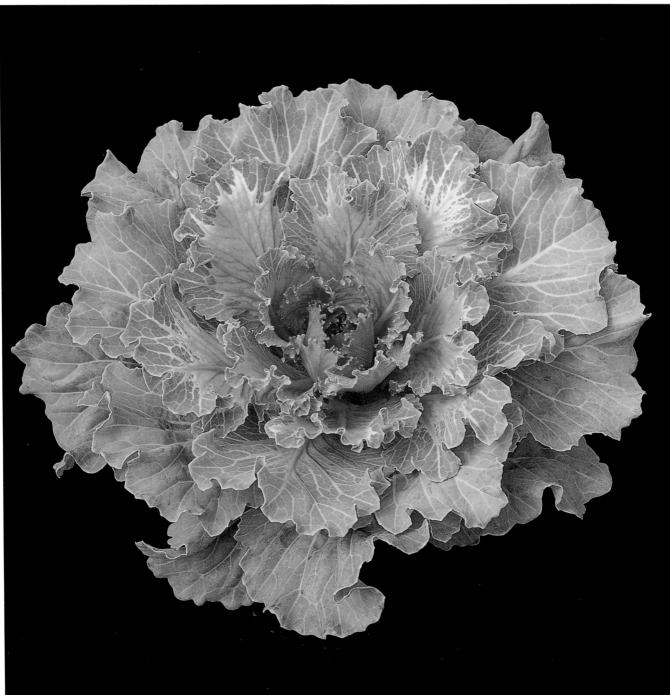

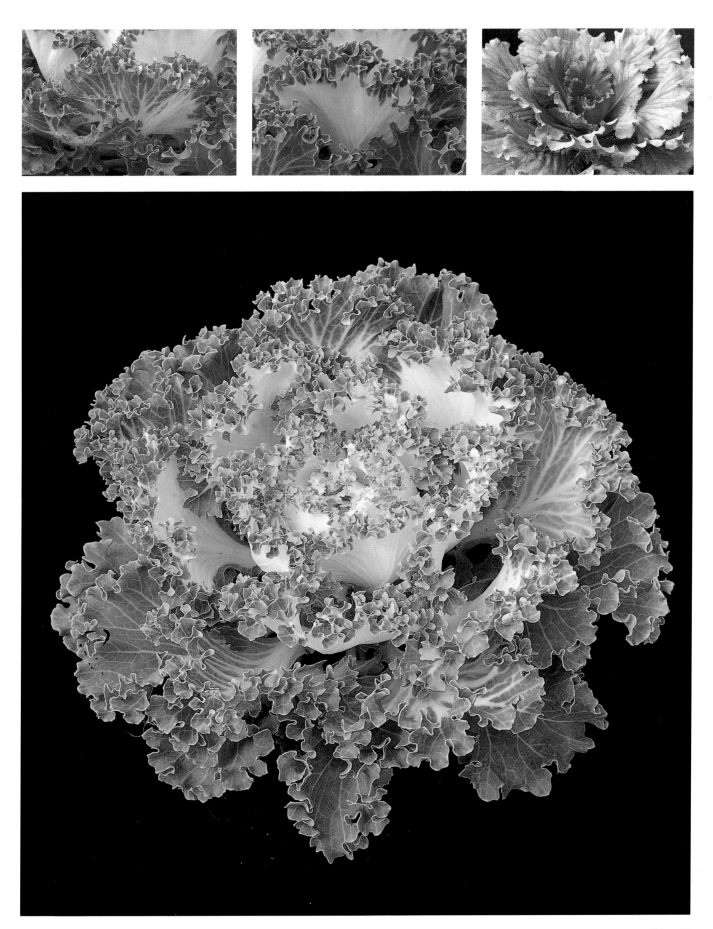

Lily

There are many varieties of lilies, which grow singly or in clumps. They range in size from 1" (2.5cm) to 6" (15cm) across. Blooming time varies, and colors include white, yellow, cream, orange and pink. Lilies may be solid or in various color combinations. Some varieties, like tiger lilies, have reddish brown spots on their petals.

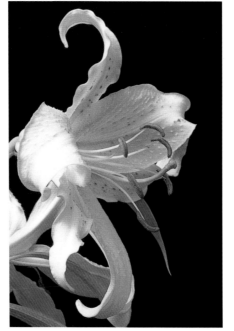
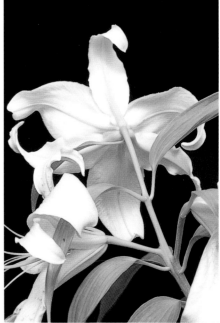

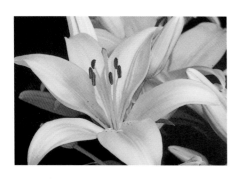

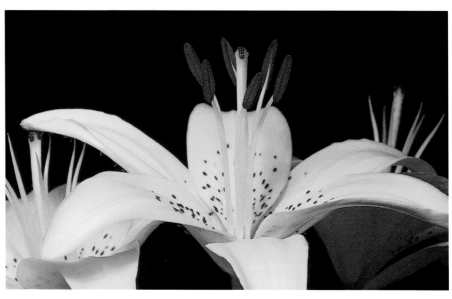

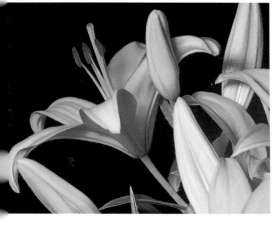

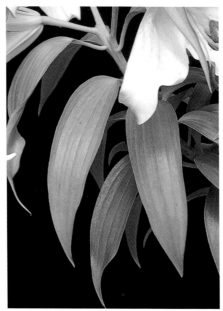

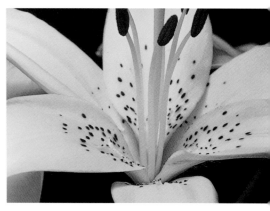

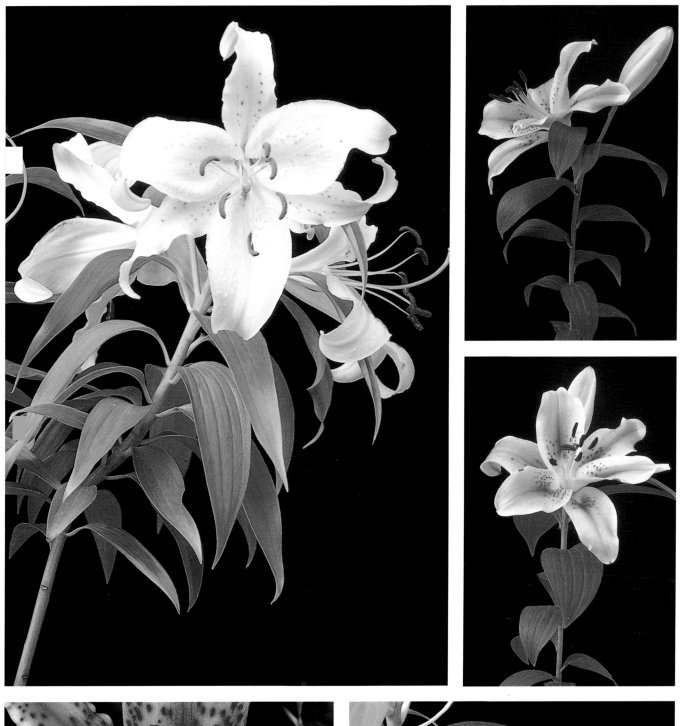

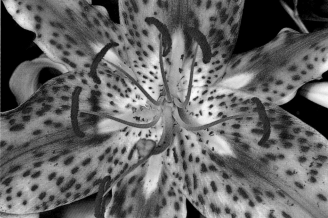

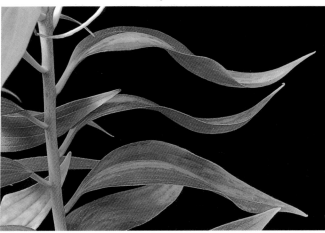

Lupine

Blooming in late spring to midsummer, this flower grows on stalks 1½' (0.5m) to 2½' (0.8m) tall. The blossoms range in color from deep blue, purple, magenta and creamy yellow to bicolored species as shown here.

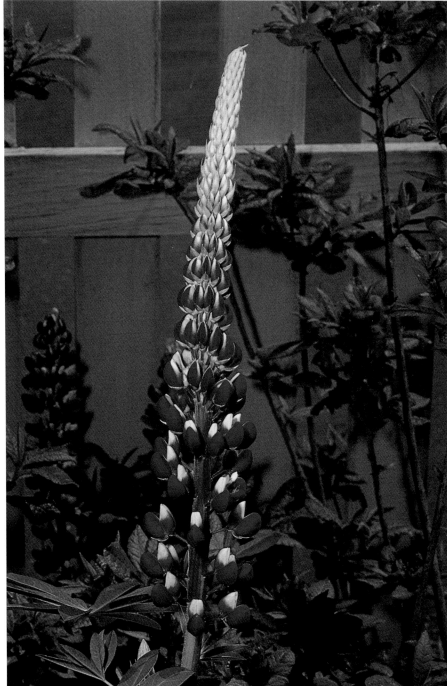

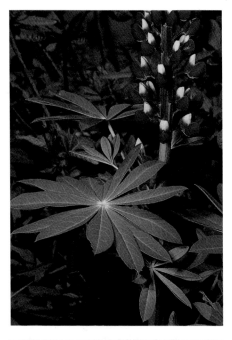

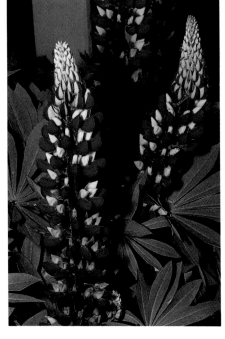

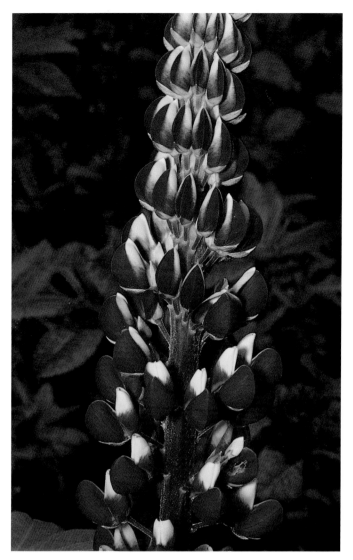

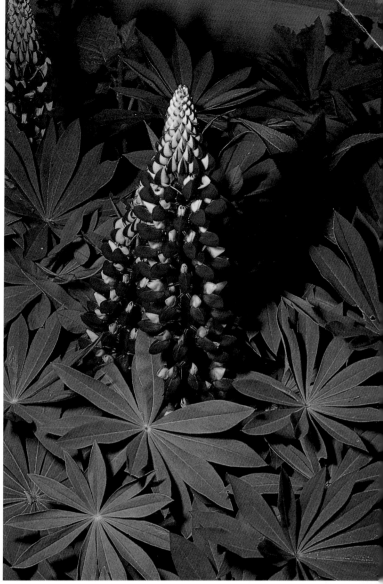

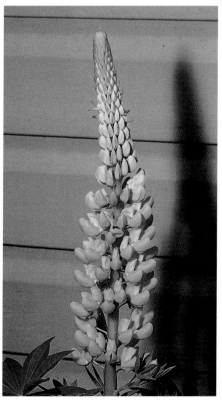

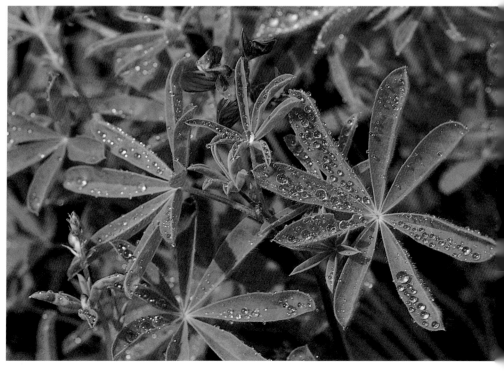

Magnolia

Depicted here is the large saucer magnolia, which blooms in the early spring.

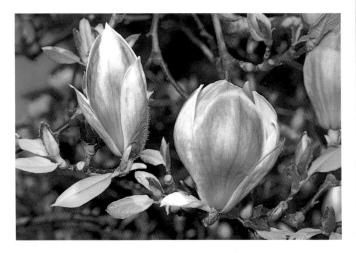

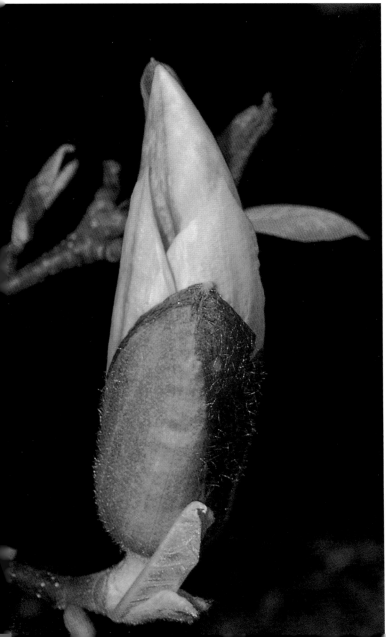

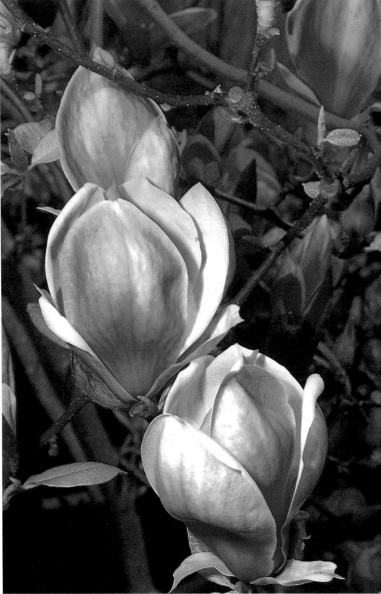

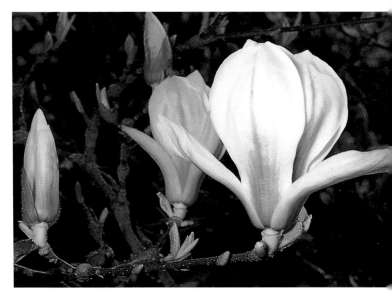

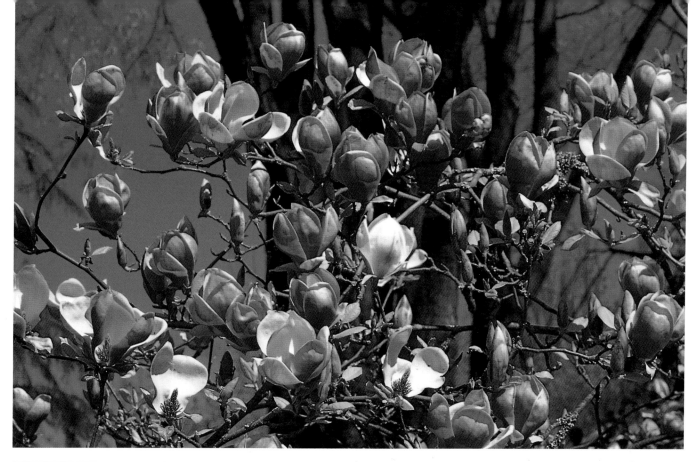

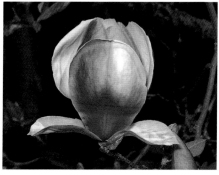

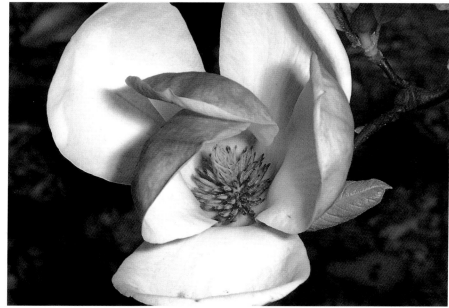

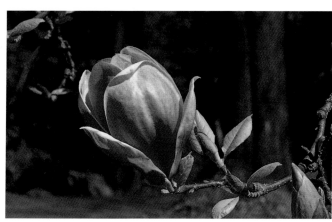

Marigold

Marigold flowers differ mainly in the structure of their petals: Some have flat, squarish petals with smooth edges, others have daisy-like petals with ruffled edges, and still other varieties are shaped like pompons with ruffled edges. Colors include yellow, yellow-orange, red with yellow or yellow-orange edges, and yellow-orange with red spots. Marigolds bloom in summer gardens.

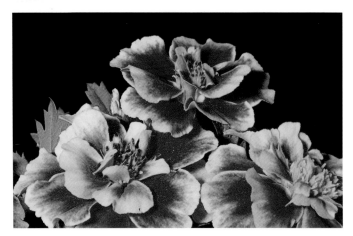

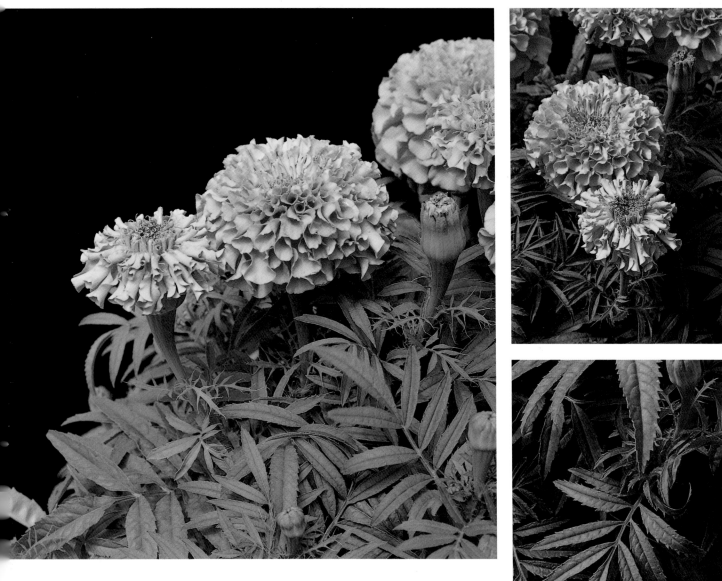

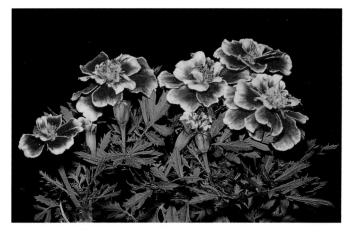
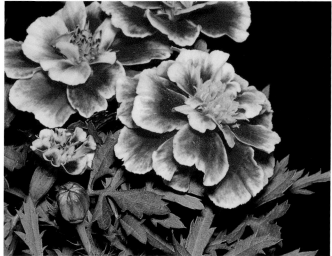
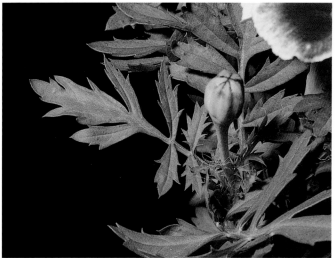
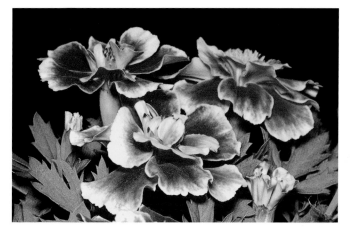
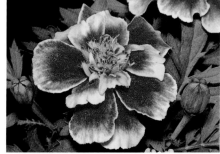
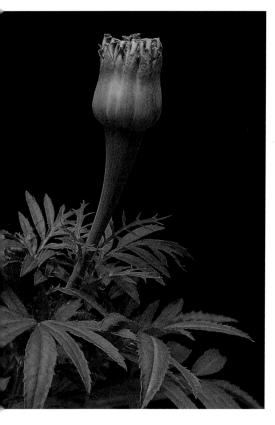
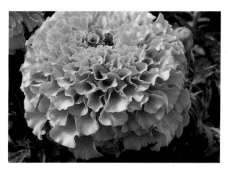
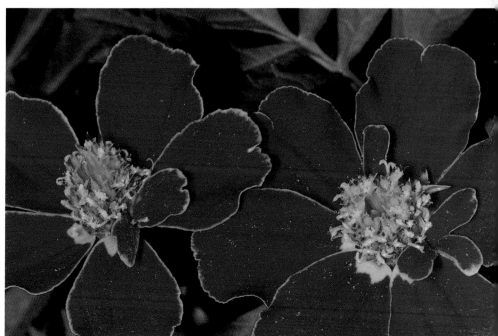

Nasturtium

Nasturtium is a small flower 1" (2.5cm) to 2" (5cm) across. It has round leaves and blooms throughout the summer. Colors include red, yellow and orange.

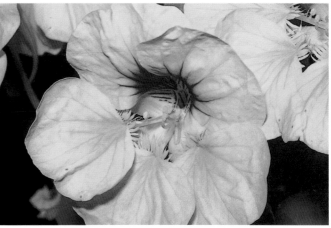

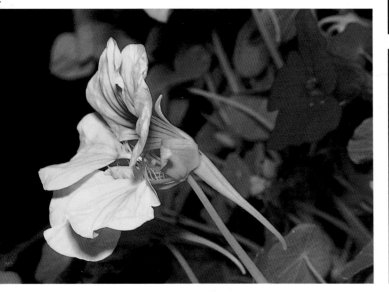

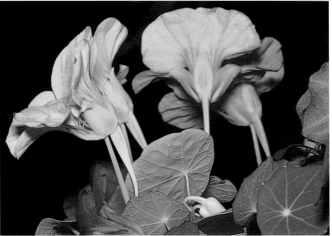

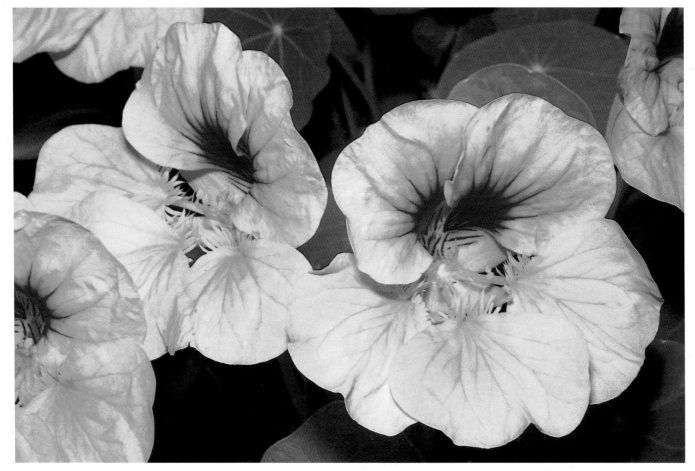

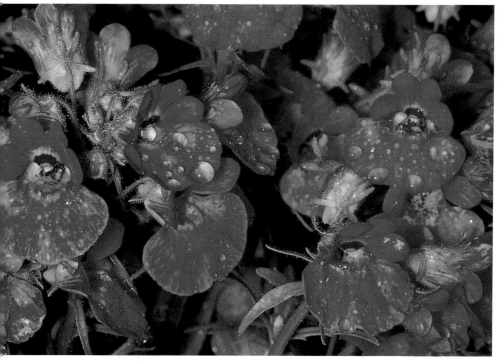

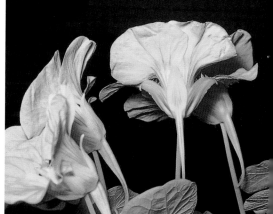

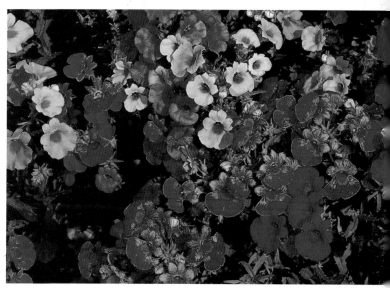

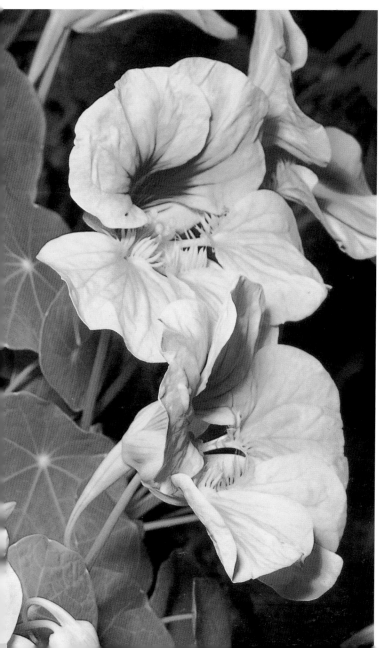

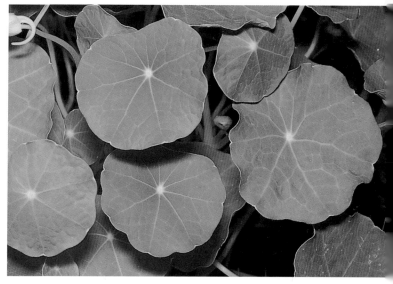

Orchid

A separate book could easily be filled with the orchid's vast variety of shapes, sizes, colors and markings. Orchids grow indoors and outdoors at all times of the year.

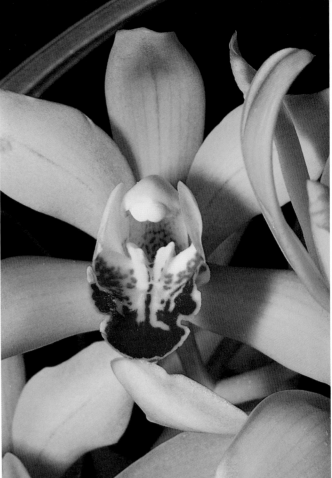

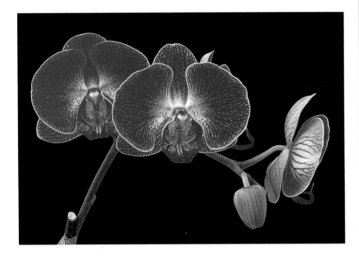

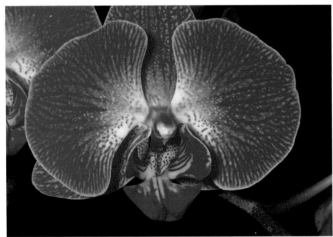

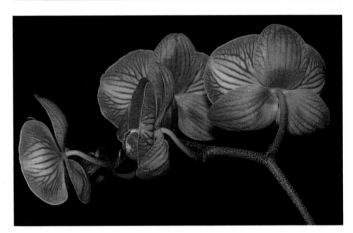

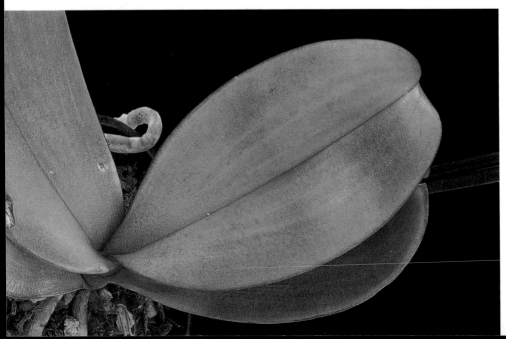

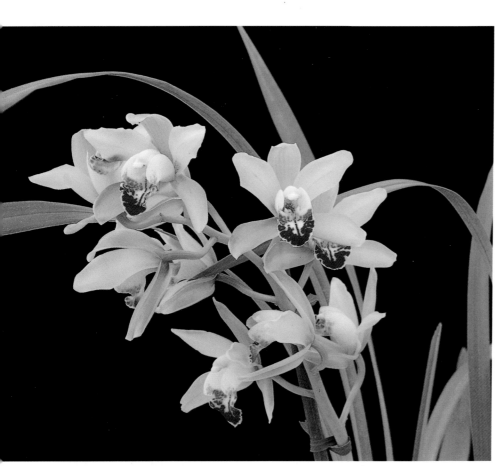

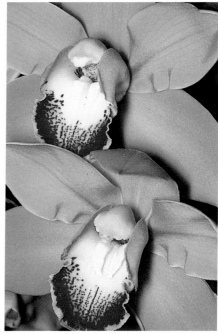

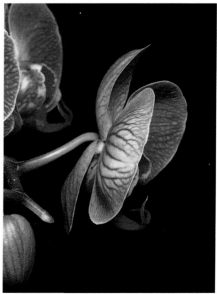

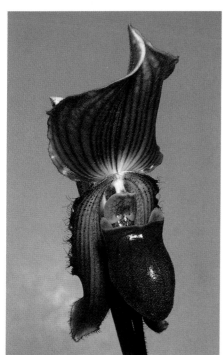

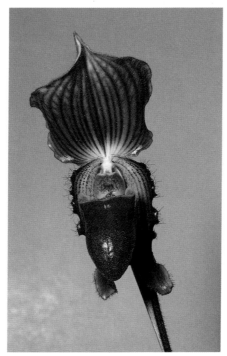

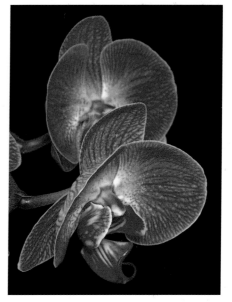

Orchid

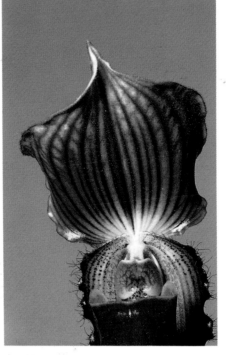

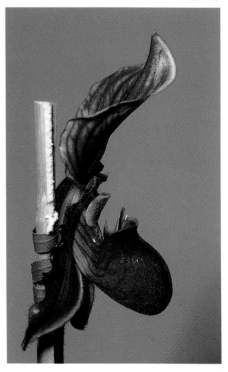

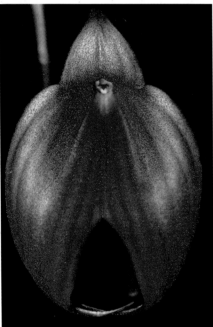

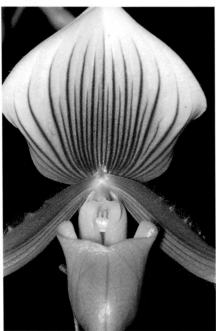

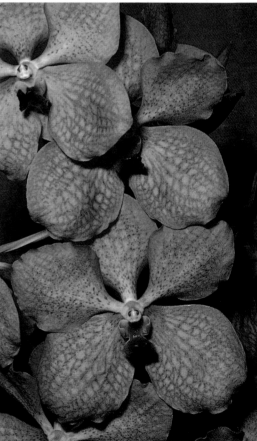

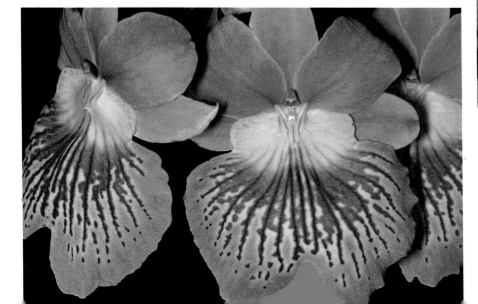

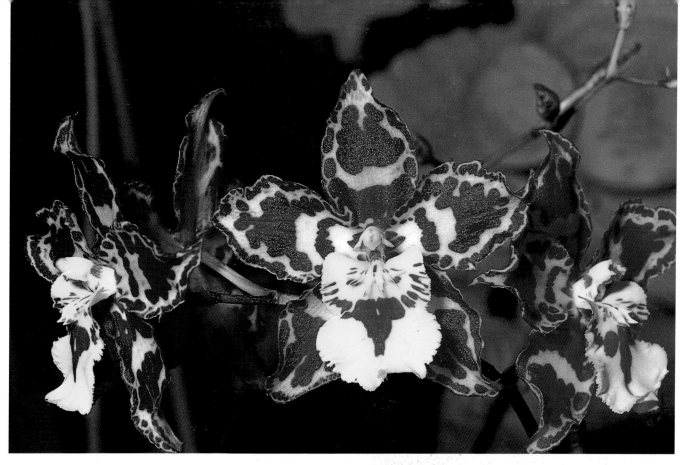

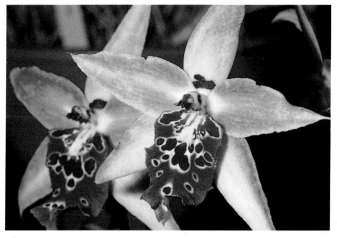

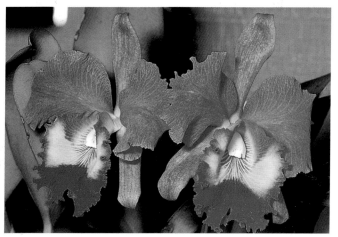

Orchids in Colored Pencil

by Gary Greene

Supplies

- Strathmore 4-ply 32" x 40" (81.3cm x 101.6cm) museum board
- 2B or B graphite pencil
- Colorless blender, such as Lyra Splender
- Bestine solvent and thinner
- Cotton swabs
- Kneaded eraser
- Koh-I-Noor #285 imbibed eraser strip in electric eraser
- Electric pencil sharpener
- Desk brush
- Krylon workable fixative

Color Palette: Berol Prismacolor

Apple Green	Limepeel
Black Grape	Marine Green
Cream	Orange
Deco Yellow	Pumpkin Orange
French Grey 10%, 20%, 30%, 50%, 70%	Scarlet Lake
	Sunburst Yellow
	Terra Cotta
Goldenrod	Tuscan Red
Indigo Blue	White
Jasmine	

Berol Verithin

- Light Green
- Light Grey
- Olive Green

Caran d'Ache Pablo

- Green Ochre
- Khaki Green
- Olive Black
- Olive Yellow

Lyra Rembrandt

- Burnt Carmine
- Cream
- Gold Ochre
- Indian Red
- Lemon Yellow
- Light Chrome
- Light Ochre
- Ochre

For those who are not familiar with colored pencil painting, the following terms are used to describe the techniques employed in this demonstration.

Layering is a light application of desired colors on top of each other, usually starting with the darkest value of any given area.

Burnishing involves layering, and then blending the layers together with a colorless blender pencil or a white or very light-colored pencil. The lighter areas of color are completed first to prevent darker colors from adjacent areas from being "dragged" into lighter areas, and the process is repeated until the entire paper surface is covered.

Wash or *underpainting* is achieved when layered colored pencil is dissolved with a solvent to create a smooth ground, which shows through subsequent layers of colored pencil.

Don't Press Too Hard
Be careful not to press too hard when using Verithin pencils, to avoid unwanted impressed lines.

1. Lay Out the Composition and Underpaint Shadows

With a medium-soft graphite pencil such as a 2B or B, sketch out basic shapes using very little pressure (too much pressure will impress lines into the paper). After the initial layout is completed, make adjustments with the graphite pencil.

Draw lines next to (not on top of) the graphite lines with a hard colored pencil such as a Verithin, using colors that correspond to the area to be painted so that the outlines disappear when the area is completed. In this case they are Light Green, Gold Ochre (Lyra) and Light Grey.

Erase the graphite with a kneaded eraser so that only the colored pencil lines remain (they may need to be touched up). Don't lay out red variegations until the surrounding light yellow area is complete, to avoid unwanted color contamination.

Layer French Grey 70%, 50% and 30% to cast shadow areas as shown. Wash with Bestine solvent and a cotton swab.

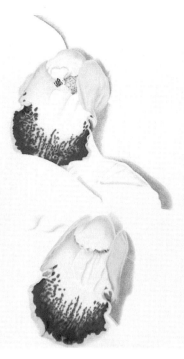

3. Continue the Centers and Paint Red Variegations

Lightly burnish left, right and upper center petals with a colorless blender or white pencil. Repeat the following until the surface is covered: Layer left and right center petals with Green Ochre, Olive Yellow, Goldenrod, Gold Ochre, Ochre and Light Ochre; layer upper center petal with Ochre, Green Ochre, Olive Yellow, Jasmine, Lemon Yellow, Light Chrome, Deco Yellow, Cream (Lyra) and Cream (Prismacolor); lightly burnish left, right and upper center petals with a colorless blender or white pencil. Layer red variegations with a gradation of Black Grape (darkest values only), Tuscan Red, Indian Red, Burnt Carmine and Scarlet Lake. Layer lower open areas with Jasmine, and burnish with a colorless blender or white pencil.

2. Paint the Centers

Layer center petal shadow areas with French Grey 20% and/or 10%, depending on the value of the shadow. Wash with Bestine solvent and a cotton swab.

Layer left and right center petals with Green Ochre, Olive Yellow, Goldenrod, Gold Ochre, Ochre and Light Ochre. Layer upper center petal with Ochre, Green Ochre, Olive Yellow, Jasmine, Lemon Yellow, Light Chrome, Deco Yellow, Cream (Lyra) and Cream (Prismacolor).

Layer lower center petal with French Grey 10% in shadow areas. Wash with Bestine and a cotton swab. Layer with Gold Ochre and Ochre. Wash with Bestine and a cotton swab again. Layer remainder of petal with a gradation of Jasmine, Deco Yellow, Cream (Lyra) and Cream (Prismacolor).

Wash lower center petal with Bestine and a cotton swab. Lightly burnish remainder of area with a white pencil. Layer stamen (lower flower only) with Pumpkin Orange, Orange and Sunburst Yellow, and then lightly burnish with a colorless blender or white pencil.

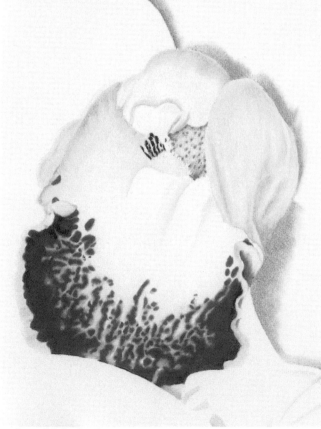

4. Stay With the Centers

Layer center with French Grey 30% and 20%. Wash with Bestine and a cotton swab. Layer with Cream (Prismacolor), and then wash with Bestine and a cotton swab. Stipple speckled variegations with Black Grape (darkest only) and Tuscan Red.

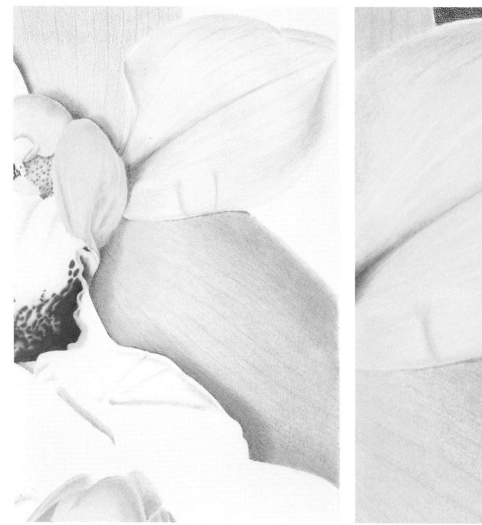

5. Complete the Petals

Layer green variegations with Apple Green, and then layer selected variegations with Terra Cotta. Wash with Bestine and a cotton swab.

Layer shadows with Olive Black, Limepeel and Green Ochre. Wash with Bestine and a cotton swab. Layer petal with Apple Green, Limepeel, Khaki Green, Olive Yellow and Jasmine. Burnish shadows with a colorless blender. Burnish remainder of petal with White. Repeat this process until the paper surface is completely covered.

6. Color the Background

Layer Indigo Blue and Marine Green until approximately two-thirds of the background area is covered with pigment, and then lightly burnish with a colorless blender pencil. Layer Indigo Blue and Marine Green until the entire paper surface is covered. Sharpen edges with Olive Green Verithin, and then spray with three or four light coats of Krylon workable fixative.

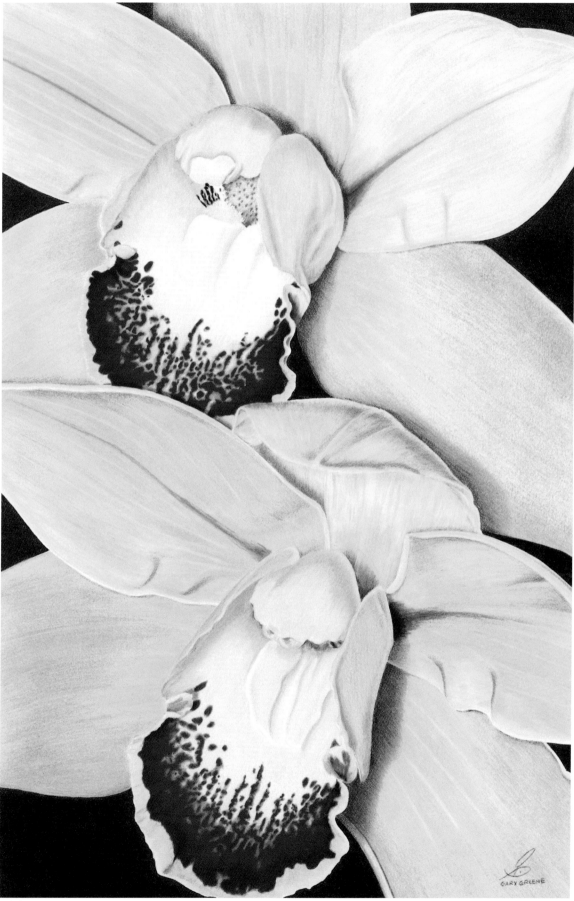

Orchids © GARY GREENE

Pansy

Pansies all have the same basic shape, differing mainly in color combinations. They are usually tricolored, including combinations of violet, purple, blue-violet, lavender, yellow, yellow-orange, orange, dark red, red, pink and white. Pansies can be found in spring, summer and fall gardens.

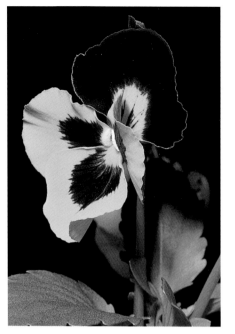
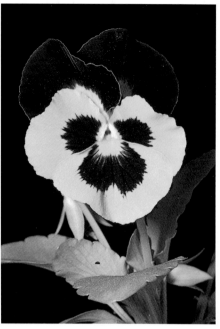

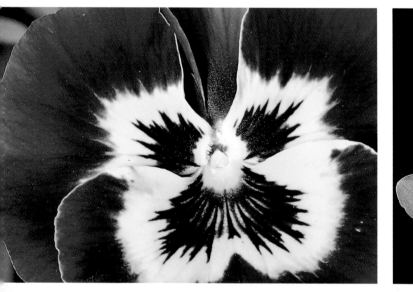
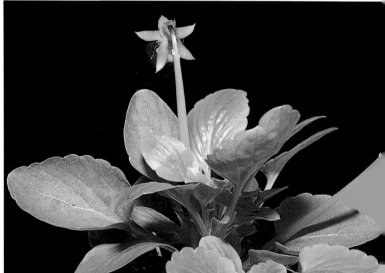

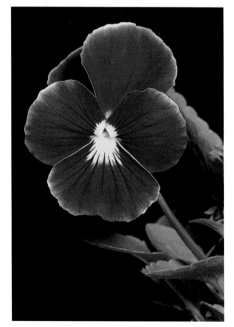
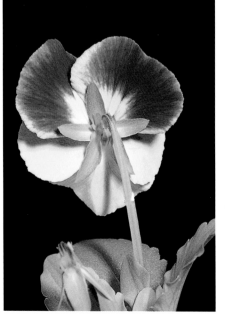
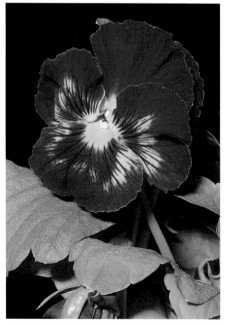

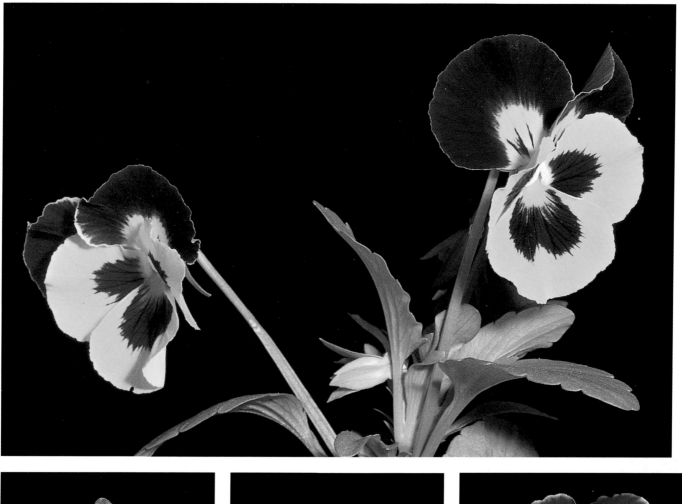

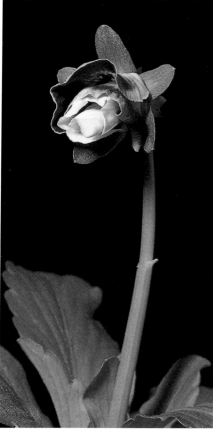

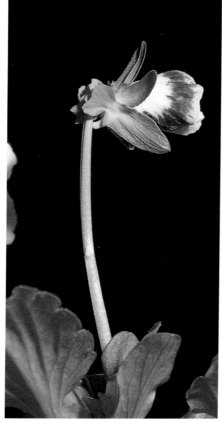

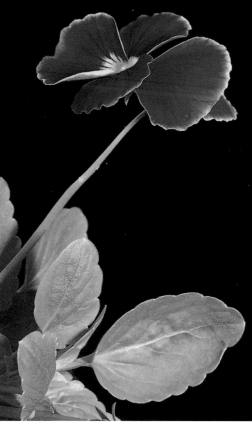

Pansies in Watercolor

The ceramic duck and water reflections were painted from reference photos in Shane's collection. The remaining elements of the picture were painted using combinations of memory, imagination and artistic license.

Supplies

Brushes
Flat bristles #1 and #5
Round sables #1, #2, #3, #6, #8, #10
2" (5cm) flat wash brush
Toothbrush
Stiff brush

Other
22" x 38" (55.8cm x 96.5cm) Arches
 300 lb. cold-press watercolor paper
Overhead projector (optional)
Single-edge razor blades
Paper towels

Color Palette
Winsor & Newton
Cadmium Yellow
Alizarin Crimson
Burnt Umber
Payne's Gray
Hooker's Green Dark
Cobalt Blue

Daniel Smith
Hansa Yellow Light
French Ultramarine
Sap Green

Grumbacher
Mauve
Chinese White

Tip
A hair dryer may be used to accelerate drying time, but care must be taken so the air from the dryer doesn't disturb the paint or dry it unevenly.

1. Prep, Lay Out Yellow Parts
Wash paper first, then dry thoroughly to remove the sizing. Paint can then penetrate it -to create intense colors and dark values where desired. Lightly transfer a thumbnail sketch with a 2B graphite pencil.

Light colors and values are added first. Using a #8 round sable brush, paint with a mixture of two-thirds Hansa Yellow Light and one-third Cadmium Yellow. Lift out some highlight areas with water and paper towels.

2. Darker Areas
Using a #3 round sable brush, paint the darker yellow areas with Burnt Umber and allow to dry one full day. Using #3 and #6 round sable brushes, paint the dried yellow of the pansy with Mauve to enhance form.

Paint dark areas with combinations of Mauve, Cobalt Blue, French Ultramarine and Alizarin Crimson. Using a #1 round sable brush, add highlights with Chinese White.

Avoid Accidents
Because the sizing has been removed, care must be taken to keep staining colors from spilling or splattering on those areas that will remain white: Cover all areas not presently being worked on in order to avoid accidents.

3. Leaves and Ceramic Duck
Using #3 and #6 round sable brushes, paint the leaves with Hooker's Green Dark and Sap Green. Each area will be adjusted later to complement, but not conflict with, the focal point. Using #6 and #8 round sable brushes, paint the duck planter with Payne's Gray and Burnt Umber. Let dry. Remove highlights with a stiff brush.

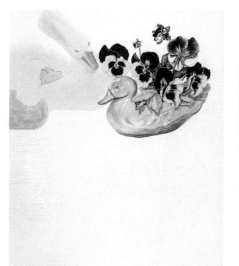
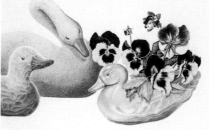
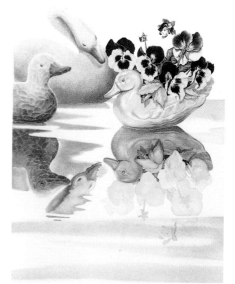

4. Stone Goose and Carved Duck

Using #8 and #10 round sable brushes, paint the stone goose with Payne's Gray, Mauve and Alizarin Crimson. Using #6 and #8 round sable brushes, paint the carved duck with Sap Green and Hooker's Green Dark. Define the forms using darker values of the previously described colors as applicable.

5. Textures and Details

To create texture in the goose, spatter alternately with a toothbrush loaded with Payne's Gray, Alizarin Crimson and then Mauve. Give the carved duck a rustic appearance using #1 and #5 flat bristle brushes, alternately adding dark values and scrubbing out highlights. Add the yellow of the pansies' reflection with some saved color, painting wet-on-wet with a #6 sable round.

6. Refine Reflection

After moistening the paper, use a 2" (5cm) flat wash brush to refine the entire reflection area with Cobalt Blue. Usually the light areas of the subject will reflect darker and dark areas will reflect lighter. Since this is a scene following a shower, the water still has slight movement, causing small areas of distortion and refraction similar to the image in a broken mirror.

7. Final Stages

Create the mirror images similar to steps 1 through 5. Paint the goose reflection with #8 and #10 sable rounds, and then spatter it with Payne's Gray, Mauve and Alizarin Crimson using a toothbrush. Finish flower reflections using the original colors, either lightened or darkened. Create water drops by lifting the shape of the drop, using #1 and #2 sable rounds and darkened original color for the shadow opposite the light source, and pulling out highlights with the tip of a razor blade after the drop is thoroughly dry.

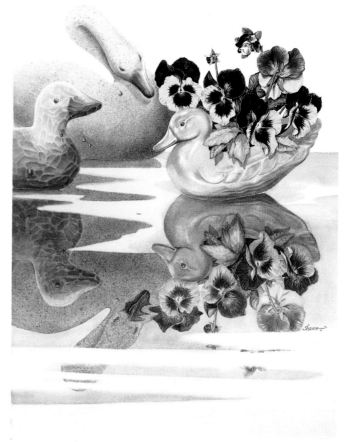

After the Rain © SHANE

Peony

A large, frilly flower, the peony varies in size from 3" (7.6cm) to 5" (13cm) in diameter and blooms from late spring to early summer. Colors include white, red, pastel orange, pink, yellow and bicolored combinations.

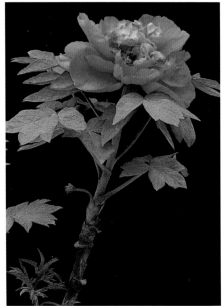

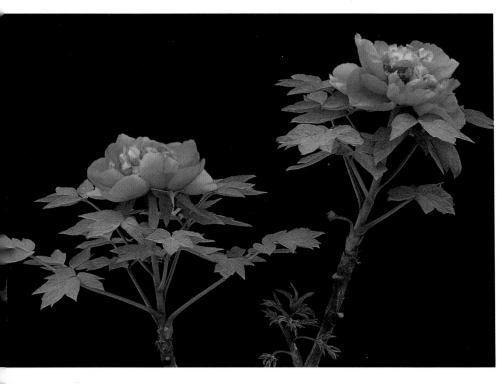

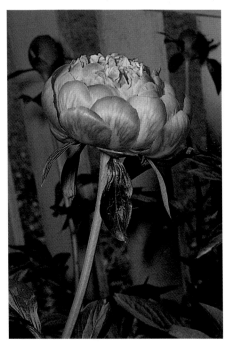

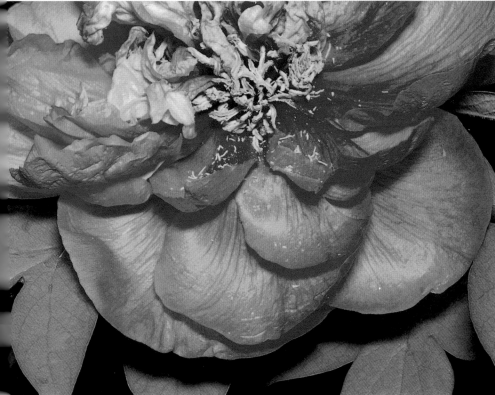

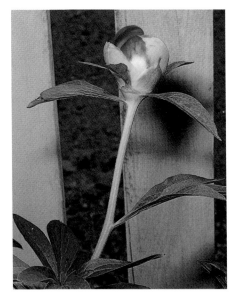

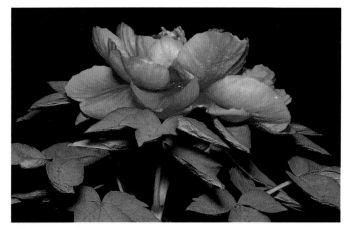

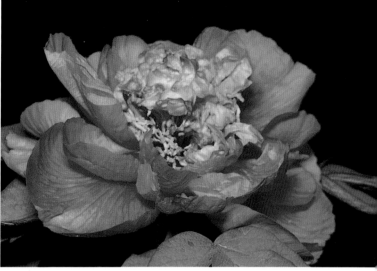

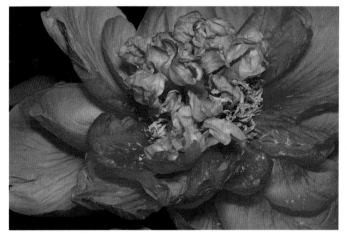

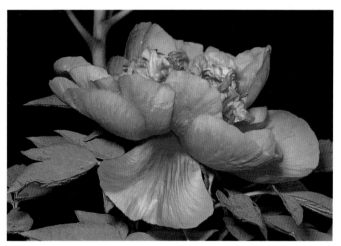

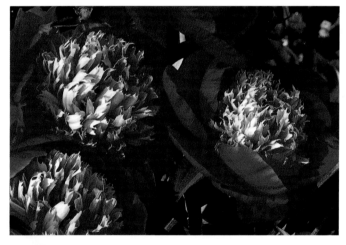

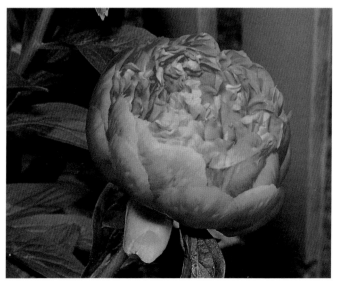

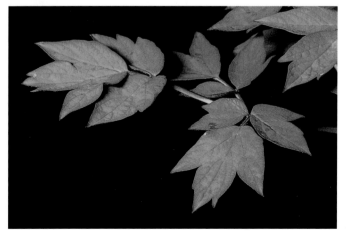

Petunia

Petunias bloom in the summer and early autumn. The trumpet-shaped flowers are about 4" (10.1cm) across. They have single or double petals with plain, wavy or frilly edges. Colors include white, pink, purple, magenta, mauve and yellow. They are frequently speckled, striped or veined in contrasting shades.

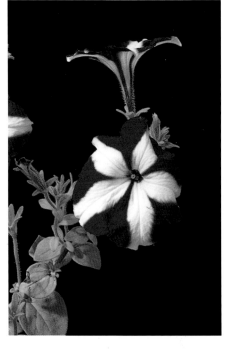
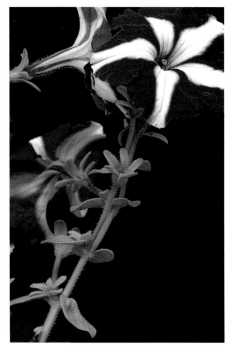
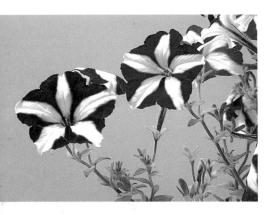
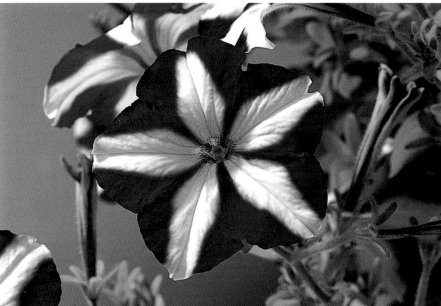
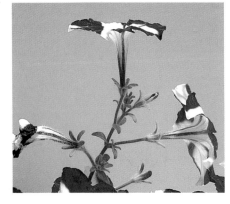
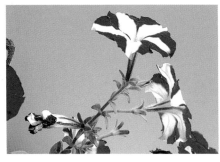
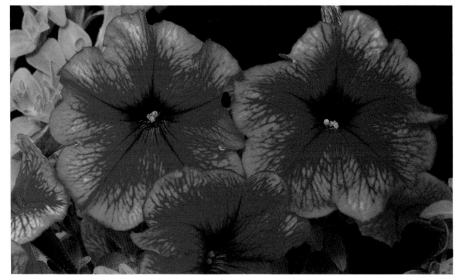

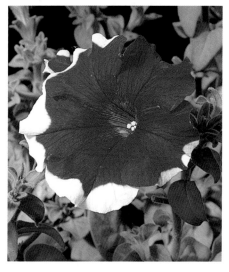

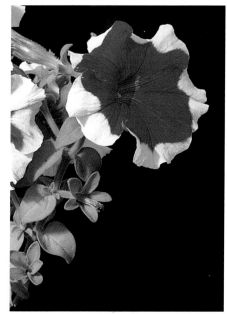

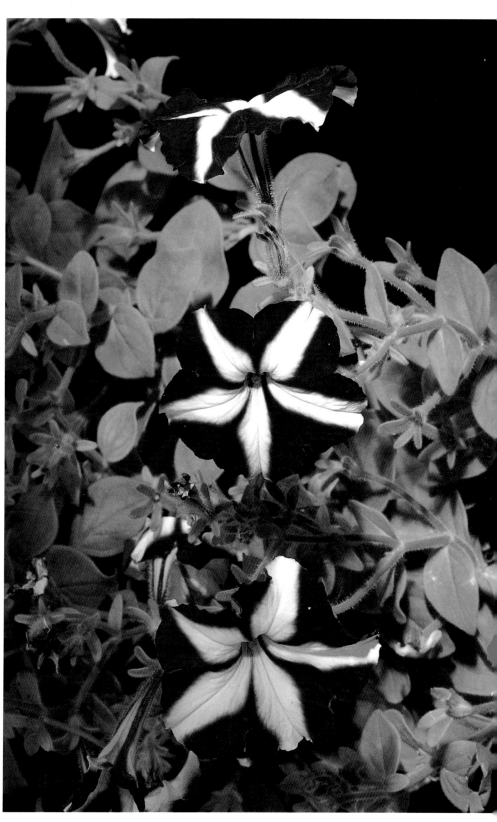

Poinsettia

Sometimes called Christmas flowers, poinsettias bloom in mid-winter. Colors include red, pink, white and cream. Some hybrids are variegated, with combinations of two colors.

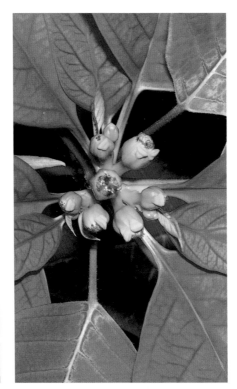

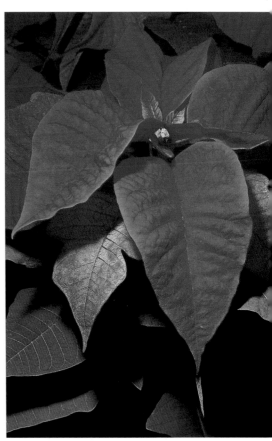

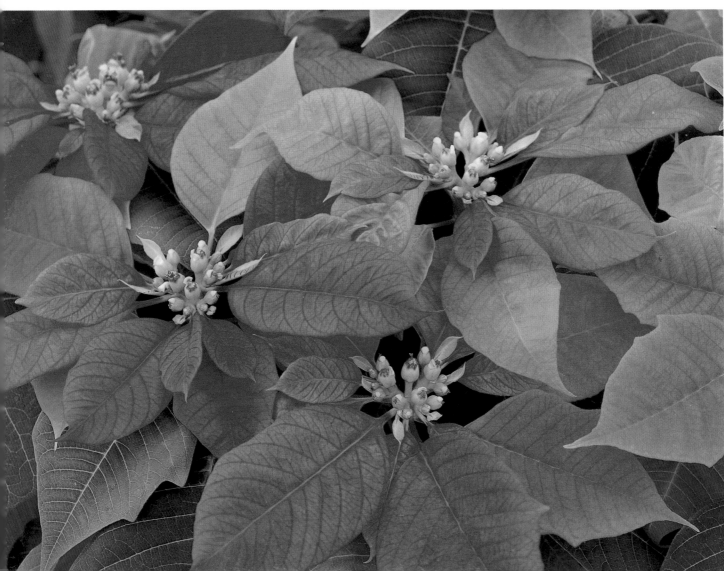

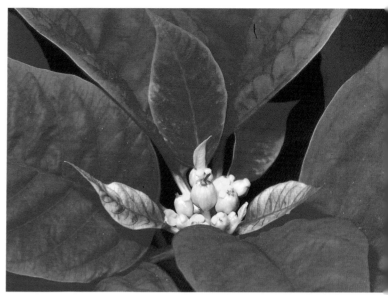

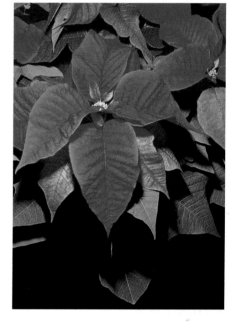

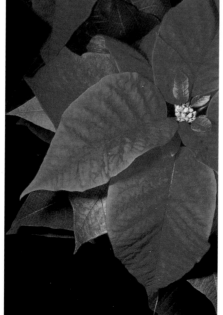

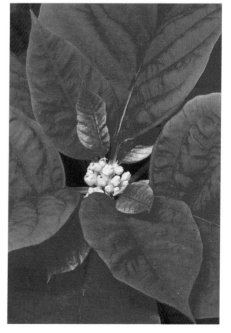

Poppy, Iceland

A smaller, more delicate version than the oriental poppy, the Iceland poppy blooms in the summer. Its petals range in color from orange, salmon and yellow to white. Centers are yellow.

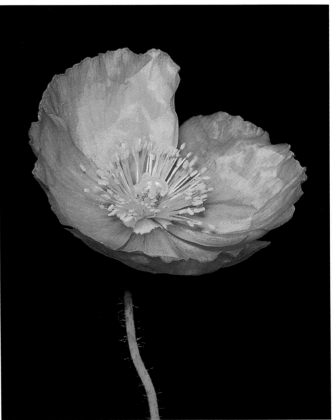

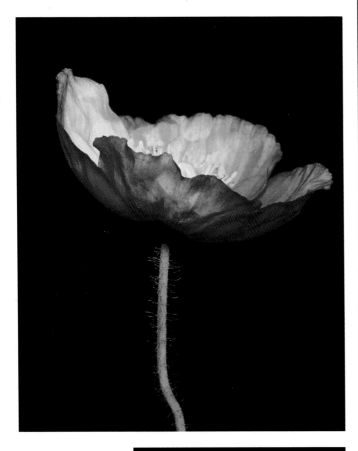

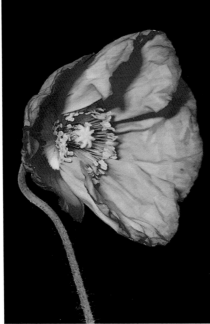

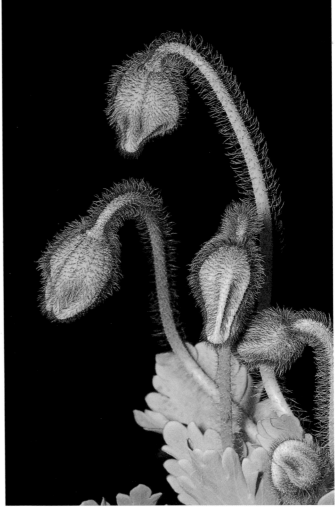

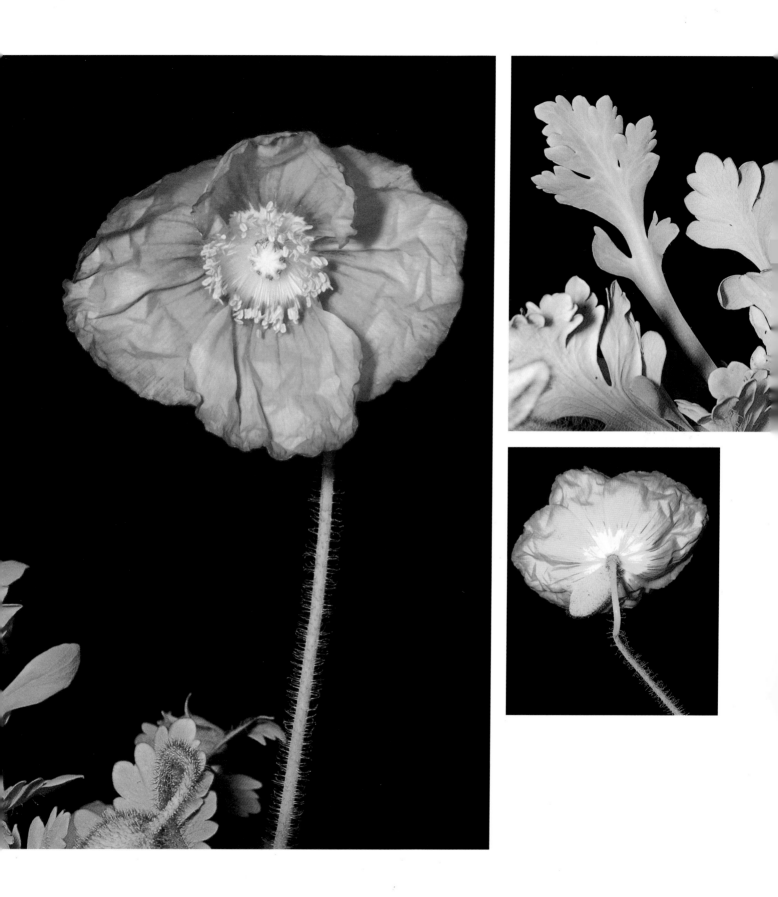

Poppy, Oriental

These brilliant flowers bloom in late spring to early summer. The leaves can reach lengths of 1' (0.3m), and the hairy stems are usually 2' (0.6m) to 3' (0.9m) long. In addition to scarlet and crimson, the petals are colored in rose pink, orange, white and maroon, with black blotches. Centers are black.

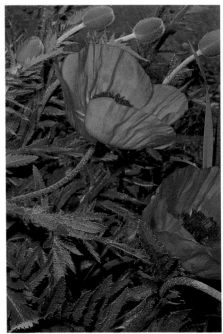

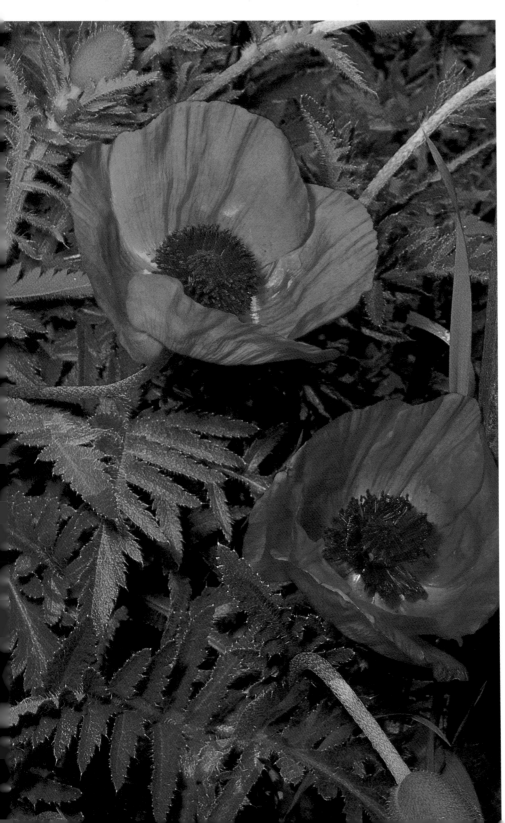

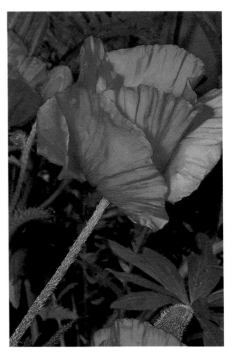

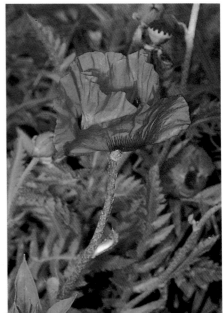

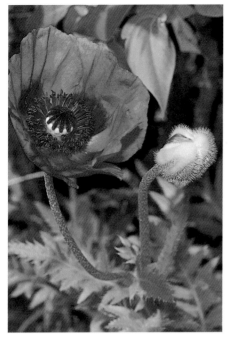

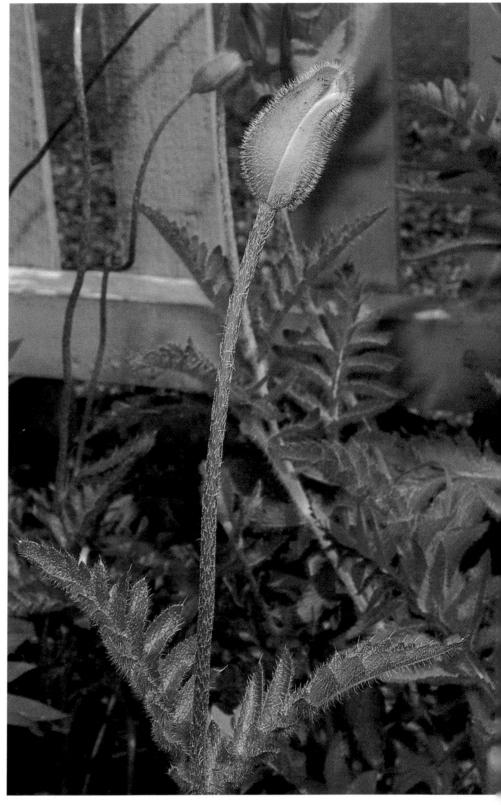

Primrose

*Measuring approximately 1"
(2.5cm) across, English prim-
roses bloom in early spring.
Most are bicolored, with yellow
centers and red, violet, purple,
magenta, pink or white petals.*

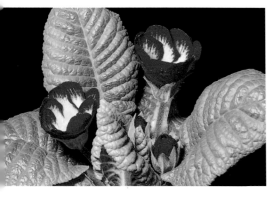

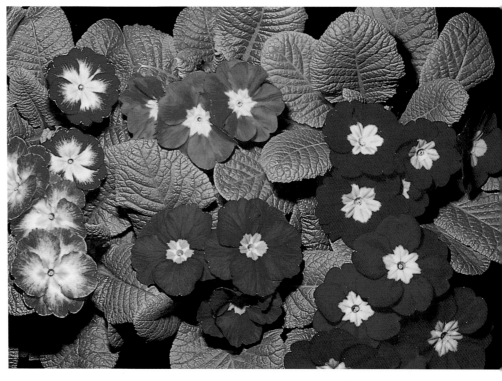

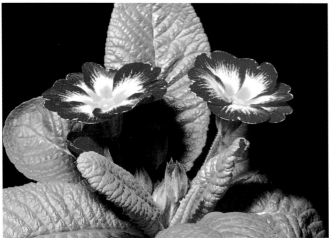

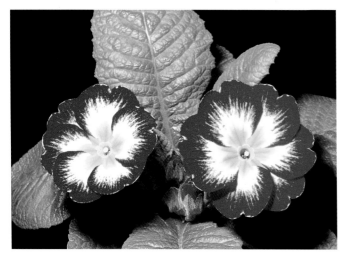

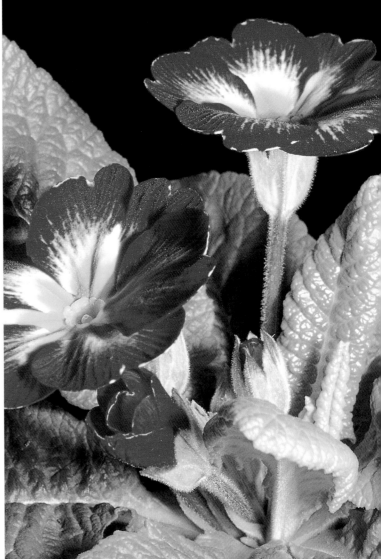

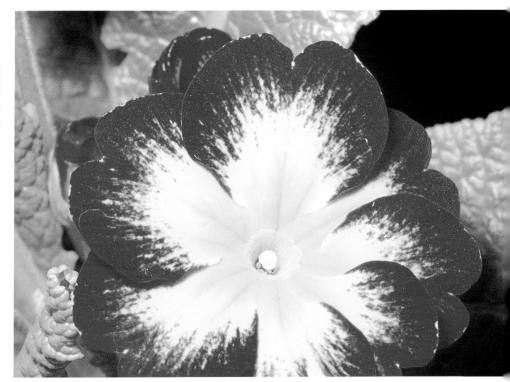

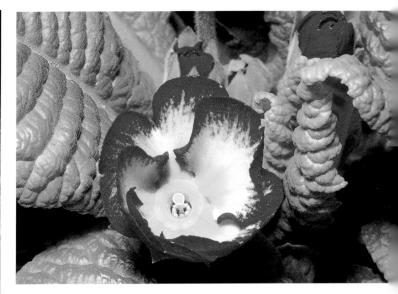

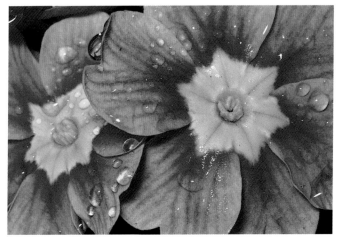

Rhododendron

Rhododendrons grow in bunches and are mainly spring bloomers. Colors vary greatly and include white, pink, red, yellow, orange and lavender. Rhododendrons often have brownish or reddish speckles on the inside of their petals.

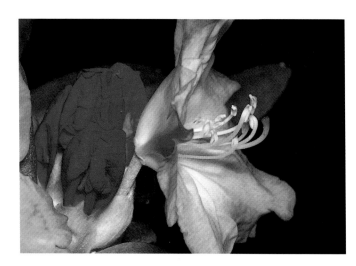

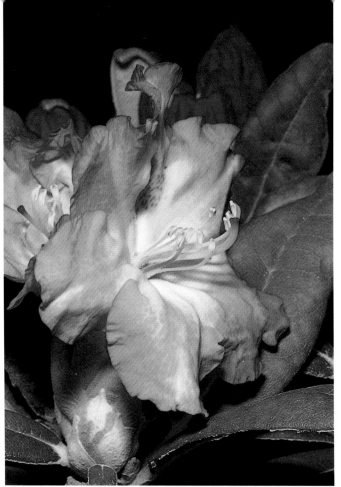

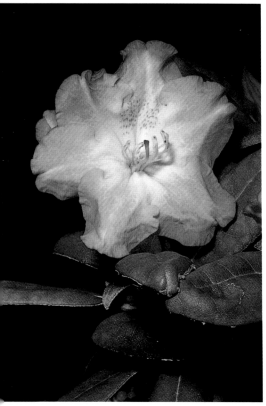

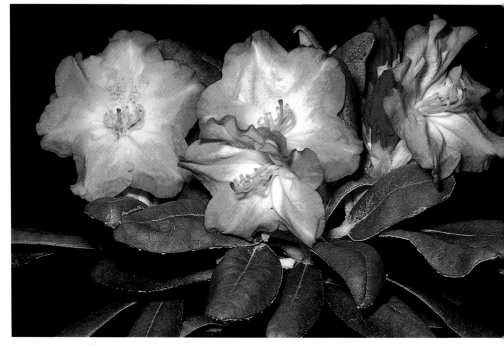

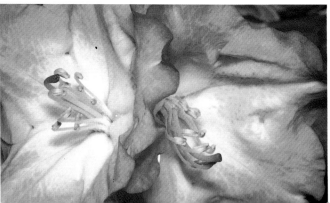

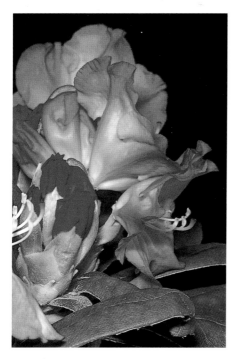

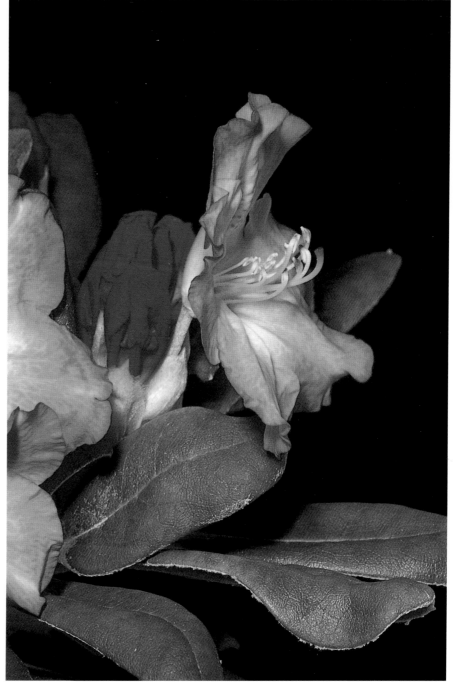

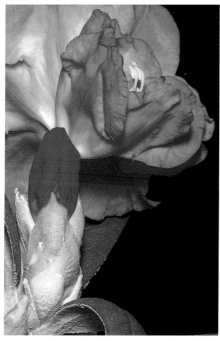

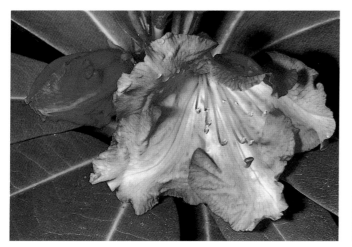

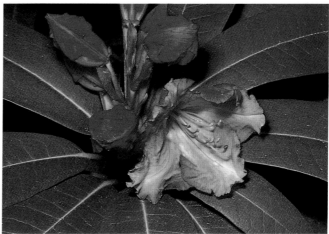

Rose

By far the most popular subject for artists of all media, colors vary greatly. They include red, purple, pink, yellow, orange, magenta, lavender, white and combinations thereof.

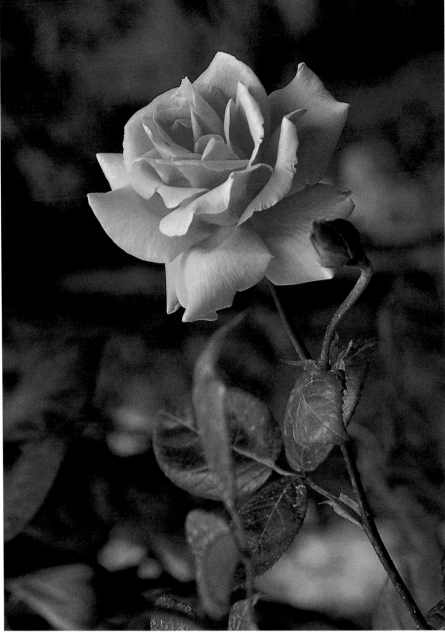

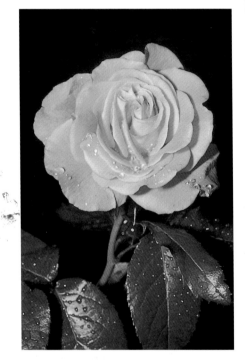

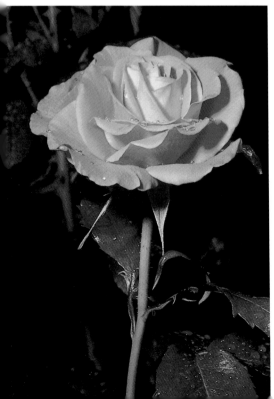

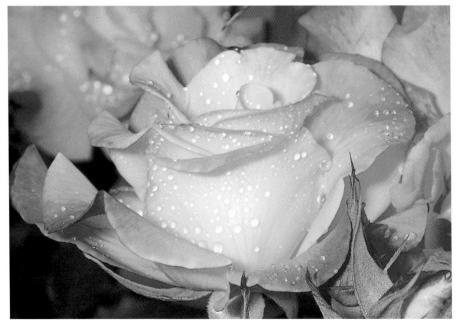

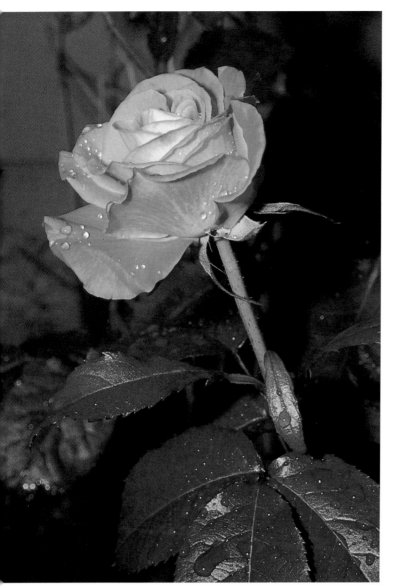

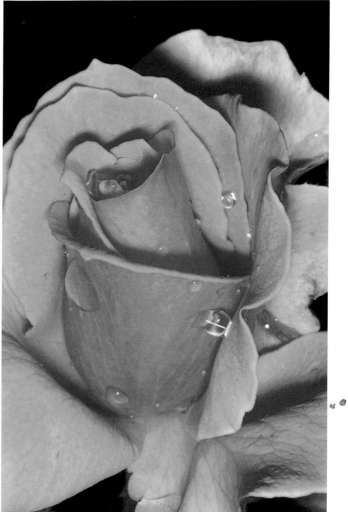

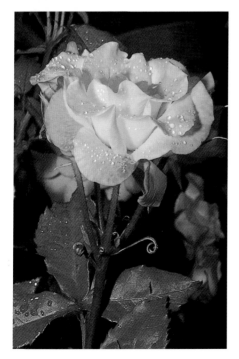

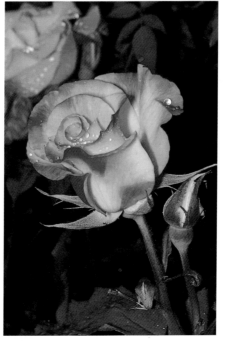

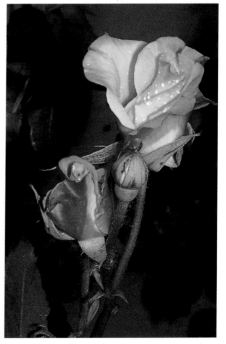

Rose

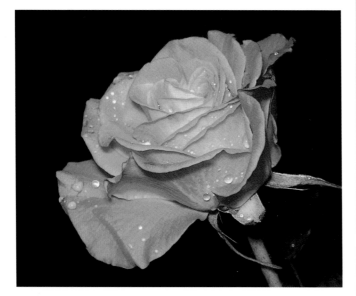

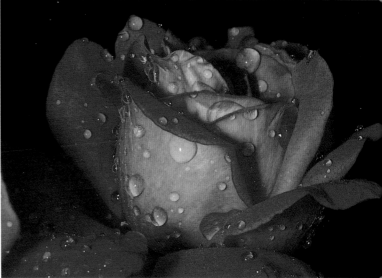

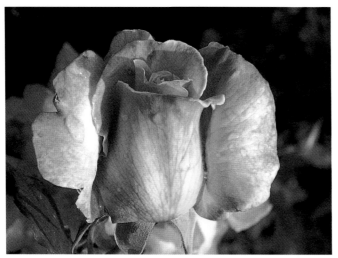

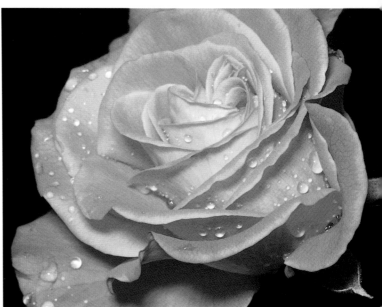

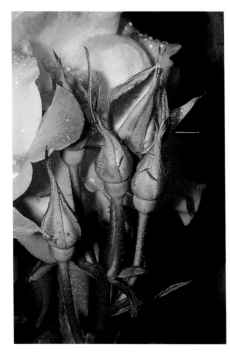

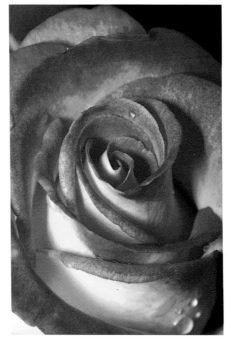

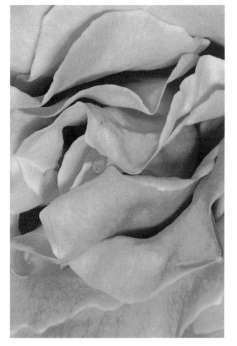
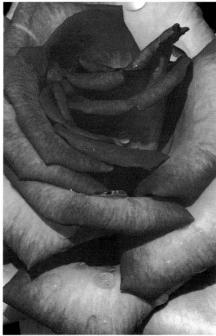
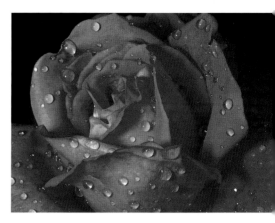
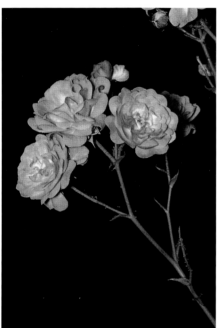
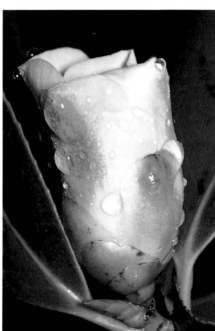
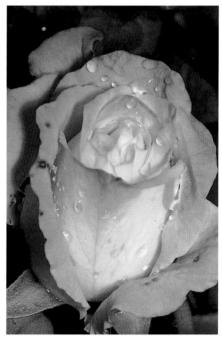
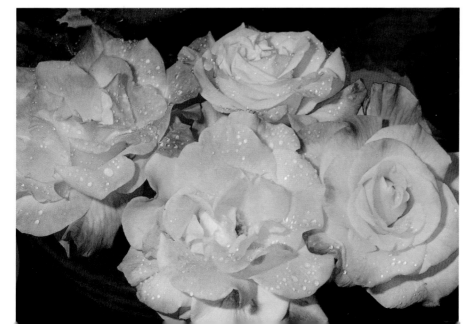

Salpiglossis

Also known as painted tongue, this 1" (2.5cm) to 2" (5cm) wide by 2" (5cm) long, trumpet-shaped summer bloomer grows on 1½' (0.5m) to 3' (0.9m) stalks. Colors include scarlet, yellow, gold, mauve and violet, with beautiful markings.

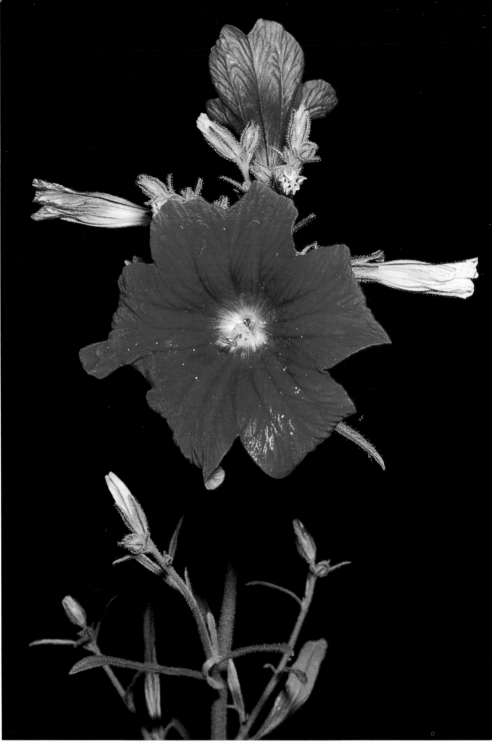

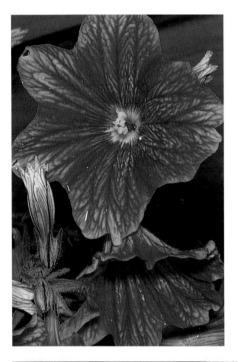

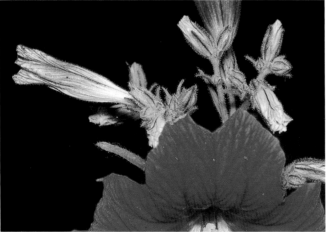

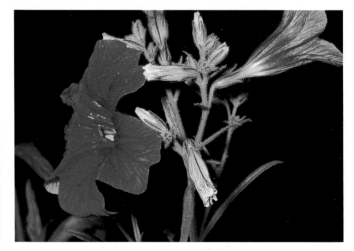

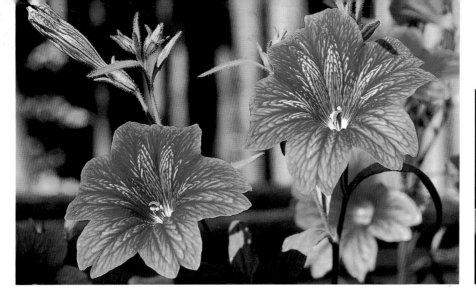

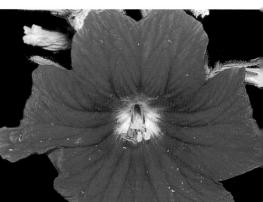

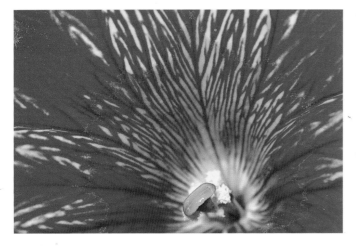

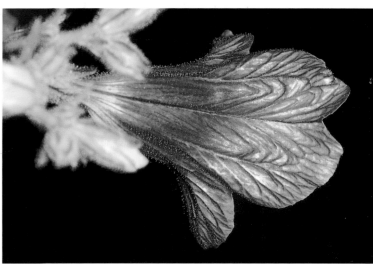

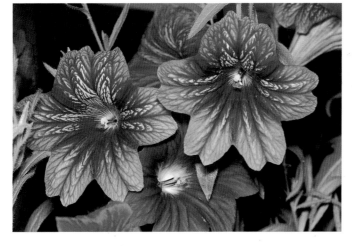

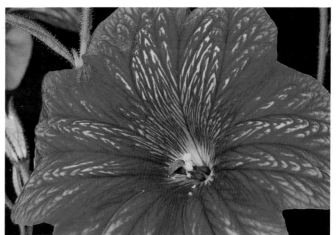

Snapdragon

The 1½" (3.8cm) diameter snapdragon flowers grow in bunches, on stalks approximately 1' (0.3m) to 2½' (0.8m) high. They are usually bicolored, having yellow throats combined with scarlet, purple, magenta, pink and white. Snapdragons bloom from late spring through mid-autumn.

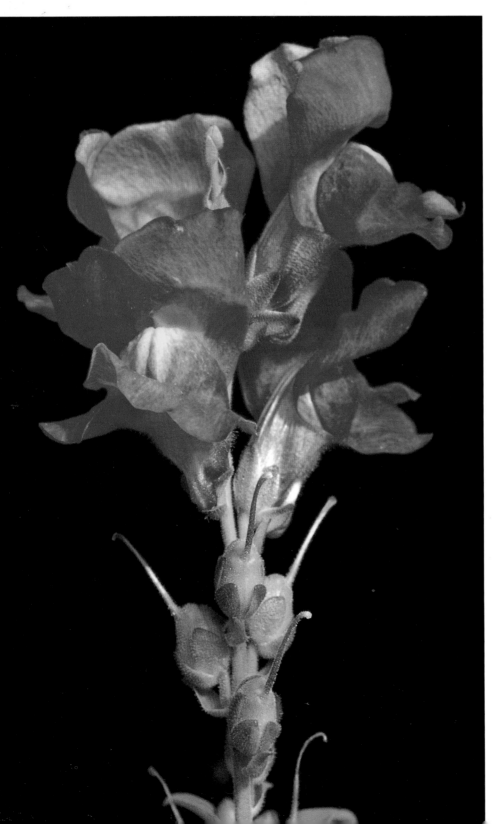

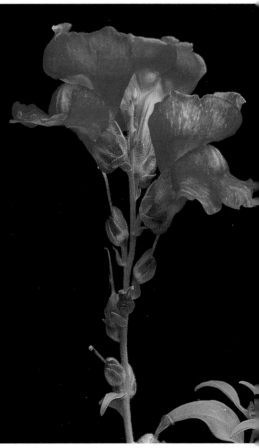

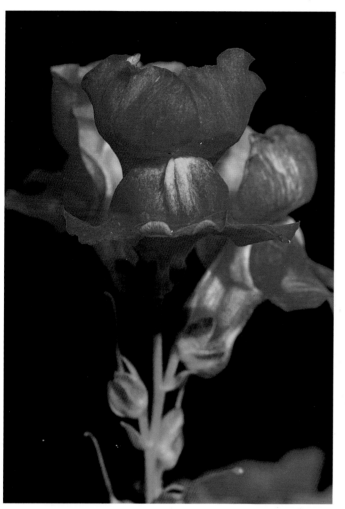

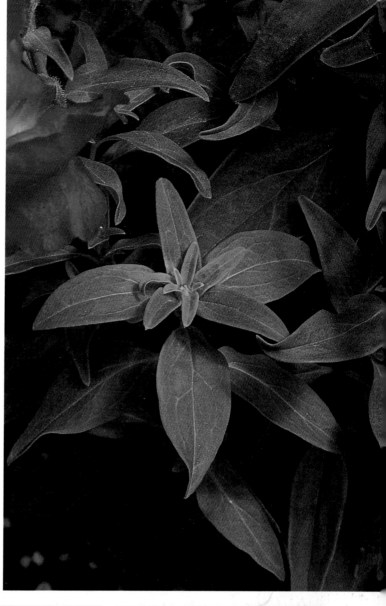

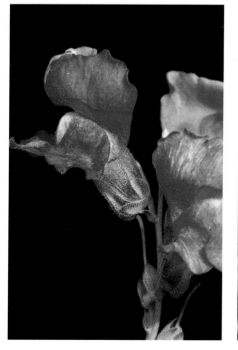

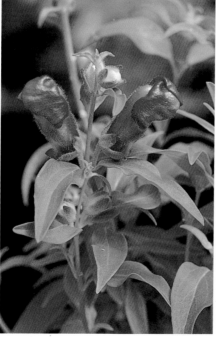

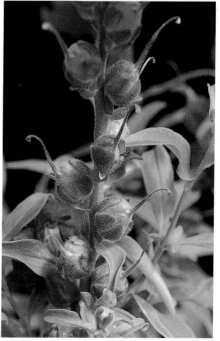

Sunflower

Sunflowers range from 3" (7.6cm) to 1½' (0.5m) in diameter and grow on stalks 2' (0.6m) to 12' (3.7m) tall. While most have yellow petals with dark brown centers, some hybrids are chestnut brown, light yellow, yellow-orange and shades of white. Sunflowers bloom in the summer and early autumn.

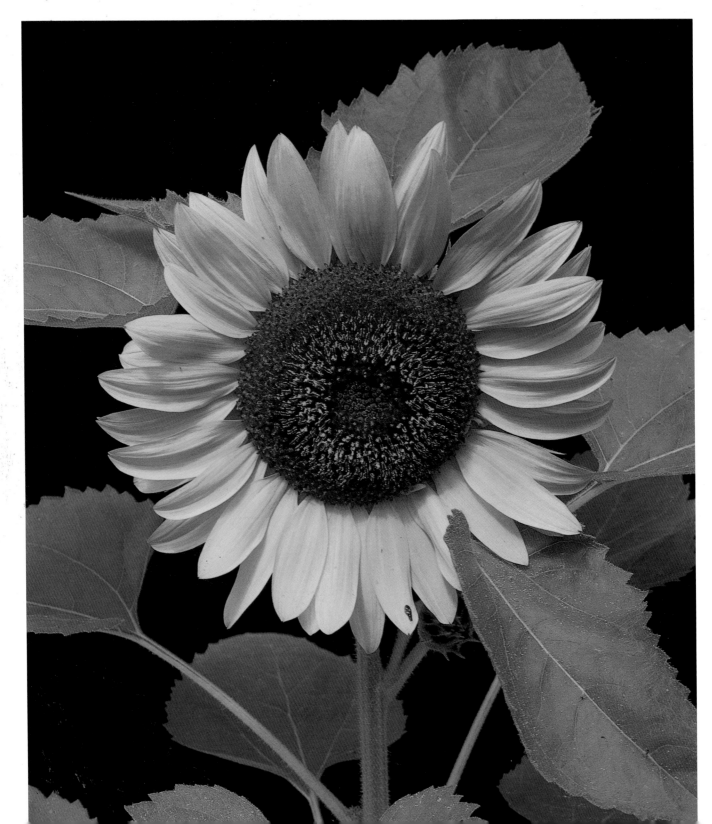

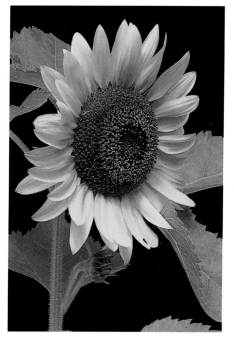

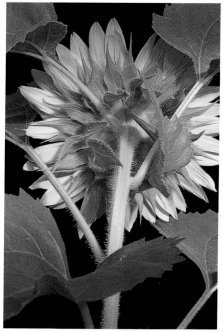

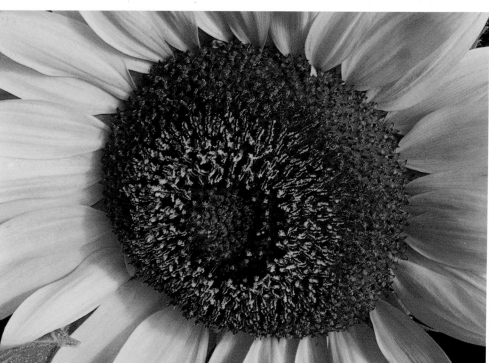

by Barbara Krans Jenkins

Sunflowers in Ink and Colored Pencil

Supplies

- 11" x 14" (27.9cm x 35.6cm) Crescent 100% rag hot-press watercolor board
- Mechanical pencil with 5mm 2B lead
- Staedtler Mars magno 2 4x0 mechanical pen
- Electric pencil sharpener
- Desk brush
- Vinyl eraser strip in electric eraser
- Stylus with small nib
- Krylon workable fixative

Color Palette: Berol Prismacolor

French Grey 10%, 30%, 50%, 70%	Pale Vermilion
Parma Violet	Light Cerulean Blue
Canary Yellow	True Blue
Cream	Mediterranean Blue
Violet	Copenhagen Blue
Deco Yellow	Burnt Ochre
White	Grayed Lavender
Goldenrod	Spanish Orange
Yellow Ochre	Sunburst Yellow
Magenta	Mineral Orange
Indigo Blue	Beige
Dark Green	Peacock Blue
Grass Green	Light Umber
Olive Green	Sienna Brown
Chartreuse	Dark Brown
Metallic Green	Dark Umber
Limepeel	Cool Gray 90%
Apple Green	Black
Tuscan Red	Blue Violet
Crimson Red	Dark Purple
Scarlet Red	White

A reverence for our woodlands and their Creator and a deep concern for the delicate ecological balance of our environment provide the motivating factors for Barbara Krans Jenkins in choosing her subjects. Through her art she tries to stir a sharper awareness and appreciation of beauty so often taken for granted.

Barbara starts with an ink underpainting on a smooth, cold-press white board. She then lightly applies several layers of colored pencil, and then lighter hues of color with more pressure, until the desired effect is achieved.

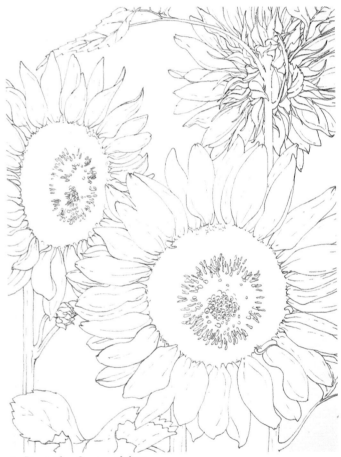

1. Draw the Composition
With a mechanical pen, carefully create a contour line drawing on the board surface.

2. Crosshatch Details

Crosshatch detail on flower heads and greenery with a 4x0 mechanical pen.

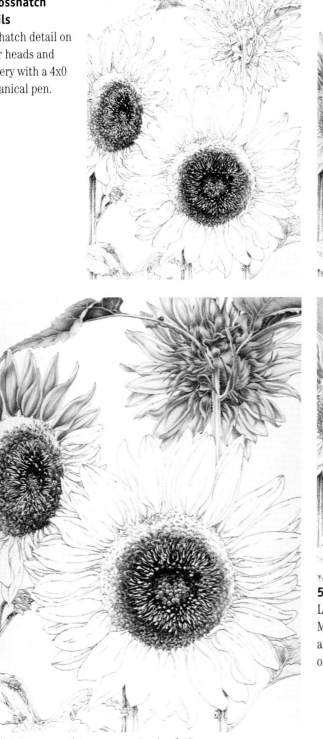

3. Paint Petals

Layer petals of top flower and top of middle flower with French Grey 70% and Parma Violet in the receding and shadow areas, and then burnish with Cream. Deepen with Violet, layer with Deco Yellow and burnish with White. Layer with Goldenrod and Yellow Ochre. Burnish with French Grey 30%, and adjust colors as necessary.

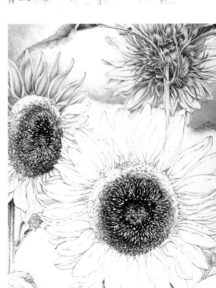

5. Paint Sky

Layer Light Cerulean Blue, True Blue, Mediterranean Blue and Copenhagen Blue, and then burnish with White, adjusting colors as necessary.

4. Paint Stems and Leaves on Back of Flower

Layer stem, leaves on back of flower, and ladybug at top with Magenta, Violet, Indigo Blue and Dark Green. Layer in shadows and folds of the leaves with Olive Green and Grass Green. Burnish with White, Chartreuse and Metallic Green, adjusting colors as necessary. Layer stems with Limepeel, Olive Green, Dark Green and Apple Green. Burnish with White. Leave highlight on the ladybug free of color, allowing white paper to show through. Layer Tuscan Red and Crimson Red in dark areas. Burnish with Scarlet Red and Pale Vermilion. Complete fuzz on stems and bracts with a sharp White pencil. Apply strokes at the point of origin for each hair, pressing firmly, then quickly drawing the pencil up and out in different directions as the hairs would grow.

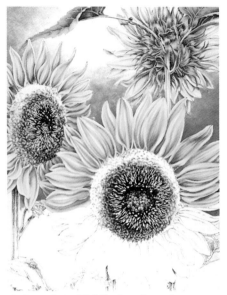

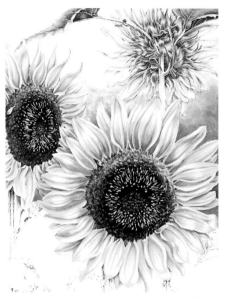

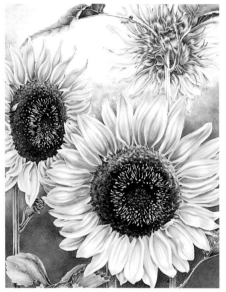

6. Complete Middle Petals and Paint Sky

Finish the middle petals with the same colors and technique used in step 3. Layer petals at the top of the foreground flower with Parma Violet, French Grey 70%, Violet and Grayed Lavender. Layer folds with Canary Yellow, Spanish Orange and Yellow Ochre. Burnish with Beige and Deco Yellow. Bring the sky down with the same colors used in step 5. Add layers of Peacock Blue and Indigo Blue.

7. Complete Foreground Petals, Paint Sepals and Punch Up Foreground Flower

Follow step 6 to finish foreground petals. Layer heads with Canary Yellow, Light Umber and Yellow Ochre. Burnish with Beige. Layer unopened buds in the middle of the heads with Olive Green. Burnish with French Grey 10%. Layer heads with Burnt Ochre and Sienna Brown. Burnish with Dark Brown. Layer Dark Umber, Cool Gray 90% and Black. Adjust colors as necessary. Punch up foreground petals by burnishing with layers of Mineral Orange, Burnt Ochre, Sienna Brown, Light Umber and Sunburst Yellow.

8. Emboss for Pollen; Complete Leaves, Ladybug and Sky

Complete the pollen on the leaves with Canary Yellow, and then emboss the surface with a stylus to create dots of yellow. Finish bottom leaves and stems using the colors in step 4. The pollen remains because the color is pressed into the board.

Complete the ladybug with the colors used in step 4, omitting the white highlight. Bring the sky down with more Copenhagen Blue, Peacock Blue and Indigo Blue, and then burnish with White.

9. Final Adjustments

Adjust colors over the entire painting with Violet, Blue Violet and Copenhagen Blue to accent middle and back flowers. Intensify the background with Peacock Blue, Copenhagen Blue, Olive Green, Indigo Blue, Tuscan Red and Dark Purple. Burnish with White and French Grey 10% as needed.

Adjust colors in the foreground leaf with the greens described in step 4. Burnish with White and Chartreuse. Accentuate pollen with a very sharp Canary Yellow pencil, using Yellow Ochre in darker areas. Apply Krylon workable fixative when complete.

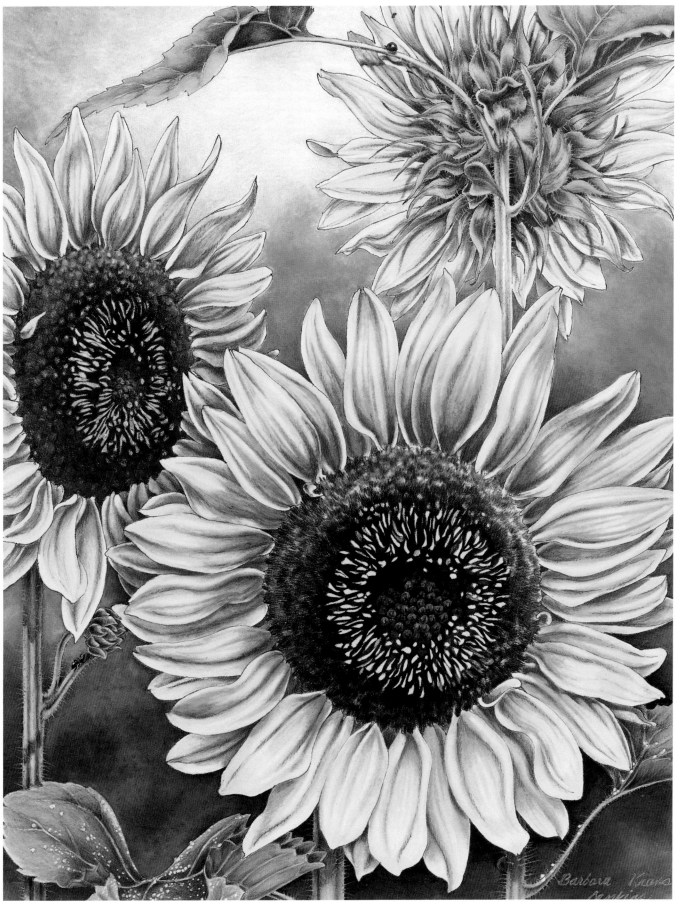

Sunflowers © BARBARA KRANS JENKINS

Tulip

Tulips, found in early spring, include varieties with pointed or ruffled petals (such as parrot tulips). Colors vary greatly, including single colors, combinations and variegated varieties of red, purple, pink, orange, yellow, magenta and white.

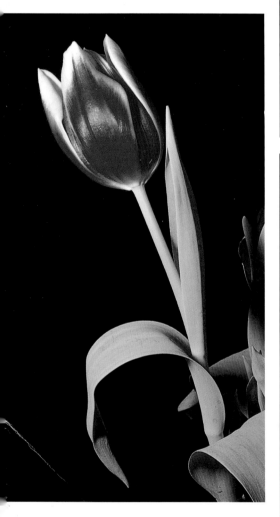

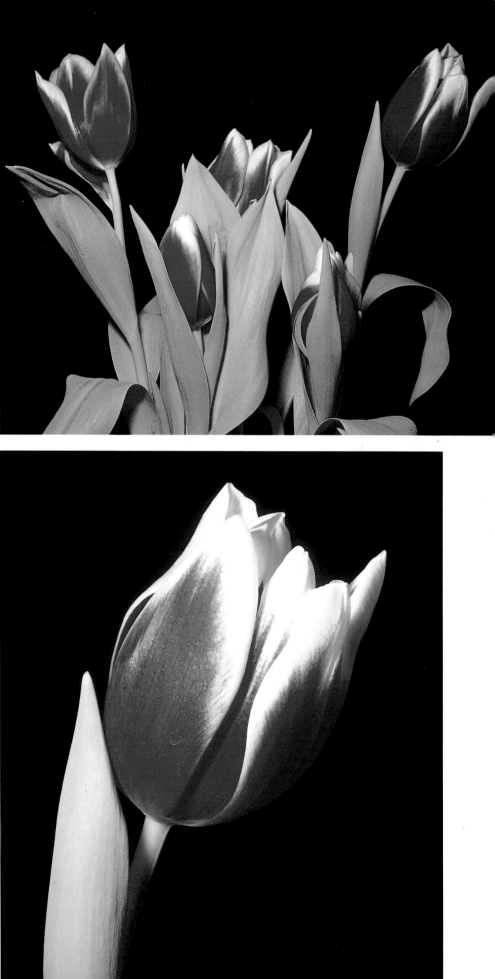

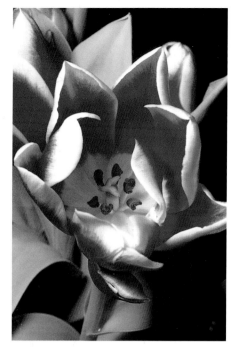

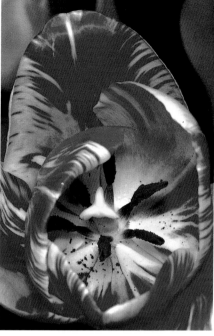

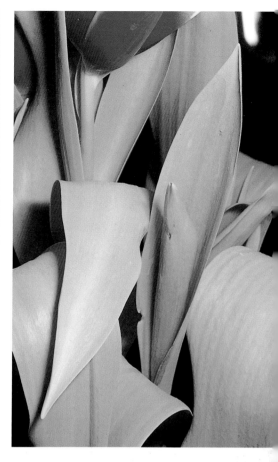

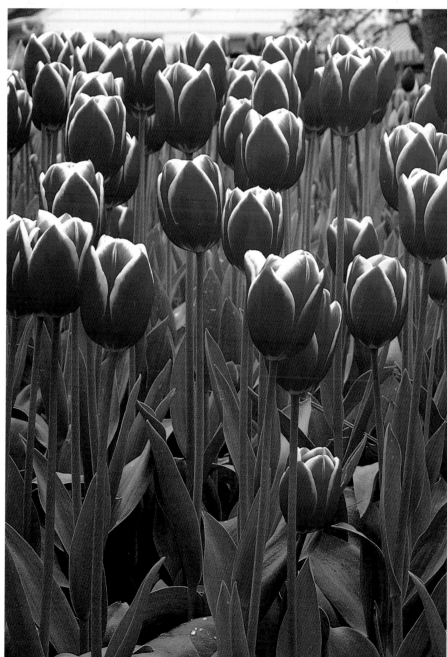

Water Lily

Water lilies, which bloom in the summer, have petals in varying shades of pink, crimson, yellow and white. Their pads, in shades of green, maroon and yellow, also vary.

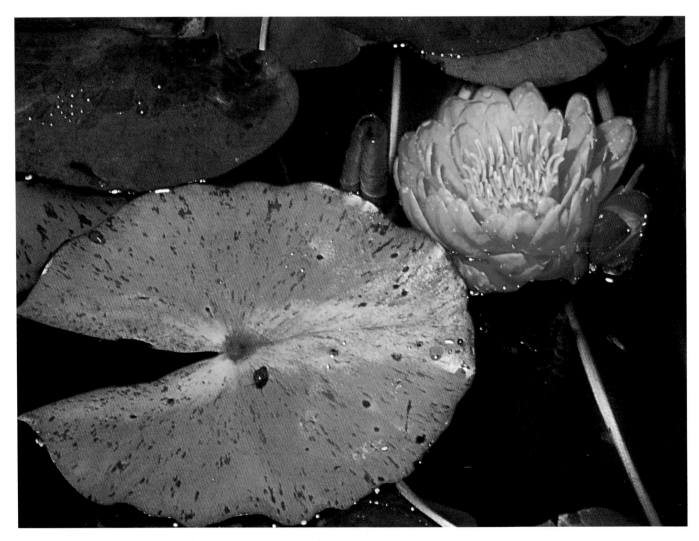

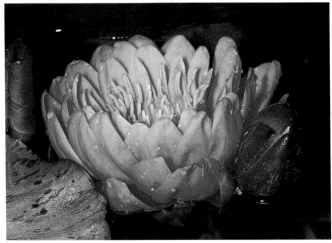

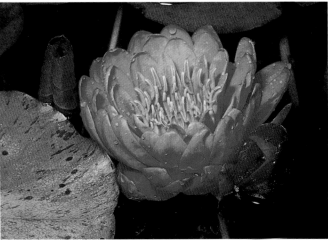

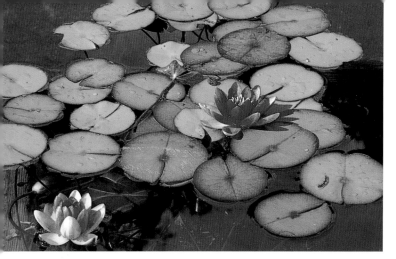

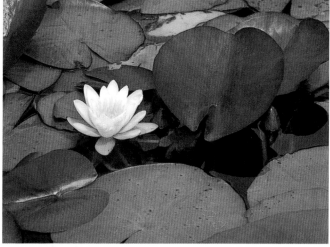

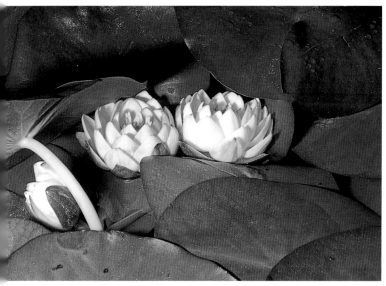

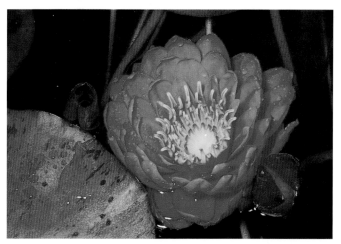

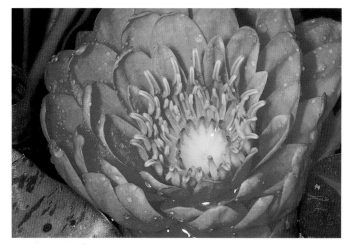

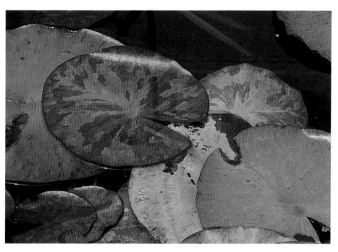

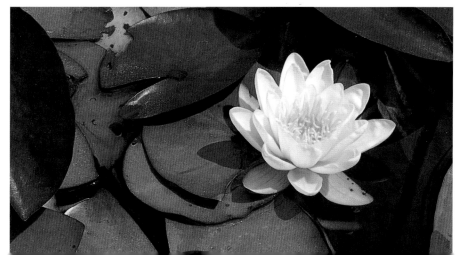

Zinnia

*This summer and autumn bloomer has large flowers, 2"
(5cm) to 4½" (11.4cm) in diameter. They grow on stalks ranging from 1' (0.3m) to 3' (0.9m)
tall. Flowers are white, red, yellow, violet and orange.*

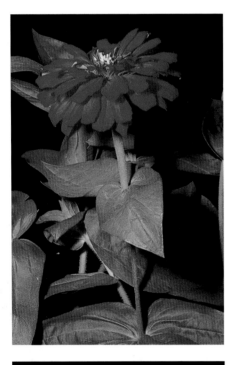

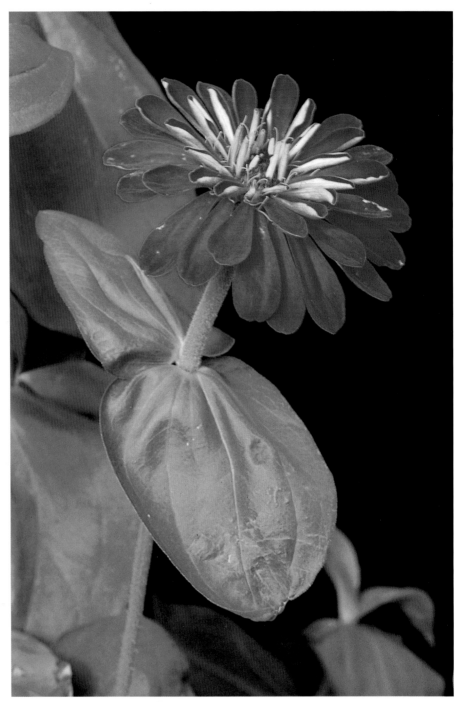

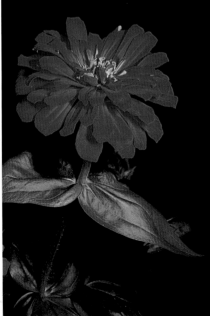

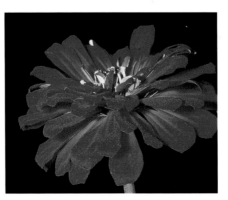

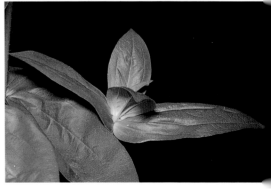

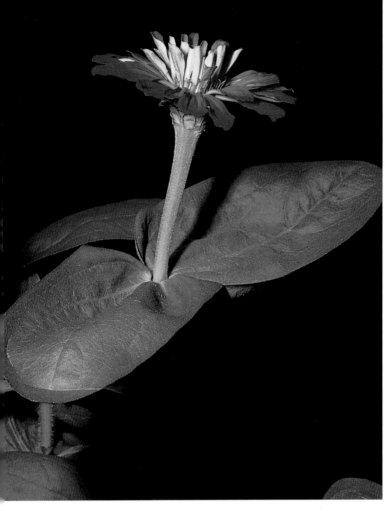
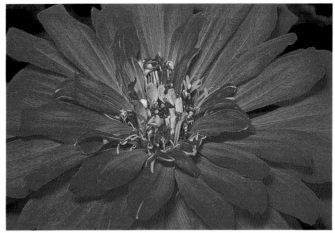
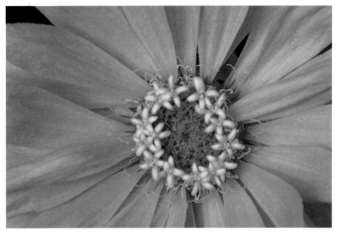
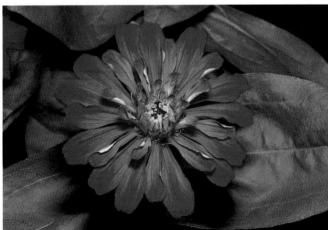
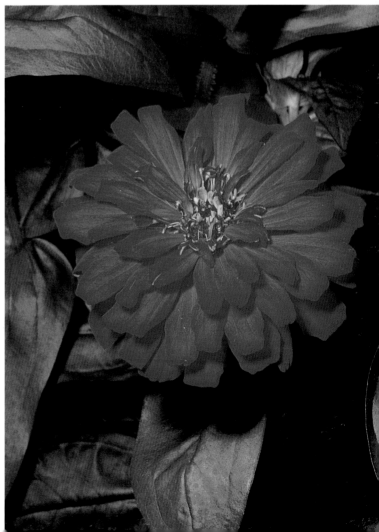

Contributing Artists

Norma Auer Adams

From childhood, growing up surrounded by lush trees, wild grasses, birds and squirrels, Norma Auer Adams has had a close link with the land and nature. Her greatest satisfaction comes when she's surrounded by them. When Norma paints, she immerses herself in images from nature and tries to create works radiant with the peace, stillness and sense of awe she finds in the natural world. Norma works with airbrush and acrylic paint on paper and canvas.

After graduating from Stanford University with a bachelor's degree in art, Norma began to paint exclusively in watercolor. She first concentrated on creating wet-in-wet abstraction based on direct observation of nature in the hills and fields of California. Artists Christopher Schink and Doris White were her mentors and teachers during this period.

In the early 1980s, Norma left California's open spaces for Manhattan and then Boston. She began to paint the urban landscape based on photographs taken while walking city blocks. There she found nature co-existing with city life in small gardens, strips of green space and parks. Flowers were important in the landscape of the city and came to assume a major role in her work. Norma's art has since evolved from abstraction to realism, from on-location to studio-based work, and from watercolor to airbrushed acrylic.

Norma's work has appeared in a number of publications: *Mastering Color and Design in Watercolor* (Christopher Schink, Watson-Guptill, 1981); *Painting With Passion: How to Paint What You Feel* (Carole Katchen, North Light, 1994); *The Best of Flower Painting* (Kathryn Kipp, North Light, 1997); and *The Artist's Magazine* (April, 1994). Her paintings have received many awards and have been shown in numerous national and regional exhibits, as well as museums such as the Southern Allegheny Museum of Art in Pennsylvania, the Asheville Museum in North Carolina and the Triton Museum in California. Norma's paintings are in collections internationally, including Citizens First National Bank (New Jersey), Connecticut General Life Insurance Company (Connecticut), Market Research Corporation of America (Connecticut) and Western Electric Company (New York).

Sandy Jackoboice

After many years of raising a family and pursuing a career in fashion retail, Sandy completed a Bachelor of Arts degree in 1989 at Aquinas College in Grand Rapids, Michigan. Art has always been a part of her life and work. Yet until classes at Aquinas introduced her to art as a viable professional opportunity, she considered it as only a means to design logos for her business, using color as it related to fashion, or as a hobby.

Three months after graduation, Sandy was made Art Program Director at the Franciscan Life Process Center in Lowell, Michigan. There she has developed, organized and is directing an artist-in-residence program, now in its sixth year. Pastel is Sandy's medium of choice, but subject matter or clients often dictate the use of other mediums. Sandy also works in water-based mediums and oil. Floral, landscapes and figurative subjects are her favorites; photographs she has taken during various trips around the globe provide her with resource material.

Sandy is a member of the Artists' Alliance, Rivertown Artist Guild, Grand Valley Artists, Midwest Pastel Society, and the American Society of Botanical Artists. She is a co-founder and president of the newly formed Great Lakes Pastel Society, a member of the International Association of Pastel Artists. Her work has been exhibited nationally and internationally. She is represented by Prys Gallery in Ada, Michigan; Art Encounter Gallery in Las Vegas, Nevada; Synchronicity Gallery in Glen Arbor, Michigan; and the Grand Rapids Art Museum Rental/Sales Gallery. Her work is also included in numerous private and corporate collections.

Barbara Krans Jenkins

Drawing has always been the love of this Akron, Ohio artist, who focuses mostly on wildlife, typically forest flora and fauna. She finds inspiration across the country as well as in her own backyard, the Cuyahoga Valley National Recreation Area.

Barbara earned a Bachelor of Science degree in education from Kent State University and studied graphic design at Akron University. She has always found drawing a challenge—particularly very fine-line pen and ink work. She enjoys working with oils, watercolor and pastels because of her love of mixing colors. But when Barbara discovered colored pencils, the medium surpassed the others (despite its labor intensity) because of the convenience, control, blendability and flexibility it offers. For love of the "process" of creating art, Barbara retains the use of a line underdrawing in ink for her paintings in colored pencil. Layering of pigments and burnishing with lighter ones make her paintings "spring to life right off the page!"

Before settling on her current style, Barbara taught and did freelance work for twenty-five years, designing logos, doing home portraits and illustrating for magazines, calendars and cards. Her work has been shown and honored in many local, regional and national shows, such as the National Christian Fine Arts Exhibit and the Botanicals National Exhibition. Her work has appeared in *The Best of Flower Painting* (North Light), *Creative Colored Pencil, the Step-by-Step Guide & Showcase* (Rockport) and *Creative Colored Pencil Landscapes* (Rockport). Barbara has placed work in private and corporate collections and conducts lectures, demonstrations and workshops. Barbara is a member of the Colored Pencil Society of America, the Akron Society of Artists and the Ohio Realist Group.

Shane

Shane has been involved in the fine arts for many years. She has instructed people of all ages and abilities, involving them in the wonder of art. Her primary love, however, has been watercolor, although she has employed various other mediums in her works. Most recently she has been involved in furthering her education to include the use of colored pencil. Shane's subjects range from portraits done in pastel, charcoal and oil to florals and wildlife in watercolor and colored pencil.

Shane is a member of the Northwest Watercolor Society and the Colored Pencil Society of America. She has numerous paintings in private collections, including one on exhibit at the Seattle Fire Department Fire Alarm Center. Her works have been shown throughout western Washington, and have been accepted into many regional juried shows, including the 1996 Edmond's Art Festival. In 1996 her colored pencil paintings were shown at the Washington State Convention Center in Seattle.

Index